FASHION DESIGNER

Concept to Collection

SANDRA BURKE

www.burkepublishing.com www.fashionbooks.info

Fashion Designer - Concept to Collection

Burke, Sandra

ISBN: 978-0-9582391-2-7

First Published: 2011

Copyright ©: Burke Publishing

Email: sandra@burkepublishing.com

Website: www.fashionbooks.info

Website: www.burkepublishing.com

Distributors: See website for international distribution.

DTP: Sandra Burke

Cover Images: Fashion Illustrations (front and back cover) - Courtesy of PROMOSTYL Paris

Dress Forms - Frances Howie

Cover Design: Simon Larkin

Printed: Everbest, China

English (UK) and English (US) spelling: In keeping with global technology the spelling of *color* is consistent. The UK spelling is *colour*.

ISBN: 978-0-9582391-2-7

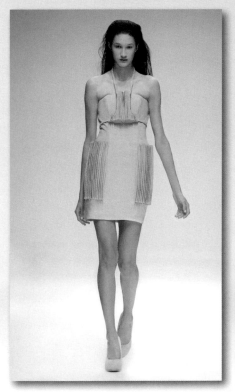 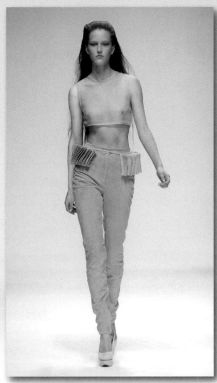 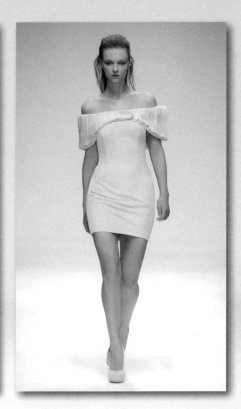

Hannah Marshall

Fashion Designer Hannah Marshall: From *S/S Collection*

Photography Chris Moore

content

Author's Note

Fashion Designer is the fourth title in my *Fashion Design Series* - it was originally planned to follow *Fashion Artist*, my hand drawing and illustration skills book; but, with the increase in the use of computer software, primarily *Photoshop* and *Illustrator* for fashion design and illustration, then, a growing need for fashion students to understand the essence of entrepreneurship, I published *Fashion Computing* and *Fashion Entrepreneur* respectively, to respond to the opportunities with new course material.

Consequently, *Fashion Designer* is more enriched as it integrates the topics in all the other books in this series, providing you with a more comprehensive portfolio of fashion and design skills.

During my research and lecture tours, visiting industry and universities around the world, I am constantly impressed by the number of extremely talented fashion designers I meet. People who are bursting with creativity and innovative ideas, and who give me further inspiration and knowledge to write my books, and in turn, to inspire you.

The aim of *Fashion Designer* is to present the *fashion design process* to enable you to take your concepts for a design to realisation as a fashion collection. This includes:

• Developing an idea, perhaps inspired by something as simple as a tiny shell on a beach; its shape, its colour, even its texture and surroundings.
• Developing your concepts into 2D, then into 3D and, finally, realisation as a fashion collection shown on the major runways of New York, London, Paris or Milan.
• And, ultimately, seeing your designs in store and *fly off the shelf*!

If you are focussed and passionate about being involved in the fashion industry you will find your niche and develop a career path, whether it is in fashion design and illustration, marketing and promotion, etc. - the opportunities are endless. *Fashion Designer* aims to direct you on that path to reach your goal.

I wish you every success in this fascinating world of fashion!

Sandra Burke
M.Des RCA
(Master of Design, Royal College of Art)

'In writing the **Fashion Design Series** I have combined my career in fashion, education and publishing to produce this series. The result is a combination of the educational requirements of fashion programs with the practical application of fashion skills used in the fashion industry.'

Foreword

Sandra Burke is the absolute perfect person to write a book about 'Fashion Design'; the fact that she is able to tackle it from an international perspective is what sets her apart. With frequent research trips to the centers of fashion, visiting fashion shows and trade fairs, industry and retail; and her lecture tours to the UK and USA, including SA, AUS, HK and Singapore, visiting universities to lecture and workshop her processes, Sandra understands the global perspective of acceptable practices.

What Sandra does so well is nurture, giving ideas to those who are not as instinctive in their own methodology, supporting them in developing strong foundations fundamental to anyone embarking on a career in fashion design. Encouraging them to apply individual styles and aesthetics but also to be able to apply them to industry standards. It is a true gift to be able to analyze one's own processes and break them down into easy to follow step-by-step formulas.

With a gifted eye, Sandra builds solid relationships with creative people who not only contribute to her books but also often end up forging strong friendships with her. I have known Sandra now for several years and will continue to contribute to her books as well as promote them in my classroom.

Jonathan Kyle Farmer MA(RCA) | Parsons THE NEW SCHOOL (NY) *Associate Professor of Fashion, BFA Senior Concepts Curriculum Coordinator, MFA Fashion Design and Society.*

Kyle has worked as a fashion designer and illustrator internationally; taught in the UK and USA; is a contributor to numerous books and consultant on special projects inside and outside of the fashion arena. A futurist, educator and practising designer, Kyle's approach is one of exploration and innovation, challenging the general perception of what it is to be a fashion designer.

Sandra Burke and I first met whilst studying at the Royal College of Art. Although we have both experienced different and diverse fashion career paths, it was a great delight to have the opportunity of finally working together.

After the launch of her first book *'Fashion Artist'* Sandra gave a master class to final year fashion design undergraduates at Leeds University. She has continued these inspirational classes on an annual basis.

Given Sandra's background and knowledge of the global fashion industry, coupled with her understanding of fashion education across the world, this latest book *'Fashion Designer'* will once again be a 'must have' on every fashion student's reading list.

The role of today's fashion designer is complex; this book will help designers appreciate the many phases of fashion from research through to product reality.

David Backhouse, M. Des RCA, Head of Fashion at Leeds University and Deputy Chair for the Yorkshire Fashion Archive.

Starting his career as a fashion designer for Roland Klein London, David launched his own business in 1986. He has designed for womenswear and menswear, retailing internationally, and designed ranges for stores including Bergdorf Goodman, Harvey Nichols, Selfridges, Harrods, and Joyce Boutique. He has been in Higher Education for the past fifteen years.

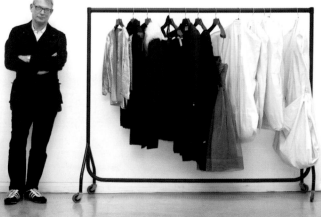

UNIVERSITY OF LEEDS

Acknowledgements

The research for **Fashion Designer** - *Concept to Collection* has taken me to some of the most influential fashion companies, fashion schools and universities around the world and further established the link between the fashion, textile and creative industries and education.

I sincerely thank all those who contributed directly and indirectly to the content of this book. The sharing of ideas, encouragement and support from the fashion industry, lecturers, colleagues and my friends internationally has been incredible. I would never have been able to write this book without them. My thanks and appreciation to you all.

Fashion Industry

Abigail Bisogno, Managing Director Foschini, Cape Town

Amanda Wakely, Designer, London (LFW)

Angelica Payne, Bendon Aus & NZ

Anita McAdam, Studio Faro, Aus

Anton Lotz, Fashion Designer, Foschini, Cape Town

Basso & Brooke, Designers, London, (LFW)

Beekay, Menswear Designer, London

Brenda Killigrew, Design Centre of Excellence (UK)

Bora Aksu, Fashion Designer, London (LFW)

British Fashion Council - London Fashion Week (LFW)

Caroline Rush, CEO, British Fashion Council (LFW)

Chris Moore, Photographer

Clements Ribeiro, Designers, London (LFW)

Craig Lawrence, Fashion Designer, UK

Erika Knight, Design Consultant and Fashion/Knit Designer

Eva Snopek, Textile Designer, CK, New York

Ewa Liddington, Head Fashion Buyer, NZ

Frances Howie, Designer (Stella McCartney, & Lanvin), Central Saint Martins (CSM)

Georgia Hardinge, Fashion Designer, London (and Parsons Paris)

Giles Deacon, Fashion Designer, London

Hannah Marshall, Womenswear Designer, London

Jamie, Castelbajac, London

Junky Styling, London

Laura Krusemark, International Citizen Design House (i.CTZN), US

Linda Logan, Fashion Designer, Cape Town

Louise Davies, Fashion Designer, London and NZ

Lynnette Cook, Designer, Illustrator, Central Saint Martins (CSM)

Maria Leeke, Fashion Buyer, London

Mike Scroope, Director, Catalyst International (Marketing)

Penter Yip, Fashionary (www.fashionary.org)

Peter Flowers, Director Foschini, Cape Town

Piers Atkinson, Milliner, London

PROMOSTYL, Paris, International Styling and Trend Forecasting

Ricki and Aviva Wolman, Citron, Los Angeles

Sally Moinet, Fashion Designer, Cape Town

Sarah Beetson, Illustrator and IllustrationWeb, International

Soo Mok, Menswear Designer, CK, New York

Universities and Fashion Schools

Allen Leroux, Fedisa, Cape Town

Andrea Coyne, Elizabeth Galloway, Cape Town

Angela Fraser, Auckland University of Technology (AUT)

Ann Muirhead, Coventry University

Arzelle Van Der Merwe, Fedisa, Cape Town

Carol Brown, University of Lincoln

David Backhouse, University of Leeds

Derek Geddes, Elizabeth Galloway, Cape Town

Gary Mills, University of Plymouth Colleges, Somerset

George Vorster, Durban University of Technology

Gill Stark, American InterContinental University

Gordon Message, American InterContinental University

Ike Rust, Royal College of Art (RCA)

Irene Dee, University of Wales Newport

Jan Hamon, Dr., Auckland University of Technology (AUT)

Jean Oppermann, Fashion Illustrator and California College of Arts

Jonathan Farmer MA(RCA), Parsons, New School for Design, NY

Joshua Masih, Arts University College Bournemouth

Julie Bentley, Northbrook College Sussex

Karen Scheetz, Fashion Institute of Technology, New York (FIT)

Lee Harding, Birmingham City University (BCU)

Linda Jones, Auckland University of Technology (AUT)

Lisa Mann, Southampton Solent University

Lucy Jones, University of East London (UEL)

Lyle Reilly, Auckland University of Technology (AUT)

Lynne Webster, University of Leeds

Mandy Smith, Auckland University of Technology (AUT)

Manjula Naidoo, Durban University of Technology

Mike Anderson, Photographer at University of Leeds

Paul Rider, Visiting Professor, Tsinghua University, consultant

Sarah Dallas, Royal College of Art (RCA)

Shari Schoop, The Art Institute of California, San Francisco

Sharon Rees, University of Wales Newport

Sheena Gao, The Arts Institute of California, San Diego

Sue Jenkyn Jones, London College of Fashion

Sunthra Moodley, Durban University of Technology (DUT)

Wendy Dagworthy, Royal College of Art (RCA)

William Hewett, Cape Peninsula University of Technology (CPUT)

Designers, Illustrators, Photographers

Aina Hussain, Fashion Designer

Amy Lappin, Fashion Designer

Anna Pahlavi, Model

Bob Shilling, Creative Director, Graphic Designer

Camilla Ruiz Ramirez, Fashion Designer, & Laden Showroom

Charlotte Hillier, Fashion Designer

Cherona Blacksell, Fashion Designer

Claire Andrew, Fashion Designer

Claire Tremlett, Tremlett & Taylor, Fashion Designer

Dale Mcarthy, Fashion Illustrator

Ella Tjader, Illustrator

Ellie Cumming, Stylist, UK

Farah Hussein, Fashion Designer

Frances Shilling, Knitwear/Textiles Designer

Gemma Aspland, Fashion Designer

Hannah Cooper, Fashion Designer

Jane Wolff, Fashion Illustrator

Jesse Lolo, Fashion Designer

Jessica Haley, Fashion Illustrator/Designer

Jinny Howarth, Fashion Designer

Kathryn Hopkins, Fashion Designer

Kirsty Messenger, Photographer

Lidwine Grosbois, Fashion Illustrator/Designer

Lucy Royle, Fashion Designer

Lynnette Cook, Fashion Illustrator, Fashion Designer

Montana Forbes, Illustrator

Nadeesha Godamunne, Fashion Designer/Illustrator

Natalie Holme, Fashion Designer

Peter Mann, Fashion Illustrator

Priyanka Pereira, Fashion Designer

Rae Hennessey, Photographer

Rachel Taylor, Tremlett & Taylor, Fashion Designer

Sarah Piantadosi, Director, Photographer, UK

Skye Pengelly, Fashion Designer

Sophia Grace Webster, Footwear Designer

Stuart Whitton, Fashion Illustrator

Tina Fong, Fashion Designer

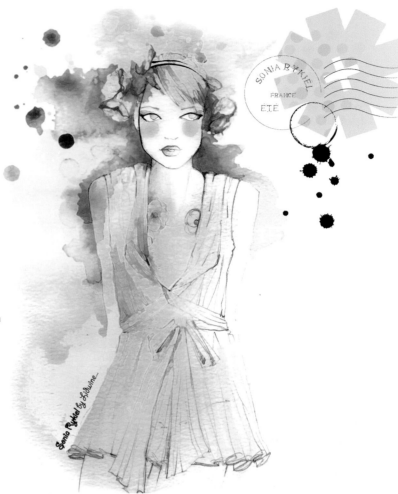

Illustrator Lidwine Grosbois: *Sonia Rykiel design*

Contributing Authors

Lisa Mann, Course Leader MA, Academic Leader School of Design, Southampton Solent University - *Fashion Forecasting* chapter

Lynnette Cook, Designer, *Design Development* chapter (sketches)

Irene Dee, Senior Lecturer, University of Wales Newport, *Sustainability* chapter - 'Eclectic Shock'

William Hewett, Senior Lecturer, Clothing Mgt., CPUT (Cape Town), *Design and Production Process,* Appendices.

Desk Top Publishing

Particular thanks for helping me become a technocrat using InDesign, Photoshop, Illustrator, etc; Alan Taylor, Brian Farley, Bert Parsons, and especially Simon Larkin who also produced the cover.

Proof Readers

A big thank you to my proof reading team, especially Dr Jan Hamon, and also Louise Davies, Angela Fraser, and my husband Rory Burke who also project managed me through the whole book writing process.

Foreword

I particularly wish to thank Jonathan Kyle Farmer and David Backhouse, for their inspirational forewords.

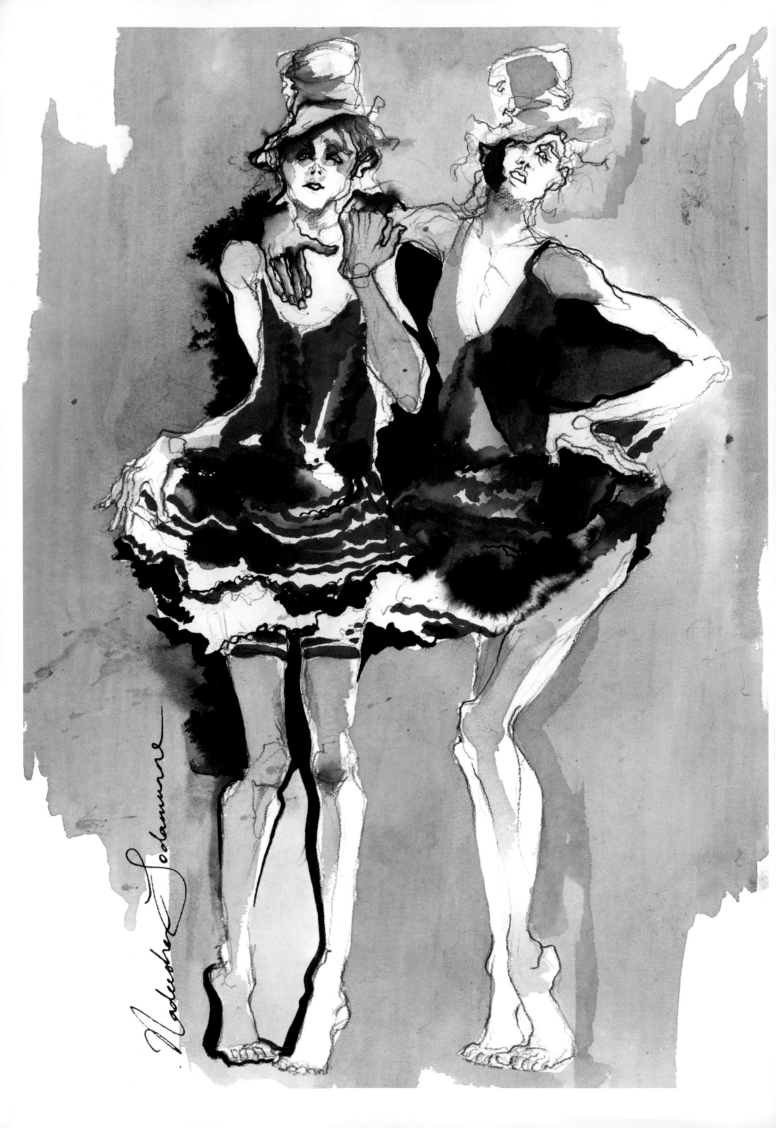

1

Fashion
and the Design Process

'Chanel is composed of only a few elements, white camellias, quilted bags and Austrian doorman's jackets, pearls, chains, shoes with black toes. I use these elements like notes to play with.' Karl Lagerfeld

What is Fashion?

Fashion has always been a reflection of our society - to some, it is considered an art form. It can transform an image, help express a person's identity, or even make a social statement. It is about promoting the 'new', and is concerned with constantly changing aesthetics. Fashion is often described as the current style that is followed by a large number of people at any one time. In its wider sense, fashion portrays the zeitgeist - the spirit of our times.

Globally, the fashion world is a multibillion-dollar industry offering a dazzling array of products in every price range, from luxury goods to the least expensive, mass produced goods. The fashion and creative industries supply chain provides employment for millions of people in the areas of; fashion and textile design, manufacturing and distribution, the media, sales and marketing, fashion retail and fashion event management. And, of course, *education,* which is responsible for training students to acquire the necessary skills, knowledge and competence to enter the fashion and creative industries.

Who is this book for and what are its objectives?

Fashion Designer - *Concept to Collection* is the fourth book in my *Fashion Design Series*. This book is ideal for aspiring fashion designers, stylists and illustrators, including fashion students, educators, technologists, and those with an interest in fashion. *Fashion Designer* will guide you through the *fashion design process* and the *fashion design brief,* introducing you to the fundamental design techniques and skills required to create a successful fashion collection or product range. This book will inform and inspire, taking you from the initial fashion concept to realisation. It aims to help you achieve a successful career in the fashion industry and become part of the global and dynamic world of fashion.

Above, Fashion Designer and Illustrator Lidwine Grosbois: *Luxury designs from Chanel and Louis Vuitton accessories ranges.*

Opposite page, Fashion Designer and Illustrator Nadeesha Godamunne: *Fashion portrays the zeitgeist - the spirit of our times.*

© Fashion Designer - Sandra Burke

Fashion Illustrator Nadeesha Godamunne

What is in this book and how to use it

Fashion Designer covers both theory and practice. It explains how to take inspiration from your design research and develop design concepts, in 2D format as sketches and illustrations, through to realising those concepts in 3D form as fashion collections and fashion products. Just as importantly, it explains the promotion, marketing and branding process, and the process of presenting your collections at fashion and trade shows.

The chapters have been set out in a logical learning sequence; in clear steps, they guide you through the key subjects embedded in the design process, and explain how they relate within the fashion and textiles industry. It divides fashion design into three distinct areas:

1. Design Research and Concept Phase

2. Design Techniques and Skills Phase

3. Design Brief and Design Process Phase

Fashion Designer is enriched with fashion and textile illustrations, presentations and photos from international industry specialists (designers, illustrators, photographers), together with self-explanatory graphics to inspire your creativity and visually aid your understanding of the design process.

1. Design Research and Concept - Chapters 2 to 7: The first part of the book introduces you to the key elements of fashion design to help you conduct your design research, and to give you the necessary background knowledge to inspire your creativity and prompt innovative design concepts:

- Chapter 2, *Design Research and the Fashion Sketchbook: Sourcing* of ideas and developing your fashion sketchbooks.
- Chapter 3, *Fashion History and Culture*: Key influences in fashion history and culture to help you design for the future.
- Chapter 4, *Fashion Forecasting - Trends and Cycles:* An analysis to help you make the correct design decisions at all stages of the process, from textiles and colors to product offering.
- Chapter 5, *Color and Fabric - Theory, Design, Sourcing and Selection.*
- Chapter 6, *Silhouettes, Styles, Details - the Language of Fashion*: The croquis figure template, and key clothing styles.
- Chapter 7, *The Fashion Market and the Customer*: A breakdown of the industry - the various sectors, market levels, clothing and product categories.

2. Design Techniques and Skills - Chapters 8 to 9: The second part of the book explains the conceptual design process; how you take inspiration from your creative research and develop your initial design concepts into 2D format. It explains the preferred formats of 2D visual communication and presentation as used in the fashion and textile industry:

- Chapter 8, *Design Development - Elements and Principles of Design:* Concept to collection (2D format).
- Chapter 9, *Design Presentations and Fashion Portfolio:* Visually communicating your designs and collections in 2D format presentations.

3. Design Brief and Design Process - Chapters 10 to 12: The third part of the book explains how to interpret a fashion design brief and meet its required aims and objectives. It explains the techniques involved in realising your 2D design ideas to become 3D fashion collections or fashion products, which are then marketed, branded and sold into the market place - from concept to collection to consumer.

10, *The Design Brief - Designing a Collection:* Exploring the design ties of a brief to develop a creative and marketable collection.

1, *The Design Studio: Construction, Samples, Prototypes:* Drafting nd making the samples or prototypes.

, *The Final Collection - Promotion and Sales:* Refining the collection cohesive range that is then marketed, branded and sold.

- *Sustainability, Fashion Business - The Designers:* These case iews support the text and present examples from practising xtile designers working in different sectors of the fashion

present the production process and useful documents; sents the international language of fashion design; *Internet Reso r Reading* and the *Index* include useful websites, company name lications, text books and key words.

More : Each book in this *Fashion Design Series* by Sandra Burke is interrel topics overlap - the intention is that the books are used intercha help you acquire a better understanding of the subject areas, w ing your portfolio of skills. With a greater appreciation of the glo industry, this will help guide you as to where you might develop y career and specialism.

At the end o ach chapter in *Fashion Designer* there will be suggestions about more information, linked to the appropriate chapters in each book in the *Fashion Design Series.*

Burke, Sandra, *Fashion Artist - Drawing Techniques to Portfolio Presentation* (second edition)

Burke, Sandra, *Fashion Computing - Design Techniques and CAD*

Burke, Sandra, *Fashion Entrepreneur - Starting Your Own Fashion Business*

Website: www.fashionbooks.info

As a fashion designer, it is impossible to be an expert in all areas of fashion. You are more likely to be successful if you find an area of fashion where you have a natural aptitude or are the most competent and specialize in that particular niche market. Once you develop your expertise you will find career opportunities naturally arise, allowing you to diversify and expand into other areas of fashion.

The Role of the Fashion Designer

A fashion designer is both a creative and technical professional who designs clothing within a specific theme for a specific purpose and a specific market. This includes cutting-edge fashion designers from *haute couture, ready-to-wear,* and designers of *luxury brands,* right through to the more commercial designers designing for the high street brands; from Dior, Chanel, and Gucci, to Zara, Top Shop, and H&M.

Successful fashion designers are not only creative innovators but also problem solvers, project managers, team leaders, coordinators, and communicators. With a passion for design, they are also constantly aware of current and future styles and trends. This includes trends in fashion, textiles and also music and culture, lifestyle, technology, and even in economic, ethical and social issues.

Most importantly, fashion designers are able to interpret a design brief and develop their conceptual ideas, translating them into marketable designs and fashion products. Commercially, this would result in the actual sale of the merchandise, but also includes designs for promotion or exhibitions. For example, in the international fashion arena *haute couture,* which is affordable by only the most affluent in society, pushes the boundaries of design and, for the fashion house in particular, is about promotion and publicity for their brand.

Above all, to be successful in the fashion industry, fashion designers require a portfolio of skills, from creative to technical to management and business skills; these skills are summarised in Table 1.1. Not every designer would be competent in every skill but most will excel in certain areas and will have a portfolio approach, meaning they will at least have an understanding of the other areas.

Fashion Designers' Portfolio of Skills			
Creative Skills	**Technical Skills**	**Business Skills**	**Management Skills**
Research (market and trend) identification and interpretation	Pattern drafting/making and draping	Entrepreneurial skills to spot opportunities	Marketing
Conceptual and analytical thinking, investigation	Garment construction/sewing	Marketing and branding	Project management
Design, creative and innovative	CAD - Photoshop, Illustrator, InDesign for design, technical drawings and layout	Sales and negotiation	Problem solving and decision-making
Fashion sketching	Tailoring	Networking skills	Leadership and teamwork
Illustration	Knitting (hand, machine) - other crafts: stitch and embroidery, appliqué		Listening and communication
Technical drawing/flats	Textiles - printing, weaving, felting		Organisational and coordination
CAD - Photoshop, Illustrator, InDesign	CAD (Patterns - Gerber, Lectra)		
Photography	Grading		
Product development			

Table 1.1 Fashion Designers' Portfolio of Skills – *shows a subdivision of fashion designers' portfolio of skills (this list is by no means the full extent of fashion designers' skills but indicates the most obvious).*

The Fashion Design Process

The *Fashion Design Process* (Fig. 1.1) subdivides fashion design into a linear sequence of interrelated activities. Each activity is performed to produce a specific result or deliverable in the process. The fashion design process is initiated by the *Design Brief (*delivered verbally or documented). The brief specifies the aims and objectives of the creative design project which could be to design a fashion garment, fashion product or a cohesive fashion collection.

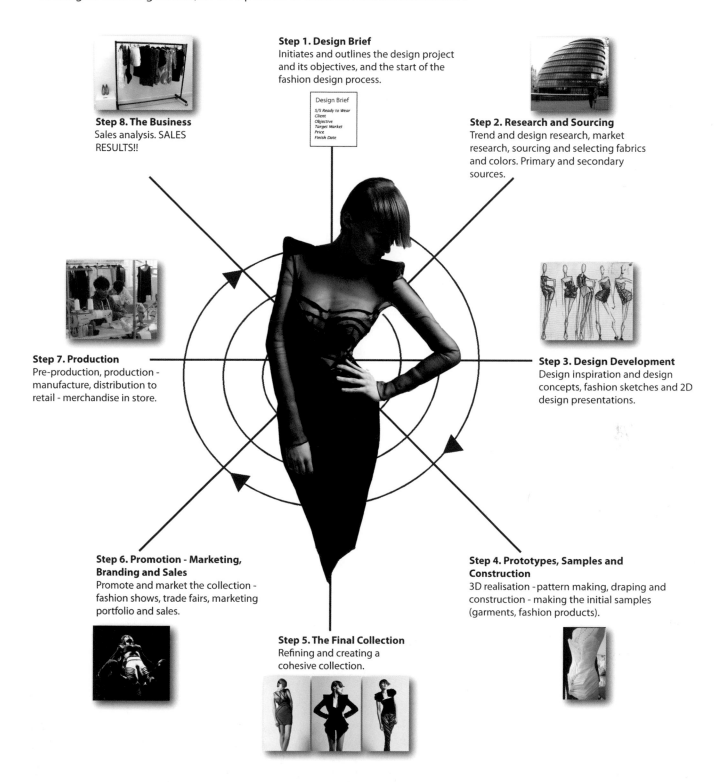

Step 1. Design Brief
Initiates and outlines the design project and its objectives, and the start of the fashion design process.

Step 2. Research and Sourcing
Trend and design research, market research, sourcing and selecting fabrics and colors. Primary and secondary sources.

Step 3. Design Development
Design inspiration and design concepts, fashion sketches and 2D design presentations.

Step 4. Prototypes, Samples and Construction
3D realisation - pattern making, draping and construction - making the initial samples (garments, fashion products).

Step 5. The Final Collection
Refining and creating a cohesive collection.

Step 6. Promotion - Marketing, Branding and Sales
Promote and market the collection - fashion shows, trade fairs, marketing portfolio and sales.

Step 7. Production
Pre-production, production - manufacture, distribution to retail - merchandise in store.

Step 8. The Business
Sales analysis. SALES RESULTS!!

Figure 1.1 The Fashion Design Process - *shows the subdivision of the Design Process as a sequence of eight logical steps presented as an iterative spiral.*

Images courtesy of Fashion Designer Georgia Hardinge, model Anna Pahlavi.

Fashion Design Process Timeline

Fig. 1.2 below shows a development of Fig 1.1, the Fashion Design Process, expanding on the seven key activities and topics covered in *Fashion Designer*. It also follows the sequence of the chapters in this book (except for *The Design Brief*).

As part of this process, as a fashion designer you will be applying your design skills and going through various stages of; inspiration, investigation, conceptual thinking, creativity, experimentation, innovation, identification and interpretation. For example:

- *Investigation*, as you research your ideas, research the fashion trends and the market.
- *Conceptual thinking*, to produce the initial idea for a concept, or the solution to a problem, when making a pattern for example.
- *Creativity* in your design work, when you put pen to paper, when draping your fabric on the dress form.
- *Experimentation* and *exploration*, as you test out fabrics and create your samples.
- *Innovation*, as you come up with a new idea that has not been produced before, or an innovative solution to a problem.
- *Identification*, as you identify who is your target market, your customer.
- *Interpretation*, as you answer a design brief, or take your 2D images and realise them as a fashion collection.

Fashion Design Process Timeline		
1. The Design Brief	**2. Research and Sourcing**	**3. Design Development**
Analyse the design brief to identify client/company aims and objectives	**Trend, design and market research, sourcing**	**Design concept to 2D presentations (boards and digital format)**
• Types of design briefs - academic, competition, client • Working to a brief and delivery date • Project/company name, theme, season, brief number, date issued • Responsibility for the project, for approvals • Problem solving, brainstorming • Parameters, constraints, and outcomes • Target market, customer, demographic • Market segment, level, price points, costings • Key dates, deadlines • Design requirements, styles, silhouettes, colors, fabrics, materials • Design presentation, samples, prototypes, collection/line/range • Fashion design project • Stakeholders' needs and expectations.	• Collection of data - primary and secondary sources (references, observations and analysis), product and market research, reports, market intelligence • Resource files, sketchbooks, digital resources • Research - store visits, shopping reports, history, culture, film, exhibitions, galleries, museums, architecture, theatre, travel • Trend analysis - fashion forecasting, cycles, fashion and trade fairs/shows, publications, online • Color, fabric, materials, handle, drape, pattern, print, embellishments, surface details/decoration, trims sourcing, sampling • Silhouettes, styles, details, clothing categories • Market analysis - sectors, levels, clothing and product categories, segments, demographics, customer.	• Design elements - silhouette, shape, volume, form, color, line, cut, style lines, construction, texture, fabrics, materials • Design principles - proportion, scale, balance, rhythm, repetition, emphasis, focus, graduation, contrast, harmony, unity, signature style • Design development, fashion croquis, fashion croquis sketchbooks • Concept, theme, fabrics, colors, sampling • Presentations and design boards (mood/inspiration/concept/theme/ story, color, fabric, styling • Fashion sketching, fashion illustration, flats, technical drawings, specs • Digital design - Photoshop, Illustrator, CorelDRAW.

Figure 1.2 Fashion Design Process Timeline - *shows a development of Figure 1.1, the Fashion Design Process.*

Louise Davies, womenswear fashion designer - advice for those wanting a career in fashion.

'As a fashion designer, it is all about deadlines, as much as the design.'

'Lately, many designers, like myself, rarely have the luxury to have the technical design experts, pattern makers and sample machinists in particular, working alongside, or even in the same building. So much of the sampling and prototypes are being made offshore, in Italy, Spain, China, India, Vietnam; so it is really important to be able to sketch well and to be able to communicate your designs visually with technical drawings, specifications, and photographs etc.'

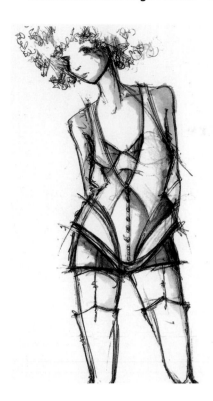

Right and opposite, Fashion Designer Cherona Blacksell: *Creating designs on the dress form, and fashion illustration - part of the fashion design process.*

4. Prototypes, Samples and Construction	5. The Final Collection/Line	6. Promotion - Marketing, Branding and Sales	7. Production
Construction and making the samples	**Refining and creating a cohesive collection**	**Design portfolio, marketing and sales**	**Design and production process**
• 3D realization, translation, developing silhouette, shape, proportion • Tools, machinery • Working with fabric on the stand/mannequin - draping, sculpting, pleating • Making patterns, drafting, draping, specification sheets, standard sizes, first pattern, dress form, creative pattern making, flat pattern, computer patterns/CAD • Construction - first samples, toile, muslin, testing, fitting, remakes/revisions pre-cost • Fabric marking and cutting • Seams, details, finishes.	• Design solution - realization, evaluating, decision-making, editing, refinement, appearance, aesthetics, performance • Final collection, quantity, stand alone, costings, price, fit, concise, cohesive • Duplicate samples.	• Promotion - marketing, branding, sales - logos, business cards, garment labels, brochures, press kits, look books, line sheets • Website, PR, press coverage • Fashion and textiles calendar, fashion shows, trade events, virtual and live streaming, sponsored shows, off schedule, alternative shows, graduate shows • Sales and collections, ranges, products, lifestyles.	• Design and production departments, organisation structure, pre-production and production (planning, cutting projections, fabric deliveries), grading, production samples • Manufacturing (factory selection, sewing, finishing) • Mass Production. • Specification sheets/technical, style sheets, production control sheet, taking measurements, design style sheet, costing sheet, tech packs/specifications documents.

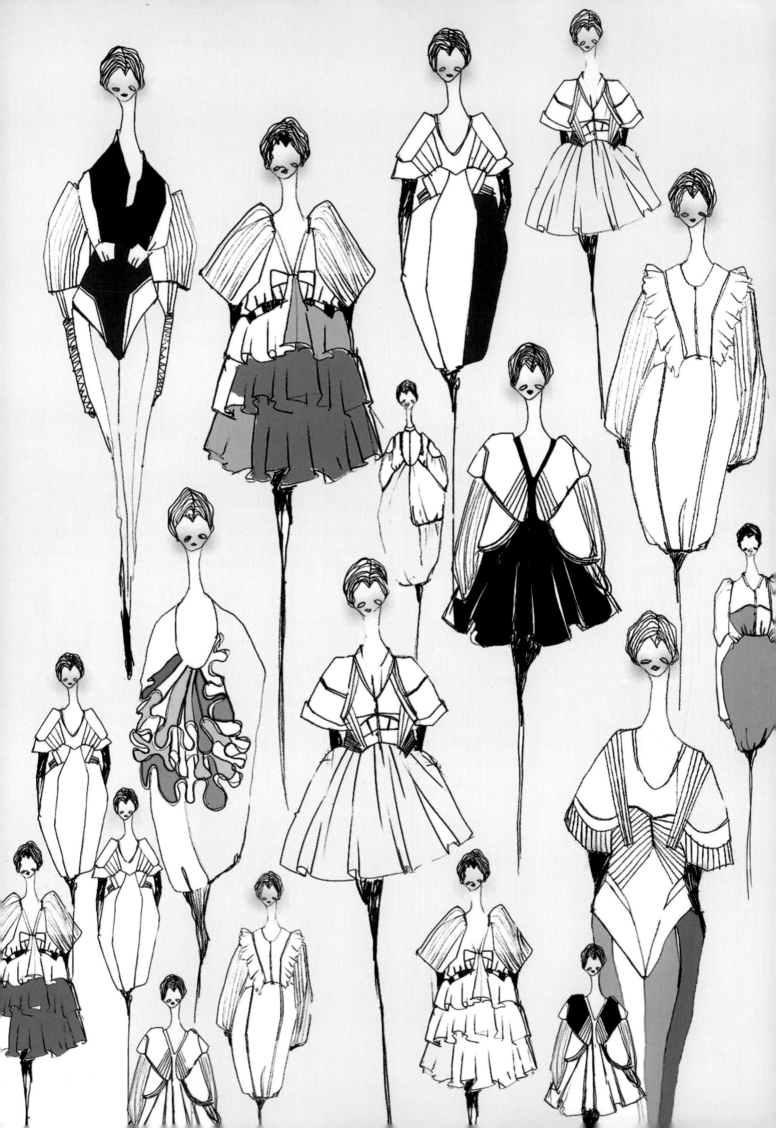

2

Design Research
and the Fashion Sketchbook

'*To create something exceptional, your mind-set must be relentlessly focused on the smallest detail.*' Giorgio Armani

All design briefs and projects begin with the need for research through investigation and gathering of related information. Fashion research supports the creative process and underpins every fashion concept. Designing a collection is not just about researching the latest fashion trends and styles, and sketching fashionable clothing; it embodies a much wider context involving the sourcing of ideas from all areas of art and design, architecture, music, history, culture, social and political issues, even nature and lifestyle. These references are used as sources of inspiration for creativity and innovation and form the concept or theme of a new design or new collection.

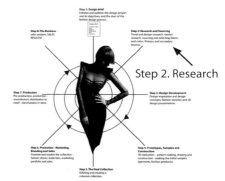

Step 2. Research

Figure 2.1: *Fashion Design Process (see p.15)*

As a fashion designer you need to be continuously on the lookout for inspirational ideas to fuel your creativity in order to design original and marketable products.

This chapter will discuss the fundamentals of fashion research and the fashion sketchbook in both two-dimensional and three-dimensional forms as part of your creative journey. It covers:

- Sources of research – the collection of primary and secondary data (the path to inspiration, innovation and creativity).
- Resource files, sketchbooks, digital resources - to document, capture and develop conceptual thinking and notions.
- The creative process - conceptual thinking challenging preconceived notions; developing your research into 2D and 3D designs.

Opposite, Fashion Designer Aina Hussain: *Aina's feminine silk designs are inspired by historic and contemporary references.*

Left, Arc de Triomphe, Paris: *Inspiration for design concepts can come from observations of historical architecture, for example this ceiling, which is typical of late 18th century romantic neoclassicism.*

1. Sources of Research - Primary and Secondary

Although almost anything can spark an idea for a design concept - a fabric, a trim, a muse (style icon: rock star, designer, actor) - as part of your design research, you will need to explore both *primary* and *secondary* sources.

Through this investigation you will be able to utilise the ideas and information gathered to personalise your artistic vision and creativity during the design development phase (see also *Design Development* and *Design Brief* chapters).

Primary Sources: These are the findings you have collected yourself, firsthand, by interviewing, sketching, photographing, or collecting samples. Primary sources of research include:

- **Retail stores** (in store and window displays) - sourcing trends; conducting market analysis and store reports; identifying what designs are in store; what is selling and, just as importantly, what is not selling!
- **Flea markets, vintage stores, charity/op shops -** found in every fashion capital and other locations: Portobello Road (London); Brooklyn and Greenwich Village (New York); and Porte de Clignancourt (Marché aux Puces) (Paris) are just a few well known examples.
- **Fashion shows and trade fairs** - these would be the ones that you personally attend and report on directly.
- **Museums, art galleries, libraries and exhibitions** - for historic and contemporary references and observations; period costume; Greek and Roman artefacts; artists and painters (Gaugin, Monet, Mondrain), etc.
- **Travel and events** - references and observations inspired by different cultures (Asian, Mediterranean, Polynesian); every day street happenings; observations made at an event or a party, etc.

Left to right, Research Inspiration from Primary Sources:

Memphis furniture, Carlton cabinet, 1981 Design: Ettore Sottsass: *MEMPHIS was a Milan-based collective of young furniture and product designers led by Ettore Sottsass. Photo from research trip to the host museum.*

Surrealist inspired sculpture photographed in Paris while on a shopping research trip: *Inspiration and research, see Niki de Saint Phalle, French sculptor.*

Royal College of Art (RCA), London*: RCA student's design project and work area in the RCA design studio. Design research inspiration includes architectural and structural sources and the fashion catwalk. The dress designs clearly embody the research that has been undertaken.*

- **Nature and everyday objects** - inspired by tangible objects, nature (shells, flowers, feathers), or everyday objects (glass, mirrors).
- **Architecture** - Guggenheim Museum (Bilbao, Spain); Gherkin (London, UK); Beijing National Stadium (Beijing, China); buildings and works by Antoni Gaudí (Spanish architect and designer). Identification of architectural influences are seen in the designs of Hussein Chalayan and Yohji Yamamoto amongst others.
- **Materials** - textures, surfaces, fabrics and trims (buttons, beads, braids).
- **Arts and media** - theatre, opera, dance, ballet, film (movies, even television), music.
- **New technologies -** developments in fabric, print, color, manufacturing, even science.

Secondary Sources: These are the findings taken from the information and statistical data obtained through other people's analysis; via reports and publications (trend reports, books, journals, magazines, television, the Internet).

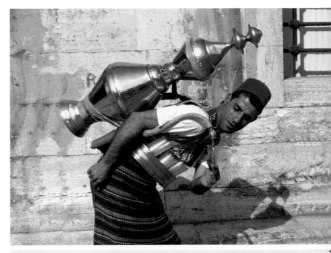

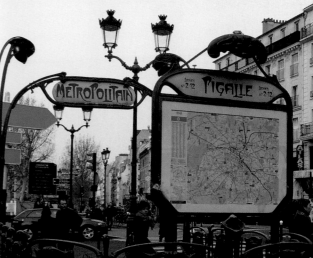

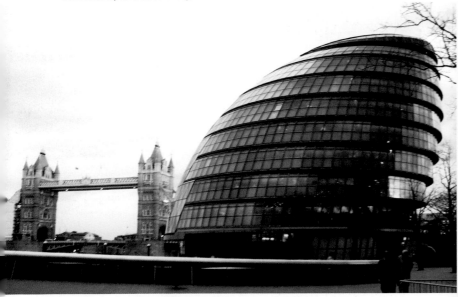

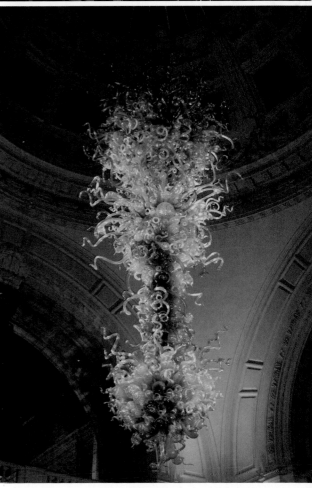

Above and right, top to bottom, Research Inspiration from Primary Sources: City Hall, *London, architect,* Lord Norman Foster.

Water carrier, *Istanbul, photo,* Angelica Payne.

Pigalle (Paris Métro). *Pigalle, named after the sculptor Jean-Baptiste Pigalle (1714–1785) was the old red-light district of Paris. Pigalle is a blend of beautiful landmark burlesque theatres mixed with bourgeois buildings, prostitutes, artists and the Moulin Rouge. Recently, it has become 'red hot' and très chic providing trendy homes for top designers, actors and models.*

Victoria and Albert Museum (V&A), London: *This 11 metre high, blown glass chandelier by* Dale Chihuly, *creates a focal point in the rotunda at the main entrance.*

Definition: Conceptual thinking, *often referred to as 'lateral thinking' (Edward de Bono) or thinking 'outside of the box', is a problem solving process where you put aside commonly accepted beliefs or constraints. As part of the creative fashion design process it means you develop an openness to explore creative new ways to solve a problem and come up with new ideas or solutions.*

2. Resource Files, Sketchbooks, Digital Resources

Creative work is an organic and free-flowing process. Most designers will constantly have a pencil and sketchbook at hand, and sketch all the time as ideas come to them. This means when they start defining a new season's collection, although they might start a new sketchbook, it's more a process of editing what they have been sketching all along.

As you start your research and develop your concepts and designs it is vital to compile the information in a logical format for quick retrieval. Physical and digital formats include:
• Research folders and sketchbooks
• Digital cameras, mobile cameras, iPhones, iPads, etc.

These resources are an essential part of your fashion design 'kit' for both capturing and storing your research. They will become your visual reference database and an invaluable source of information for your design projects.

Resource folders (also called design resource folders, cutting files, magazine clipping files or reference files): Use to store research information for collating your magazine clippings/tear sheets, photographs and fabric swatches.

Sketchbook (also called journal, visual diary, visual notebook, and/ or croquis sketchbook): Use to document and develop conceptual thinking and notions. Sketchbooks are essential for quick rough sketches, developing fashion ideas and creative thinking. You might also attach swatches of fabric or trim or small magazine clippings to individual pages.

Note: As part of a design brief for an academic assignment, your sketchbook is often an essential component to be submitted with your final presentation work. It demonstrates your creative journey and your design process (conceptual thinking, quick drawing skills, and color and fabric sensitivity).

Left to right, Jonathan Kyle Farmer (Designer and Associate Professor at Parsons):
An old diary - *put to perfect use for quick sketches.*

Pages from sketchbooks (graph paper, colored paper) - *thinking 'outside of the box'; creative thinking and conceptual notions involving experimentation with silhouettes, shapes and paper cut-outs.*

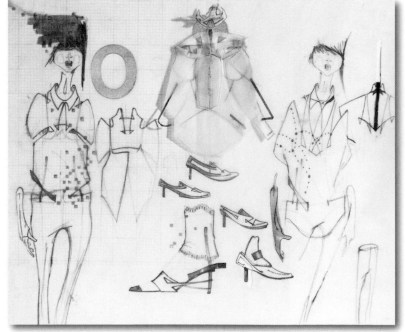

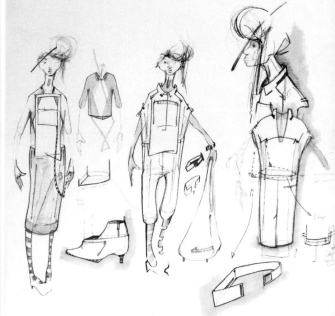

Type of Sketchbooks

Sketchbooks are available in a variety of sizes, grades, colors of paper, and bindings, and have different uses:

- A pocket size sketchbook is useful for jotting down notes, thumbnail sketches and ideas. Always keep a small sketchbook with you to quickly capture references and ideas. Excellent for store reports, museum and art gallery visits - wherever you are there will be something that sparks an idea that you need to capture - never rely on memory alone.
- Larger sketchbooks (A4/9x12 inch or bigger) are excellent for developing design ideas and concepts, and for developing a *Croquis sketchbook* to show progressive design development (see *Design Development* chapter).
- Even an old diary or second hand book could be used as an innovative form of sketchbook.

Digital Resources

Digital images should be filed logically (architecture, colors, fabrics, etc.) for instant access, and used for inspiration or to digitally enhance your fashion illustrations and presentations.

Digital capturing devices include:

- Digital cameras and mobile phone cameras: These are excellent for instantly capturing inspirational images at every opportune moment. Just like your small sketchbook, you should always carry with you some type of digital capture device.
- Scanners: These are useful for scanning fabric, trims, artwork, visuals, etc. When scanning your artwork, you will generally achieve a much cleaner, clearer image compared to taking a photograph.

Online downloadable Images:

Copyright and royalty free downloadable images from the internet can also be useful for backgrounds or as a starting point for a fabric design, a PowerPoint presentation, etc. Usually these are low resolution files, so they might become pixelated if you needed to enlarge or publish them in a book or magazine.

Digital sketching: As technology develops there are constantly new and innovative ways to work and sketch digitally. **Graphics tablet** (also referred to as digitizing/drawing/pen tablet, graphics pad), and trackpad tablets are alternative devices used to create sketches on the computer. They allow the designer to either draw on the tablet or the monitor (*Apple iPad, Wacom* probably being the most well known brands, and the *Inklet* trackpad tablet, an app for *MacBook*). This type of sketching is an option but it requires practise; its limitations might lead you to prefer to pick up a pencil instead.

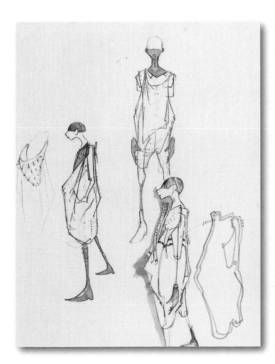

3. The Creative Process

As part of the creative process, this section presents developments in conceptual thinking.

The designers here have developed their research and used different resources, various materials and media, to innovatively create and experiment with the 2D and 3D form.

In the fashion industry, the design team will often work through a brainstorming session, where all thoughts and ideas are presented as a mind map, and then work individually on an aspect of the design brief.

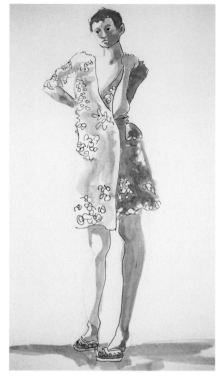

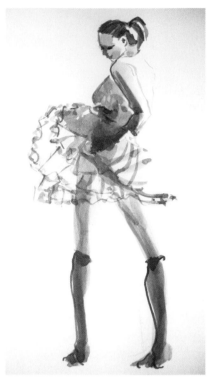

Above, Fashion Illustrator Jean Opperman: *As a fashion designer, it is important to understand the shape and movement of the body, and the way fabric and the garments drape and hang on and around the physical form, so sketching the body from the observation of a live model is an important part of the creative design process. It also helps with the development of fashion illustration skills - extremely useful when creating a croquis sketchbook and fashion presentations (see the* Design Development *, and* Design Presentations *chapters).*

Bottom left to right, Fashion Designers Kathryn Hopkins and Jessica Haley: *Exploring ideas for texture and surface design.*

KH: *Sketchbook - exploring ideas for the theme 'India' using lace, florals and soft colors for inspiration.*

KH: *Exploring the 'India' theme into fabric design (chemically treated). Silk fabric was attached to gauze/net using lurex thread then tied, as if tie dying, then put in bleach - over a few minutes the silk decayed into a spider's web of lurex thread.*

JH - *Stitching and embellishing using found pieces of trim - suspender clip and button, braids, threads, buckle, ribbons.*

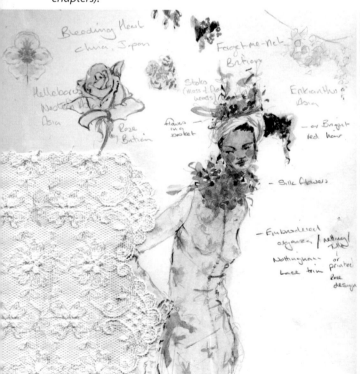

Draping/Modelling: This technique uses the dress form to help develop the design. It is a creative way of designing a garment by sculpting the fabric and experimenting with silhouette, line, texture and form by folding, tucking, pleating, cutting, slashing and pinning the fabric to the desired shape (see the *Design Studio* chapter).

Inspiration for this type of creative process can be taken from the Japanese designers – Rei Kawakubo, Issey Miyake, Yohji Yamamoto and Akira Isogawa. Evidence of 'reshaping' a woman's body but amplifying her femininity can be seen in their designs. They draw inspiration from contemporary Japanese design as they fuse two cultures; from the East by exploring traditional techniques using complex methods of twisting, folding, stitching, and reinterpreting them with technology, and through innovation borrowed from the West.

'I try to base each collection on a theory or an idea in the hope that it can take your mind to another dimension.' Akira Isogawa

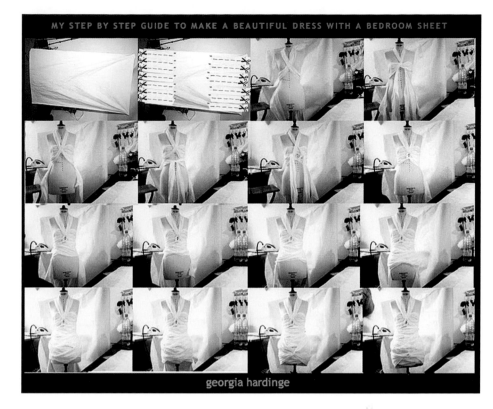

MY STEP BY STEP GUIDE TO MAKE A BEAUTIFUL DRESS WITH A BEDROOM SHEET

georgia hardinge

Above, Ready-to-wear Fashion Designer Georgia Hardinge: Taking a plain cotton sheet, Georgia creates a dress by sculpting on the dress stand. *'I was always interested in art and sculpture, fashion came to be a way of expression. Fashion has become my media which allows me to recreate my forms of architecture. And what I love is to challenge myself to make something creative yet wearable at the same time.'*

For more information see:

Fashion Artist- *Art Kit, Sketch Books,* and *Drawing from Life* chapters

Fashion Computing - *Scanning and Digital Photography* chapter.

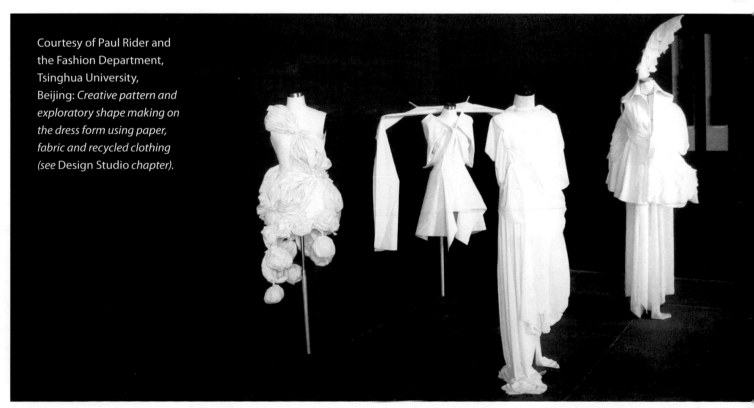

Courtesy of Paul Rider and the Fashion Department, Tsinghua University, Beijing: *Creative pattern and exploratory shape making on the dress form using paper, fabric and recycled clothing (see* Design Studio *chapter).*

3

Fashion History *and Culture*

'*Fashion is not something that exists in dresses only. Fashion is in the sky, in the street, fashion has to do with ideas, the way we live, what is happening.*' Coco Chanel

Fashion designers are constantly looking out for the next new fashion trend and the next wave of opportunity to tap into when creating their upcoming collections. As part of their design research and design development, it is essential they are not only aware of the latest and emerging styles in fashion but are also able to identify historical and cultural references.

During each fashion era, silhouettes and styles of dress develop from a variety of influential factors and include changes in culture; politics and the economy; technology and industrial developments; the style of popular music, film, art, and architecture; and the consumers' needs or, rather, the consumers' desires.

This chapter will highlight some of the key stages in the historical evolution of fashion and cultural revolutions. It will help you to adopt a greater awareness of the relationship between the patterns of fashion, culture (subculture, pop culture) and aspects of society, both past and present. It will encourage you to build an inspirational research data base and library to broaden your conceptual horizons and creativity, and design your collections. Researching what has gone before, will help you design the future.

Opposite page, Fashion Illustrator and Designer Nadeesha Godamunne: *Historical observations and analysis are in evidence in this 60s inspired contemporary fashion illustration.*

Right, Fashion Designer Linda Logan: *Silhouettes of contemporary fashion illustrate how different parts of the body become the focus through shape and form.*

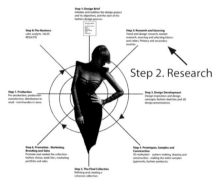

Step 2. Research

Figure 3.1: *Fashion Design Process (see p.15)*

© Fashion Designer - Sandra Burke

Fashion Cycles: Historically fashion is seasonal; it moves in cycles – what is 'in' one day is 'out' the next, but often revamped within a decade or two to become the 'hottest' trend once more. All fashion designers, Julien Macdonald, Miuccia Prada, Marc Jacobs, and John Galliano etc., use historical and cultural references when designing their innovative collections. They strategically use a kaleidoscope of ideas, taking a detail from one era and mixing it with another, or taking aspects from the latest street or cult fashion to create their collections. The result is a unique design with their own signature and style, something which suits their particular label and branding and, most importantly, something that will attract both their existing and potential customers.

Film: Numerous period films and television series, cult movies and music videos have been made which provide useful visual references for research; *Elizabeth* (starring Cate Blanchett), *Atonement* (starring Keira Knightley), *Saturday Night Fever* and *Grease* (starring John Travolta), *Pulp Fiction* (starring Uma Thurman), and *The Rocky Horror Show* (starring Tim Curry).

Period Costume: Original examples of period dress can be found in museums, private collections, galleries, exhibitions, vintage stores and even thrift/charity shops. The *Victoria and Albert Museum* (V&A), the *London College of Fashion* (LCF), and the Museum at the *Fashion Institute of Technology* (FIT, New York), are just three well know sources for research. And, of course, the Internet provides a plethora of online historical references.

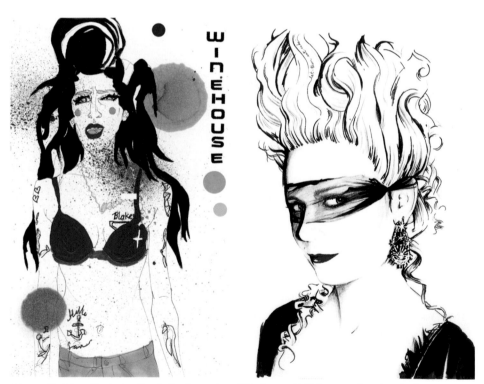

Above, Fashion Illustrator Sarah Beetson: *Amy Winehouse, British pop culture iconic singer-songwriter, rock star and even fashion designer, helped to popularize the term 'slut-chic' in the Noughties (2000-2010). Her distinctive style, especially her 'extreme high hair' reminiscent of 18th century hairstyles, has been the muse for fashion designers such as Karl Lagerfeld.*

Above right, Illustrator Dale Mcarthy: *During the 18th century hairstyles and wigs were extreme - often so high they could incorporate decorative objects, even stuffed birds! Masked balls were popular entertainment in court. Marie Antoinette 1755-1793, Queen of France and influential fashion icon of the period is illustrated here from the movie of the same name, starring Kirsten Dunst.*

Clothing, Costume and Fashion

The evolution of fashion takes us from the beginning when man simply needed clothing to protect himself from the elements. From this it evolved to encompass modesty to cover nakedness, then to body adornment to accentuate sexual and physical attractiveness. Progressively, clothing became a way to present social standing, to differentiate between the professions and different groups in society and lifestyle. Prior to the 19th century there were even strict regulations that dictated who could wear what type of clothing, further emphasizing social differences.

Pre 1900s and the Beginning of Haute Couture

Before 1850 the wealthy had their clothing made-to-measure to their personal design requirements by tailors and seamstresses. At the same time, out of economic necessity, every middle-class and lower income woman learnt to sew and make clothes for herself and her family.

Charles Frederick Worth 1825-95. Designer. Following his early years in London working in a draper's shop then serving an apprenticeship at a haberdashery, in 1845 Worth moved to Paris. Still involved in the dressmaking business, in 1858 Worth opened his own house with businessman, Otto Bobergh. There he worked with luxurious fabrics creating his own designs and collections which he presented to royalty, society ladies, and the '*demi-monde*' (women on the fringe of respectable society supported by wealthy lovers). His recognition spread throughout Europe and America. A gifted designer, he raised dressmaking to a new level, that of *haute couture*, and changed the course of fashion forever.

Timeline entering the Nineteenth Century 1800-1900:

- *The Directoire Period and the Empire Period 1790-1820*
- *The Romantic Period 1820-1850*
- *The Crinoline Period 1850-1869*
- *The Bustle Period and the Nineties 1870-1900.*

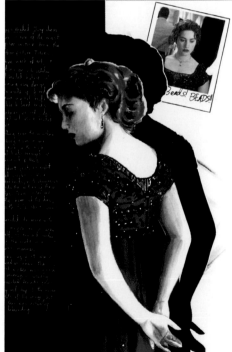

Above, Illustrator Jane Wolff: From the mid 1800s *the fashionable corset, the crinoline, bustle (undergarments), and later the hobble skirt and the waspie, were designed to enhance the silhouettes of women but, whether by design, entrapped them. From the late 1980s onwards many designers used corsetry in their designs as outerwear but it was made by using more comfortable fabrics and construction methods.*

Far right, Illustrators Dale Mcarthy and (top right) Peter Mann: *The Empire line, a low cut dress gathered under the bust, was popularized by Empress Josephine during the French Napoleonic Empire (1796 -1814). Illustrations show a 1912 Empire style evening dress worn by Kate Winslett in the film, Titanic.*

+ History Timeline - Key Eras and Events +

Pre 1900s and the Beginning of Haute Couture	Changing Roles of Women	The Roaring Twenties	A Time of Crisis	The New Look and Youth Culture	Swinging 60s, Hippies and Punk	Post Modernism	Fin de Siècle	The Noughties
Pre 1900s	1900 - 1919	1920 - 1929	1930 - 1945	1946 - 1959	1960 - 1979	1980 - 1989	1990 - 1999	2000 - 2010

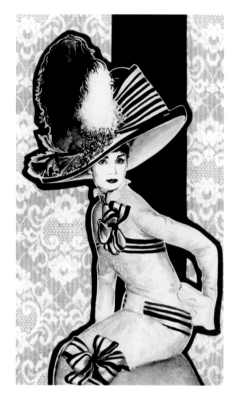

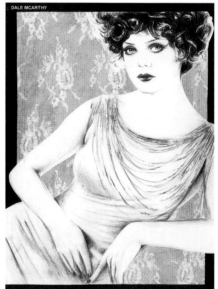

1900-1919 Changing Roles of Women

During this period, women of wealth from New York, London and other cities would typically go to Paris to the designer salons to have their wardrobes updated; women's roles were changing and they became involved in politics, played sports and went to college to study. Retailing had grown and many women, although still looking after their families, found work in the stores and the factories that produced the merchandise.

Silhouette & Edwardian Dress 1901-1910: High-collared, long sleeved outfits, tightly fitted and boned corsets gave a small waistline, full bosom and curved full hips - the S-bend. Bustles gave increased fullness (behind) and skirt lengths reached the ankles. Hats were either enormous and adorned with plumes, or small floral affairs.

Paul Poiret 1879-1944. Designer. Pioneer of colorful Art Deco. Poiret inspired interest in Orientalism through his designs (turbans, tunics, harem pants, kimonos), and liberated women from the wearing of restricting corsets. He, in turn, had been inspired by Serge Diaghilev and the Ballets Russes.

Further Research: Georges Lepape (Illustrator), Gustav Klimt (Painter), Jeanne Lanvin (Designer), Madame Paquin (Designer), Mariano Fortuny (Textile and dress designer), Futurism (Art movement), Leon Bakst (Costume designer), Rudolph Valentino (Silent screen era icon), Gibson Girl, hobble skirt, bloomers, frock coat, spats.

Left top to bottom, Illustrator Dale Mcarthy:
Typical dress of an Edwardian Lady - from 'My Fair Lady' starring Audrey Hepburn.

With Paul Poiret's and Mariano Fortuny's design influence, the 'S' shape gave way to the chemise and women's dress became less restrictive; softer shapes and beading emerged.

Right, Fashion Designers Clements Ribeiro S/S collection, London Fashion Week: *Historical references of Coco Chanel's designs can be seen in these contemporary styles - the yachting theme, gilt buttons, collarless braid trimmed cardigan-jackets, and a slightly androgynous look.*

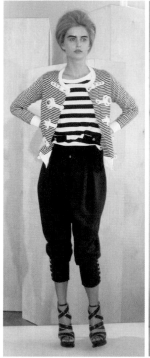

1920-1929 The Roaring Twenties

Postwar Europe: By the 1920s the effect of World War 1 (1914-1918) had changed life dramatically – economically, socially and psychologically. During the war women had taken on men's occupations; by 1920 the amount of women in the workforce had reached 23%. During this decade unemployment started to escalate, but as people wanted to let loose and enjoy themselves a new optimism came about and, with it, the Jazz Age – the Charleston girls, Garçonnes and Divas, and Josephine Baker, and the entertainment industry boomed. This was an era of throwing away the corsets and dancing the night away. Androgyny became popular as women adopted boyish figures and sleek bob haircuts, while men were almost becoming more feminine, paying increased attention to their looks.

Coco Channel 1883-1971. Designer. Style Icon. Her designs influence fashion trends even today. She revolutionized the way women dressed and, throughout the 20s, created one memorable fashion idea after another; her styles were simple with a 'throw away' elegance. In her lifetime, she put women in trousers, introduced *yachting pants* (wide-legged trousers based on sailors' bell bottoms) and beach pyjamas, tweed skirts with twin sets and strings of pearls, popularized the little black dress, created costume jewellery, gilt chain handbags, and the (now classic) collarless braid trimmed cardigan-jacket.

Gloria Swanson 1899-1983. American actress of the silver screen. Style icon, and mysterious siren with smouldering sexuality who fascinated film goers.

Louise Brooks 1906-1985. American actress of the silent screen. Style icon, model, famous flapper of the Jazz Age. Known for her distinctive sleek bob and boyish figure.

Sonia Delaunay 1884-1979. Artist. Associated with futurism, fashion and textiles - known for her bold use of color, geometric designs in contrasting colors, and futuristic designs, art and textiles. Patou, Schiaparelli, and other designers of the 20s and 30s were influenced by her designs.

Further Research: Jean Patou (Designer), Edward Molyneux (Designer), The Triadic Ballet, Dandy, Oxford Bags, Cloche hat.

Above, Fashion Illustrator and Designer Nadeesha Godamunne: *In the 1920s women often dressed in masculine clothes (trousers, jackets and suits). Coco Chanel herself wore the clothes that she adapted from traditional menswear, presenting an androgynous unmistakable signature look. Here, smouldering eyes are reminiscent of actress Marlene Dietrich.*

© Fashion Designer - Sandra Burke

1930-1945 A Time of Crisis

Thursday, October 24, 1929 the New York stock exchange crashed (known as Black Thursday). This started a global money market free-fall, and a global economic crisis. By 1932 there were 30 million unemployed worldwide. Women's emancipation went backwards; they were expected to stay at home, do the housework, bear children and look after their husbands' and families' needs.

Wartime (1939-1945) was a time of improvisation, stretching resources, recycling, and ration coupons. A dearth of women's nylon stockings made them resort to staining their legs brown with tea, coffee, or 'leg paint', using an eyebrow pencil to trace a seam line.

Silhouettes and Styles: Fashion was still largely led by Paris. The boyishness and angular shapes of the 1920s were diminishing; there was a return to femininity and curvy, flowing lines and defined waists. Women's dress lengths were longer in the 30s, but shorter during the war years, by regulation, to save fabric. Short, straight bobbed hair gave way to long and wavy.

Style Icons: At the end of the 1920s the silent screen had developed into 'talkies' and the actresses of the day were even more influential as fashion and style icons.

Actresses: Jean Harlow, Hollywood's original blonde bombshell, a style icon with 'bottle blonde' hair, dressed in marabou, white satin, shimmering silver lurex and diamond bracelets.

Other style icons include; Tallulah Bankhead, Marlene Deitrich, Greta Garbo, Jean Harlow, Katharine Hepburn and Ginger Rogers.

Elsa Schiaparelli 1890-1973. Designer. Cubism and Surrealism influenced her often wildly eccentric designs - playing with the conventional she created new possibilities in design with examples of displacement. Schiaparelli's 'shoe hat' is a classic of this genre; she brought the foot to the head with a surreal contortionism.

Further Research: Cristobal Balenciaga, Madame Grès, Madeleine Vionnet, Nina Ricci, Norman Hartnell, Salvador Dali (Surrealist painter), Christian Bérard (Painter, designer illustrator), Jean Cocteau (Poet, novelist, actor, film director, and painter), Clark Gable.

Elsa Schiaparelli created wild, eccentric hats and designs - and today (left to right):

Master Milliner Stephen Jones, Headonism exhibition, LFW: *Showcased hats from emerging British milliners. Headonism, curated by Stephen Jones, featured five couture pieces from each designer.*

Milliner, fashion illustrator, and entrepreneur Piers Atkinson, LFW: *Presenting the hat he illustrated and created.*

Right: *During this era headscarves became popular tied under the chin (or as a turban);* Chanel *designed gilt chain handbags;* bowler *hats (derbies) were associated with London businessmen (in the late nineteenth century worn by men and women for horseback riding and hunting). In the 50s* Christian Dior *designed fitted jackets with nipped in waists. As seen here, these historical references have been revamped by current high street fashion designers. Winter collection for* Top Shop, *London.*

1946-1959 The New Look and Youth Culture

Post-war austerity saw rationing continuing in many countries and, due to the shortages of fabrics, the fashion silhouette was still slim. That was until **Christian Dior,** 1905-1957, heralded a new era in fashion, one of extravagance. As a new haute couturier, he presented glamorous, lavish and luxurious styles, with pinched in waists and full skirts that swirled below the calf (his designs required many yards of fabric). His 1947 collection was immediately christened the *'New Look'* by the press, an overnight success, copied throughout the Western World.

By the postwar 1950s, the American lifestyle was being mimicked everywhere – no home could be without a fridge or washing machine. The US economy was booming, Europe was rebuilding; there was more disposable income for fashion. Haute couture was being bought by wealthy women, and the middle-classes were sewing their own. Prêt-à-porter/ready-made clothes were becoming more popular.

Grace Kelly 1929-1982. American actress. Style Icon and Princess. This on-screen princess became a real princess reigning over the principality of Monaco. Hermes named the *Kelly* handbag after her.

Audrey Hepburn 1929-1993. Actress. Style Icon. Popular for her gamine looks. Best known films - *Sabrina* (1954), *Breakfast at Tiffany's* (1961), *My Fair Lady* (1964).

Sex Goddess: Many young female actresses of the 50s brought to the screen a confidence as well as an eroticism and sexuality in a more pronounced way than previous eras – they became the sex goddesses of the movies; Marilyn Monroe, Sophia Loren, Bridget Bardot. Then came *Barbie* (doll), born in the US in 1959, with her exaggerated figure – big bosom, tiny waist and legs that went on for ever. Barbie continues to enjoy worldwide popularity.

Youth Culture: In the 1950s youth began to rebel against the bourgeois values of their elders and the establishment. From *Rock-'n'-roll* and its idols; Elvis Presley, Little Richard, Chuck Berry, to film and its idols; James Dean and Marlon Brando, came strong American influences on music and fashion. Denim jeans went from being working clothes to the latest fashion trend.

Further Research: Fashion Designers: Norman Hartnell, Pierre Balmain, Jacques Fath, Hubert du Givenchy, Jacques Griffe, Jean Dessès; Costume Designers: Edith Head, Adrian; Savile Row, Teddy boys, the A-line, the barrel line and the Y-shape, elbow length gloves, 50s glamour, pearls.

Illustrator Jane Wolff: *Many female actresses became fashion style icons and sex goddesses during this period. History has come full circle as this can be said of many of the female celebrities today. This illustration reflects this historic era - modern day style icon and 'sex goddess', Scarlet Johansson.*

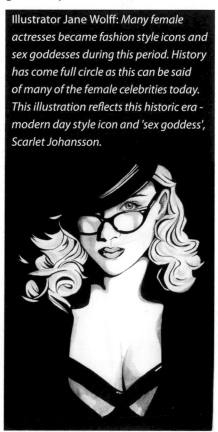

Above, *Fashion* Illustrator and Designer Nadeesha Godamunne: *The swinging 60s,* Carnaby Street *look for men was the modern dandy, a flamboyant figure in frills and velvet, and, in contrast (below), the* Punk Rock *street culture of the mid 70s. This illustration symbolizes the bastion of punk ideals, anti-establishment and anti-capitalist attitudes.*

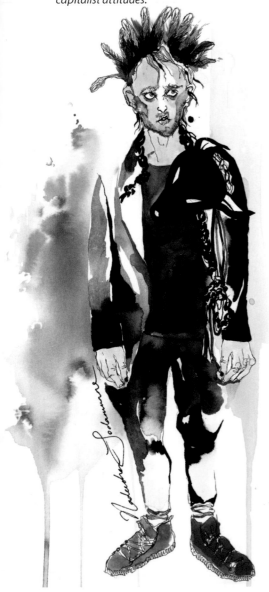

1960-1979 Swinging 60s, Hippies and Punk

In the 60s fashion was becoming more readily available and affordable at every income level - there was a growth in the number of people dressing more fashionably, especially in the youth market. Several factors caused this: in the US and Europe, the development in international trading with lower-wage earning countries and, with it, mass-production and distribution; more people owned a television and went to the movies; and the growth of department stores, boutiques, and mail order. Haute couture, although still strong, was less lucrative, and prêt-a-porter collections were seen in most fashion houses' collections.

The early 60s gave us the **Swinging 60s, Carnaby Street** and the **Beatles.** The pendulum swung back to boyish figures as **Twiggy**, the waif-like, 15-year-old British model, took the world by storm. Women's hairstyles went from the beehive, hairpieces and huge amounts of hairspray to the short, revolutionary five-point-cut, the bob or wedge, popularized by Vidal Sassoon - meanwhile mens hair got longer. In the late 60s, disillusioned by the ongoing Vietnam war and materialism, a youth 'counter-culture' originated on the West Coast of America - their message was for peace, *'Make love not war'.* They turned to Eastern cultures and dress, and the **hippie look** and **flower power** evolved; long floaty flower print dresses and 'peasant' style blouses, flower print shirts for men, denim jeans and long hair for both sexes. Fashion in the 70s continued to be softer with tweeds, soft prints, hand-made looks with hand-knitted or crocheted scarves and hats, long patchwork skirts, peasant skirts.

Mary Quant 1934-. Designer. Her designs epitomized young British fashion. With her low-priced, avant-garde styling she popularized the mini skirt, colored tights, skinny rib sweaters, low slung hipster belts and PVC.

André Courrèges 1923 -. Designer. His functional, uncluttered, futuristic styling was almost architectural in design due to his attention to construction. He became known as the 'Space Age' designer, literally reflecting the interest in the advances of space exploration, particularly in the US. Trouser suits, trapeze-shaped dresses, catsuits, transparent fabrics, cut-out dresses, the Courrèges boot, stark colors, white and silver, were all part of his signature look.

Vivienne Westwood 1941 -. Designer. One of the most influential designers of our time. In the late 60s she opened a shop in the King's Road, London with Malcolm Maclaren; it represented an anarchic urban youth culture. Punk, which grew from the youth cult, street fashion and music, took off as a mainstream fashion trend in the mid-70s helped along by Westwood, Maclaren and the Sex Pistols (Punk Rock Band). Bondage trousers; leather jackets with anarchist slogans; safety-pinned torn t-shirts; spiky red, pink, green and orange colored hair; mohican-style haircuts; identified the look which later was adopted by the 1980s ready-to-wear designers.

Further Research: Yves Saint Laurent, Ossie Clark, Zandra Rhodes, Bill Gibb, Biba, Laura Ashley, Pierre Cardin, Andy Warhol (Pop artist), Richard Avedon (Photographer), Royal College of Art, Style icons Jacqueline Kennedy (First Lady, wife of US President) and Lauren Hutton (Model), Tom Wolfe's 'The Electric Kool-Aid Acid Test', Woodstock Festival, hipster pants, the transparent look, tent dresses, hot pants, trouser suits and jump suits, platform shoes.

1980-1989 Post Modernism

This was the decade when *'Power dressing'* for women became a key fashion look, partially influenced by two television series, *Dallas* and *Dynasty*. There was also an increase in Western women completing university education and entering management positions made possible by the liberating effect of the contraceptive pill which had been introduced in the mid-60s. Big hair, sharply tailored suits with big padded shoulders, and high heels gave women a *'superwoman'* confidence as they tried to successfully juggle their job, home and family.

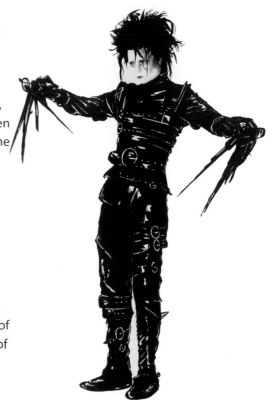

Fashion was now totally international; French haute couture no longer dominated the fashion scene as Britain, Italy and Germany were creating fashion that was successfully being marketed worldwide. The United States was supplying up-to-date casual classics, and Japan had marched strongly into the fashion scene with its avant-garde designers.

Style Icons: Madonna 1960-. Rock singer. With her in-your-face sexuality and constantly changing guises; a reincarnation of Marilyn Monroe, a brassy peroxided leather-clad punk, a 40s *Evita* (film) screen siren. Madonna is one of the ultimate post modern heroines. She famously popularized the wearing of corsetry, bras and bustiers as outerwear.

Jean-Paul Gaultier 1952-. Designer. With ground breaking ideas he has become a significant contributor to fashion and ready-to-wear. He took the corset and designed it for outerwear and, most famously, designed Madonna's provocative corsets with cone shaped bra cups for her tours in the late 80s/ early 90s. He resurrected his infamous conical bra for his Spring-Summer 2010 collection, 20 years or so later.

Diana, Princess of Wales 1961-1997. The Cinderella, fairy tale princess of the 80s, loved the world over, became the people's *princess* and their *'Queen of Hearts'*. From a *'Shy Di'* to a super confident style icon in chic designer dresses, power suits and haute couture evening gowns. After her divorce, she emerged as a caring and sharing, new-age princess, in chinos and white shirts. The paparazzi followed her every move.

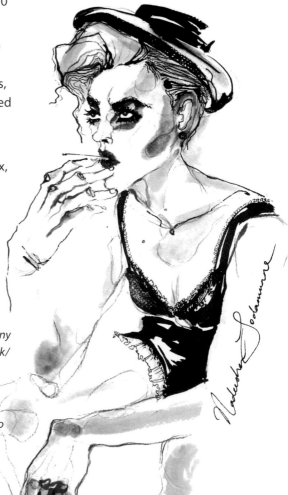

Further Research: Donna Karen, Calvin Klein, Ralph Lauren, Christian Lacroix, Thierry Mugler, Karl Lagerfeld, Giorgio Armani, Gianni Versace, Pierre Cardin, Gym gear, activewear, pouf skirt.

Top right, Illustrator Dale Mcarthy: *In the 1990 film,* Edward Scissorhands *starring Johnny Depp - Scissorhands' costume, illustrated here, could have been inspired by a* Gautier *rock/* Vivienne Westwood *punk creation. Academy Award winner* Colleen Atwood *was the costume designer for the movie.*

Right, Fashion Illustrator Nadeesha Godamunne: *From the 80s onwards, Jean-Paul Gaultier, designer, and Madonna, rock singer, have influenced fashion world-wide, and no more so than with the trend towards wearing underwear as outerwear.*

Above, Illustrator Dale Mcarthy: *In the 90s, celebrities, from actors and singers, to models, were becoming style icons and influencing fashion more so than in previous decades; Nicole Kidman (actress) and Gwen Stefani (singer) amongst others. The movie,* Moulin Rouge, *starring Nicole Kidman as* Satine, *had a direct influence on fashion as burlesque became the inspiration for many designers.*

Below, Fashion Illustrator Sarah Beetson: *In the 90s, fashion lost its strict distinction between age groups and the sexes and, to a degree, young and old, male and female could wear virtually the same styles; leisure pants, jogging pants, T-shirts, sweatshirts.*

1990-1999 Fin de Siècle

There began a popular respect for the environment; recycling, vintage clothing, thrift/charity shops. Developments in technology had produced massive changes in the media and communications industries, and with it techno music. It also gave us plastic wrap, vinyl, Teflon and other synthetic fibres and meant there were new ways to shape garments. China had become a manufacturing hub, and with it cheap designer clothes and knock-offs.

Fashion designers looked back at the past; it was the decade of **retro** and **techno**. They redesigned existing shapes and styles, and revived designs of the 50s, 60s, 70s and the futuristic designs of **André Courrèges** and **Pierre Cardin**; even the 1920s was revamped. But the designs always had a new twist and, of course, were made in new fabrics, prints and colors. Intervals between fashion cycles became shorter. Dress codes relaxed; dressing up for the theatre, opera or eating out was no longer expected and, in many office environments, jeans and leggings were allowed. The activewear market was thriving - it was acceptable to mix the look with more formal wear - designer trainers with smart pants, for example.

Consumerism, grew along with the importance of the 'Designer' labels which were not only for the wealthy but for all income levels and ages. Designer names were displayed on the outside of garments and products, on a T-shirt emblazoned across the front. Advertising was all about the product.

Grunge appeared from street culture. Its shock value displayed a political, anti-consumerist, anti-establishment, anti-fashion statement. It evolved from thrift store clothing, mismatched, torn garments and deconstruction. As with all street culture it spread from the youth to rock bands and then to the fashion runways - it went from subculture to mass culture. Marc Jacobs was named the 'guru of grunge' for his radical collection for Perry Ellis in 1992.

Jean-Paul Gaultier and **Vivienne Westwood** continued to stretch the boundaries with their originality in design. (In recognition of her personal merit Vivienne became a Dame in 2006.)

Models such as Claudia Schiffer, Cindy Crawford, Linda Evangelista, Naomi Campbell, Kate Moss and Christy Turlington became **Supermodels** with superstar status.

Further Research: Muicca Prada, Dolce and Gabana, Calvin Klein, Christian Lacroix, Karl Lagerfeld, Jil Sander, Rei Kawakubo, Gucci, Ann Demeulemeester, Dries van Noten, Dirk Bikkembergs, Belgian Fashion, Antwerp's Academy of Art, Hugo Boss, John Galliano, Alexander McQueen, Stella McCartney, Dior, Givenchy, Chloë, beanies.

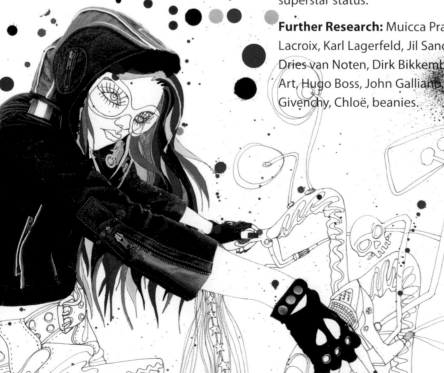

Jean Paul Gaultier is quoted as saying, *'GENDER BENDING – Almost anything can be worn by both men and women. The clothes themselves have no gender. What is considered feminine today was masculine before, and vice versa. All my career, I have tried to make men equal to women: a woman can be feminine in a pantsuit and a man very masculine in a skirt.'*

2000-2010 The Noughties

A decade of **celebrities** and **designer luxury** and **lifestyle**; designer stores and shopping malls sprang up absolutely everywhere. Western countries ran down their manufacturing industries to take advantage of the low cost manufacturing prices from China, Malaysia, Indonesia etc. This made luxury and mass-produced goods even more affordable for all.

Retail therapy became a pastime for many. Internationally, consumerism at all income levels reached proportions never seen before. It was fuelled by the media, newspapers and magazines like Grazia, and through the Internet and new technology with blogging, Facebook and YouTube.

The **paparazzi**, creators of gossip fodder, hounded the celebrities for the ultimate shot (complimentary or otherwise). **Celebrity endorsement** grew. What the celebs (actors, sports people, popstars) wore, especially to an event such as the Oscars, frequently became the next *'must have'* fashion item. Luxury brands and high street fashion retailers thrived on this. Recognising celebrity endorsement proved to be a profitable marketing strategy. Many brands had celebrities model their merchandise, even design a fashion line (or at least have their name on the label); for example, Kate Moss's collaboration with Topshop. Topshop then proceeded to collaborate with many key fashion designers; Christopher Kane, Emma Cook, Mark Fast, Ashish, Richard Nicol. Hip hop artists and rappers also took the lead with their own clothing lines; Sean 'P-Diddy' with the Sean John clothing line, Jay-Z, Pharrell and DMX.

Luxury Market: More affordable and popular meant customers could dress in designer labels from head to toe, or simply buy the T-shirt, the shoes, the bag, the eyewear, or the perfume. And, of course, there were the designer knock-offs.

Bagonomics: Designer bags were driving the fashion industry. Regardless of the fact that there was a massive markup on the retail price, they sold not only to the wealthy but to all income brackets - it was the way many brands survived.

Mass Market: Primark or 'Primani' (take on Armani) and other similar high street retailers worldwide churned out the latest styles in cheap fabric using cheap labour to create cheap retail prices. Consumers wore the luxury brands (Burberry, Chanel, Gucci, Prada, etc.) but teamed the look with a mass-produced brand (H&M, Mango, or a Topshop T-shirt, for example).

Forever Young: The emphasis for all sexes was to maintain their youthful looks by the way of dress, by having cosmetic surgery, using 'miracle' anti-wrinkle creams, fitness regimes and personal trainers. Keeping fit and eating healthier foods had become part of everyday life and with it came the growth in designer leisurewear and activewear, and technology breakthroughs in 'smart' fabrics with all year round fabrics keeping the body cool and warm as needed, breathable fabrics, quick drying, sweatproof, odourless etc. and, ultimately, more comfortable clothing.

Technology: iPods became a design statement. Bling was popular especially with the growth in rap music culture. Technology gave us iPhones and iTunes; downloading and uploading, and information spread instantaneously around the world. Everyone could see what was new, what was the latest in trends and lifestyle, and this sped up fashion cycles even more than ever before.

Further Research: Savile Row, Bilboa effect, Guggenheim, Louis Vuitton 'Alma bag ', Abercrombie & Fitch, Gap, Pop and style icons; Lady Gaga, Lily Allen, Dita Von Teese, rock-indie bands.

Above, Illustrator Jane Wolff: *Agyness Deyn, supermodel of the noughties, famous for her hats (bowlers, trilbys) and haircuts, and her cool style.*

Below: *Jean-Charles de Castelbajac 1950-. Designer. Came to fame in the mid-70s. His stores represent the best of avant-garde fashion and lifestyle. Store assistant, Jamie, in the* Castelbajac *flagship store in London.*

© Fashion Designer - Sandra Burke

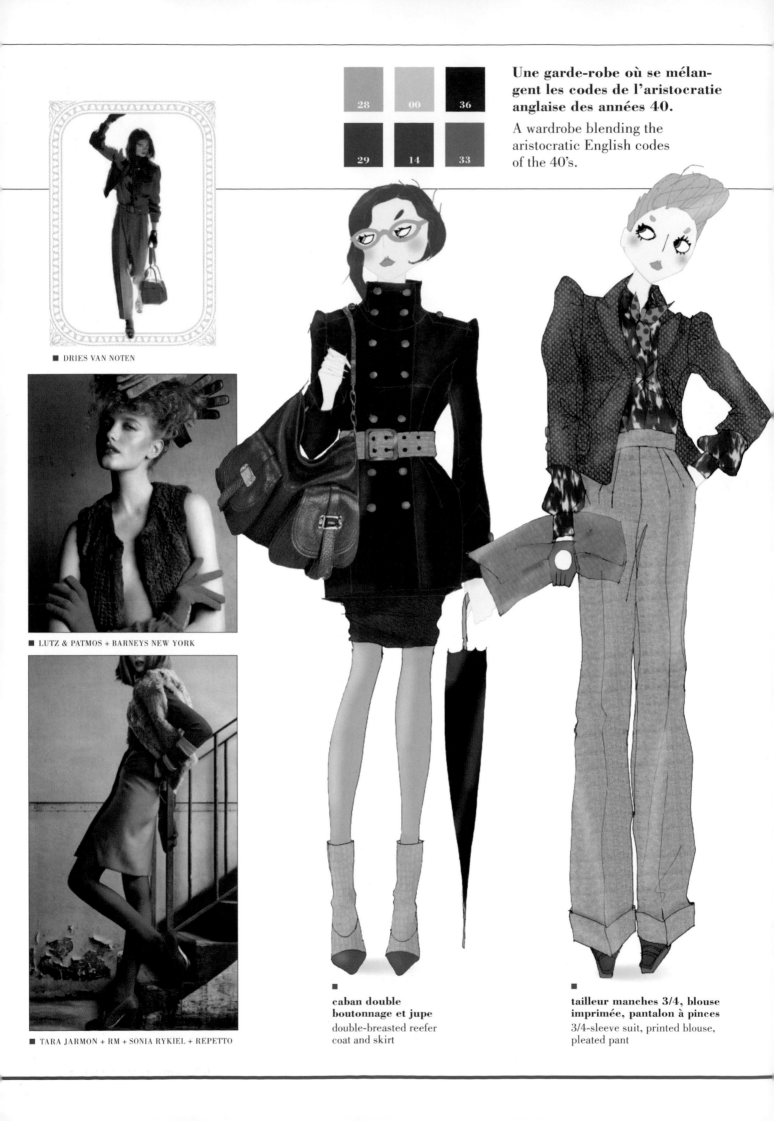

Une garde-robe où se mélangent les codes de l'aristocratie anglaise des années 40.

A wardrobe blending the aristocratic English codes of the 40's.

28 00 36
29 14 33

■ DRIES VAN NOTEN

■ LUTZ & PATMOS + BARNEYS NEW YORK

■ TARA JARMON + RM + SONIA RYKIEL + REPETTO

■ **caban double boutonnage et jupe**
double-breasted reefer coat and skirt

■ **tailleur manches 3/4, blouse imprimée, pantalon à pinces**
3/4-sleeve suit, printed blouse, pleated pant

4

Fashion Forecasting
Trends and Cycles

Lisa Mann

'It is charming to totter into vogue.' Coco Chanel

Those trying to decipher and interpret the process of predicting the fashion trends of the future have often viewed fashion forecasting as something of a mysterious business. It is, however, a fairly scientific process that provides important information to decision makers within the fashion industry. Without this information companies and brands stand to lose considerable amounts of money by investing in the wrong textile, color, design or product offering.

This chapter will present fashion forecasting under the following headings:
• A fashion forecaster's role
• Brief history of fashion forecasting
• Fashion cycles
• Why fashion forecasting is necessary
• How to predict trends
• Trend forecasting information
• Fashion forecasting services.

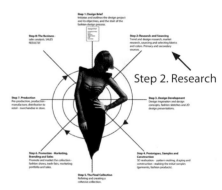

Figure 4.1: *Fashion Design Process (see p.15)*

Left, Courtesy of **PROMOSTYL Paris,** international trend forecasting agency, from their Womens Winter Trends *book,* theme *'l'aristocratie anglaise des années 40'* (the *aristocratic English codes of the 40s).*

manteau manches raglan, double boutonnage, poches plaquées
raglan-sleeved coat, double-breasted with patch pockets

PROMOSTYL

1. A Fashion Forecaster's Role

Could you predict what the essential items would be for a fashion buyer or designer to include in their range one year ahead, or predict what the most important fashion colors or fabrics will be in two years time? Fashion forecasters specialize in gathering information and identifying trends to help fashion designers and buyers, stylists, etc., make the correct color, design and product choices when it comes to placing orders or designing products. Their role includes:

• Research of consumer lifestyles and fashion trend movements - international or specific to a particular niche area.
• Attend fabric shows and provide reports on the most important information, runway/catwalk reporting.
• Provide mood/trend boards presenting the prominent shapes, colors, fabrics and details.
• Market research by way of shop reports and consumer buying habits on the high street, knowing what the competition is doing, what new stores are opening, what new designers are in the process of developing.
• Scouring trade and consumer publications for indications of trend movement.
• Sales analysis for specific areas of the market or for a particular product area.
• Reporting on developing new technologies and how they could impact on consumers' lives in relation to fashion.
• Tracking the media, looking out for the next big influential film, musical, celebrity or band to hit the headlines.
• Assist with timing, when to introduce a particular trend for maximum impact.
• Decipher social, demographic, cultural and economic trends and present their impact on fashion and spending habits.

Below, Trend Identification: *Could you predict what the most important fashion colors will be in two years time?*

Right, Courtesy of **PROMOSTYL Paris,** international trend forecasting agency *from their Womens Winter Trends book, t*heme 'Memphis'.

2. Brief History of Fashion Forecasting

As far back as 1915, The Color Association began to provide color intelligence and direction to important industries ranging from automotive companies to fashion stylists. Fashion has since been broken down into a number of market segments, such as accessories, sportswear and lingerie, and has now become a major market for forecasting services.

Première Vision, a large visionary prediction indication event held in Paris every year, was started in 1973 by some entrepreneurial weavers who decided to show their fabrics at the International Centre in Paris. Three years later they began to propose seasonal color/fabric trends to lead the way in their field; the next year they were joined by others in the weaving and textile industry. By the 1990s Première Vision had evolved into a worldwide network of events that more recently has taken place in Brazil, the USA and Canada.

The 60s and 70s demonstrated a time for considerable changes in the fashion industry; retailers saw shifts in consumer behaviour as people began to react to events and themes communicated through the media. It was no longer simply a case of looking to catwalk shows and couture designers to predict what consumers would want to buy. Other influences began to affect consumers' buying habits; trends started to emerge from the street and cultural and social groups began to create their own fashion 'looks'. Fashion retailers, designers, stylists and manufacturers felt that

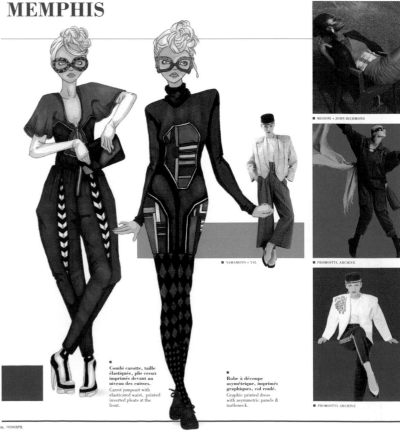

MEMPHIS

■ MISSONI + JOHN RICHMOND

■ YAMAMOTO + YSL

■ PROMOSTYL ARCHIVE

Combi carotte, taille élastiquée, plis creux imprimés devant au niveau des cuisses. Carrot jumpsuit with elasticated waist, printed inverted pleats at the front.

Robe à découpe asymétrique, imprimés graphiques, col roulé. Graphic printed dress with asymmetric panels & turtleneck.

■ PROMOSTYL ARCHIVE

16. PROMOSTYL

things were *'shifting under their feet'* and that they should find some way of reading the market by examining the broader social influences that were affecting their consumers.

Since these changes and developments, many companies, agencies and consultancies have been formed offering a wider range of services including working with companies on their seasonal range development.

Promostyl, for example, has been a world-leading trend forecasting company for more than 40 years. The extensive knowledge of trends that Promostyl has developed has made them a trusted partner for a wide variety of high profile clients. The nature of the communication of the trend information that Promostyl offers its clients has changed noticeably since their beginning. With the onset of technological developments in print and online media, the reach of trend forecasting companies has grown considerably; information can be delivered around the world very quickly in an increasingly visual way, meaning that competition in the forecasting industry is fierce. Companies such as Promostyl however, have years of experience behind them and some extremely well established clients that trust the information provided by the Promostyl consultants and trend reporters. Today forecasting companies need to ensure that the information they distribute is kept up to a very high standard and maintain their up-to-date trend analysis to remain the leaders in their field.

3. Fashion Cycles

Fashion trends tend to move in cycles; thirty or forty years ago it might have taken a few years for a trend to move through the stages from emergent trend to emulation and finally to mass production. More recently, the fashion industry has become much faster paced, with some trends emerging and filtering through to high street retail stores within six to eight weeks. Fast fashion retailers who can react quickly to trends emerging in this way stand to maximize their company profit as they will capture the market interest while it is at its highest. Sometimes these trends might not have been predicted, but will suddenly emerge as the result of a particular event, film, or even by a rising celebrity influence.

There is often no telling how long a fashion trend will last, or how quickly the cycle will end; it is therefore very useful for fashion designers to have a fashion forecasting specialist on hand to use all their expertise in reading and tracking the market. Consumer behaviour should be studied in order to make a judgment on how long the product or trend in question might last. (See *Fashion Market* chapter, *Fashion Trends Lifecycle*)

Designers, retailers and manufacturers make decisions on how much of a particular trend to put into production for present and future seasons, therefore they need information on how long a trend is likely to last. Some items will stay around for a long period of time with a slow cycle of movement. Trench coats, for example, have been a 'classic' fashion purchase for many years and do not look set to decline at any time soon. Although those that purchased such an item when it first emerged on to the fashion stylist and celebrity horizon, will have almost certainly moved on to something that has a more contemporary look that will later also trickle across to the emulation stage and then mass production.

Color trends are an important area of interest to fashion designers, textile designers and fashion buyers; color will often be the starting point for a new collection or trend. Colors are often communicated as visual images or photographs, and one beautiful, inspirational image will capture the complete color palette for a trend or theme. Fashion illustration can also be used to interpret how important different colors within a palette might be, some will be accent colors and others will be of fundamental importance to the predicted trend.

Left, Fashion Designer Charlotte Hillier: *Photograph - Brick Lane, London, a haven for emerging trends.*

© Fashion Designer - Sandra Burke

4. Why Fashion Forecasting is Necessary

This page and opposite: *Kenzo* 'Fashion in Motion' *event at the V&A Museum. These designs represent the 'trickle down' effect - a trend that filters down from a designer catwalk show.*

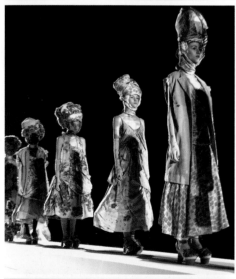

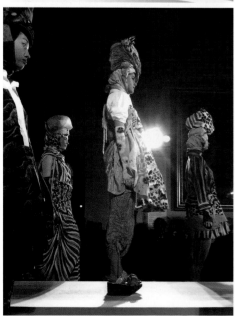

Every decision maker within a brand or company, from designer to executive director, is called upon to make attempts at forecasting the future wants, needs and desires of their consumers. These people are highly qualified to make important decisions but if they get professional direction from forecasting companies it will give them more confidence that they are making the right decisions - making the wrong decisions about future products or designs can be incredibly costly. This can affect the image and reputation of the company or brand, and can obviously have negative financial implications. Forecasting consultants are often called in before the decision making stage to give presentations and guidance on their predictions. These will be tailored specifically to the type of company or product area that they have been asked to focus on. Several different forecasting companies and consultants might be called upon in order to gain a balanced view and ensure that the information is interpreted for the right market. All of this activity cuts down on the risks that the retail company or designer is taking when going into production for the future season.

Short and Long Term Forecasting: You will sometimes hear fashion forecasting discussed as *'Short Term'* or *'Long Term'*. This is because the timelines being considered when gathering and making sense of forecasting information might be different for different companies or markets.

Long Term: Often fashion designers and companies will be interested in what patterns of behaviour might be taking place on a macro (large scale) level over a long period of time; this would be of particular interest to companies dealing with large quantities or global production. Long Term fashion forecasting would consider five years or more into the future; this seems like an extremely long time frame to consider but, for those making decisions on re-positioning or the introduction of new stores or products, it is essential to be well informed this far ahead.

Short Term: Short Term forecasting is much more immediate, and allows for a quick turn around on decisions being made for the fast paced fashion retail sales industry. Short Term will usually mean approximately one year or more, occasionally it can be six months, or for the forthcoming season. This type of prediction assists retail companies and brands to move more quickly on providing up to the minute trends to their customers.

Trickle Down and Trickle Up Effect: The 'trickle down' effect is when a trend filters down from designer catwalk shows or boutiques to the high street. It is then seen interpreted in a variety of ways by consumers, then becoming known as 'street fashion'; it filters from the 'elite' to the masses. The 'trickle up' effect is when street fashion filters its way through into the main-stream, gets noticed by retailers and gradually becomes available to all types of consumers. Fashion designers will often then begin to adopt the key areas of this trend into their collections.

5. How to Predict Trends

Fashion forecasters are usually plugged into a huge network of data sources. They will carry out or have access to a large amount of primary research and sales information, and will often be in touch with new technologies and scientific developments. They will also have a large network of contacts within a range of lifestyle industries and attend important consumer events around the world. A considerable amount of observation will take place; observation of consumers, the economy, the retail market place, social activities, and travel and leisure pursuits being undertaken. All this information is then analysed, and it is the role of the forecaster to make some sort of sense of it all and spot the major themes and trends that might be emerging, and identify those that will have an impact on the fashion industry.

It is important for fashion professionals to note just how many aspects of culture, society, social change, art, technology and politics actually influence fashion and the development of trends. Table 4.1 attempts to demonstrate some of the many different influences that need to be considered when predicting fashion trends and how they can trickle up or down and have a long or short-term effect on the fashion industry.

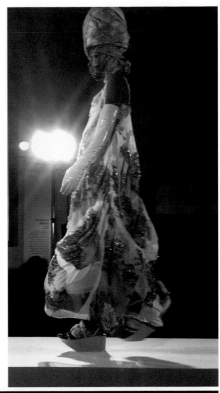

Influence	Trickle up or trickle down effect	Long term or short term effect on fashion trends
Celebrity - Music, sport, actor, socialites, royalty.	Down	Dependent on calibre, longevity and credibility of the celebrity.
Financial stability of the economy, consumers' personal wealth, changing perceptions of status.	Down from an economic perspective, with government policies affecting consumer finances. Up from a consumer perspective, with people cutting down on spending.	Long or short term effect.
Social trends, travel & leisure (e.g. skateboarding, surfing, roller skating, BMX bikes, etc.), social networking.	Up and down	Long and short
Runway/Catwalk influence, couture, new designers.	Down	Seasonal
Technological developments, innovations, personal technology.	Down	Dependent on whether the technology is sustainable for the consumer.
The media, magazines, TV, radio, advertising, online media, etc.	Down	Short
Textile & Fibre trends, color, fabric types, weaves, knits.	Down	Long
Street fashion, vintage style, consumer styling, international influence, cultural influence.	Up	Long
Art, Street & urban art, cultural art.	Up and Down	Long and Short
Architecture/interiors.	Down	Long
Film, theatre, music, ballet, opera, circus.	Up and Down [street theatre and home made movies, (YouTube) now have an effect on consumers].	Short

Table 4.1 Table of Influences - *shows the trickle up and trickle down effect in the fashion industry.*

6. Trend Forecasting Information

This section presents the components of trend forecasting information for fashion design. Listed below are just some of the many elements that the particular companies mentioned within this chapter offer as fashion prediction services and includes their different styles of presentation.

It is important to note that they all point the viewer to what they feel are the most fundamental elements for each trend for the season in question. These are highlighted very clearly in any publication or online presentation with the use of images, drawings, photographs, fabric/textile samples and text/words.

Elements within the presentations include:

Fashion and garment illustrations: Fashion illustrations are a great way to show a fashion look in its most recognizable form. Most frequently the illustrations used for prediction information will show garments on the body.

Fabric/Textile directions: Fabrics tend to move in trends; man made fabrics were very important during the seventies, more recently natural fabrics have become the preference for consumers.

Trim and detail directions: There is often a prominent trend towards a particular type of trim or detail on garments - there could be a trend for lace trim on garments across all markets or, perhaps, leather cutwork might be forecast for accessories and outerwear.

Silhouette shapes: Drawings of silhouette shapes will provide an indication of the fashion silhouettes for the season, for example, it might be that trousers for a season will be skinny, flared, or bell bottoms. There are often a few prominent shapes that are 'on trend' and these will be what designers will use as a guide when developing their ranges for that particular season.

Technical drawings to demonstrate shape, proportion and construction: Proportion is very important in fashion and can have a strong effect on how a garment looks. A trend can sometimes be determined by changing the proportion of a garment. For example, hoodies (hooded sweatshirts) might have huge hoods on them for two seasons and then begin to have more standard sized hoods in future seasons. It is very important for the designer to get this right and for the timing to be correct.

© Fashion Designer - Sandra Burke

Styling suggestions: These take the trend further than just the styles of the individual garments. Styling suggestions help buyers to understand what consumers might wish to purchase to complement their garments for that season. Styling is often seen as something that leads trends - stylists should have a good 'eye' for successfully putting garments and accessories together in new ways.

Street style/image galleries/retail trends: Most forecasting or prediction agencies will have huge archives of imagery that has been taken by their own trend reporters, covering areas such as windows, retail spaces, street fashion, architecture and art. Many hours and large amounts of money are spent sending trend spotters to different parts of the world to capture inspirational imagery and spot new emerging trends and themes.

Accessory trends to accent the suggested fashion looks: Accessories are of fundamental importance to the fashion industry as they will often be the main source of income for a brand or retailer during slower periods of trade. This means that retailers and designers need to be aware of developments in accessory trends and appreciate how they relate to garment trends.

Button, buckle, popper and fastening styles: Knowledge of trend developments in this area of the market is important to designers as they need to know the type of products such as zips and buttons, that will be available to them for their future product sourcing and manufacturing.

Retail trends and store windows: This information is highly relevant as it provides an insight into how retailers are interpreting the seasonal trend to their consumers; ultimately this will have a big influence over the success of the trend. Window display is an increasingly important way for retailers to communicate with consumers as they compete with the growing popularity of e-commerce and multi channel retailing.

Both pages (top and below, left to right): The components of fashion and trend forecasting information.

Art Influence: *Broomhill Sculpture Gardens, UK - 'Three Women'; 'Red Shoe' - Greta Berlin sculptor.*

Retail: *Milan store window, accessories*

Designer: *Shoes - Graduate Fashion Week, London*

Retail: *Vibrant wellies - new trend and 'festival fashion' to the fashion norm*

Designer: *Graduate Fashion Week - coat*

Street: *London Fashion Week, 'setting trends'*

Retail: *Sun hat, sunglasses and red hair.*

This page and opposite, Courtesy of **PROMOSTYL Paris,** international trend forecasting agency *from their Youth Market Winter Trends book, t*heme *Apocalip.*

Fashion Designer Charlotte Hillier: *Photographs - Brick Lane area, London, a haven for street fashion and emerging trends - the trickle up effect.*

7. Fashion Forecasting Services

Fashion forecasting takes place on many different levels within the fashion industry. The prediction information is presented in a diverse range of styles and formats; the forecasting agencies and publications will be aiming their information not only at different types of fashion companies and brands, but also at the various product areas, such as accessories, menswear, sportswear or childrenswear. Some forecasters provide a service that caters for all product areas; this requires them to carry out a very large and diverse range of research.

The ways in which forecasting agencies distribute the information they generate are constantly changing; with technological developments of more recent years, information can now be delivered much faster online with daily updates becoming the norm. Blogs, mobile phone apps and social media sources are all very good methods of delivering information around the world very quickly.

The following pages list some of the key forecasting and prediction companies and consultants globally. Each one presents their information quite differently with a distinct identity and style.

It is important to note that they all point the viewer to what they feel are the most prominent and fundamental elements for each trend for the season in question.

As a fashion designer, or any kind of decision maker in the fashion industry, you would need to analyse all the trends presented and observe all the elements included in each of the different styles of presentation, in order to decide which is most appropriate for your company or brand.

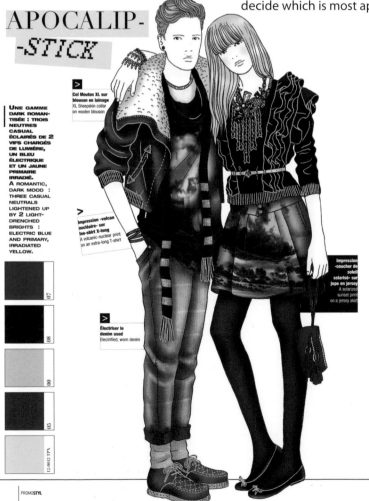

APOCALIP- -STICK

UNE GAMME DARK ROMAN-TISÉE : TROIS NEUTRES CASUAL ÉCLAIRÉS DE 2 VIFS CHARGÉS DE LUMIÈRE, UN BLEU ÉLECTRIQUE ET UN JAUNE PRIMAIRE IRRADIÉ.
A ROMANTIC, DARK MOOD : THREE CASUAL NEUTRALS LIGHTENED UP BY 2 LIGHT-DRENCHED BRIGHTS : ELECTRIC BLUE AND PRIMARY, IRRADIATED YELLOW.

Col Mouton XL sur blouson en lainage
XL Sheepskin collar on woolen blouson

Impression -volcan nucléaire- sur tee-shirt X-long
A volcanic-nuclear print on an extra-long T-shirt

Impression -coucher de soleil solarisé- sur jupe en jersey
A solarized sunset print on a jersey skirt

Électriser le denim used
Electrified, worn denim

PROMOSTYL

PROMOSTYL (www.promostyl.com): Promostyl is an international trend research and design agency that began creating trend books in the 60s. Based initially in Paris, the agency now has branches in New York and Tokyo. Over the years Promostyl has extended its offering which includes, design consultancy, market analysis, retail space design, training, and conferences in trend prediction. Trend books are created on a seasonal basis and provide fashion designers with the season's important trend directions and color indications including the Pantone color references. CDs are usually included as part of the trend book package; this enables designers to use the ready made templates of the season's most important garment shapes and details to design, style and create their own bespoke items as appropriate to their market. Promostyl has a creative team that travels around the world to discover and analyse the latest consumer behaviour patterns; agents work in countries as far reaching as Africa, China, Japan, India and Australia.

WGSN (www.wgsn.com): WGSN (Worth Global Style Network) is a totally online international forecasting service. It was created in 1997 by two brothers, Julian and Marc Worth, and was sold to the media group EMAP in 2005. WGSN provides a very rich source from which users can access a wide range of trend information. Users such as companies and designers subscribe to this service at a cost. WGSN have representation and trend scouts all around the world with satellite offices in cities like New York and Hong Kong. The online nature of the service provides a very quick way to update information and offers immediate access to up to the minute trend reports from around the world.

MUDPIE (www.mpdclick.com): Mudpie began in 1993 as a UK design consultancy and developed as a childrenswear prediction service, focusing primarily on casualwear for babies, children and teenagers. The company has since broadened its scope to provide trend analysis and forecasting services via printed publications and online via Mpdclick.com. Mudpie is now one of the world's leading trend intelligence resources.

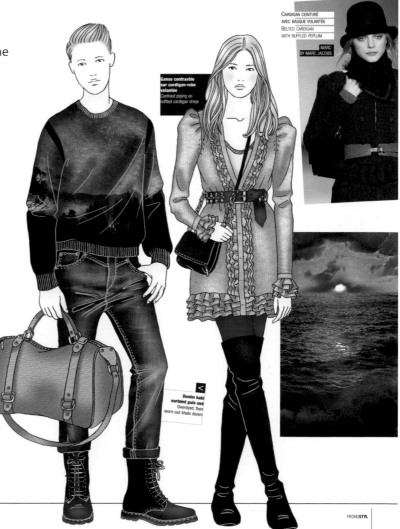

© Fashion Designer - Sandra Burke

STYLESIGHT (www.stylesight.com): Stylesight offers trend forecasting and consultancy services. The main headquarters are based in New York; there are also satellite offices in other centres such as Shanghai, Hong Kong and the UK. Stylesight provides inspirational imagery, information on lifestyle and consumer trend shifts, runway and trade show coverage, along with design development and consultancy services. Stylesight offers a wide range of fast accurate fashion trend information online to many thousands of clients on an international scale. Key trends, seasonal color palettes, macro trend predictions and graphic print directions are extremely important parts of the offering provided by Stylesight. Online 'webinars' and live conferences offered by Stylesight communicate important trends and predictions to designers quickly and on a worldwide scale; these are incredibly valuable resources for designers the world over.

PECLERS (www.peclersparis.com): Peclers is based in Paris. It is a leading international styling/design and trend information agency for products such as fashion, cosmetics, home and lifestyle goods. Peclers can provide solutions for companies that are looking for added creative input and sometimes even provide services to manufacturers that might want to incorporate fashion into their product offering. Peclers produces 18 trend books for fashion, cosmetics and accessories per season - extensive research is carried out in order to produce these seasonal books. It also offers marketing and promotion strategies as well as garment design services. Peclers' trend books provide information that is easily translatable for companies that wish to design products that will be future best sellers.

TRENDSTOP (www.trendstop.com): Trendstop.com is a leading online trend forecasting and analysis service; it provides information by offering a visual and inspiring trend information service. Trendstop is well known for the quality and accuracy of its trend analysis services, offering fast accurate information online. Downloadable key seasonal trend silhouette shapes can be used and edited in Illustrator and Photoshop programs. This allows fashion designers to work with the most important fashion garment shapes for the relevant forthcoming season.

Top to bottom and opposite:

Ellisha Mann: *Researching Stylesight's trends online.*

Trendstop: *One of the leading online trend forecasting and analysis services.*

Lisa Mann and Suzie Norris, editors: *'3rd Floor' fashion trend publication, Southampton Solent University - to inspire and inform. Photographer Pippa Gower. Stylist Francesca Roberts.*

Fashion Designer, Gemma Aspland: *Trends and styling board.*

THE FUTURE LABORATORY (www.thefuturelaboratory.com): The Future Laboratory is a UK based consumer prediction agency. Since setting up the service in 2001, it has developed into a global consultancy providing independent research, creative thinking and bespoke client operations that respond to a brand or company's individual need for research and enquiry. The Future Laboratory has many clients in the retail, technology, finance, automotive, food, fashion and creative industries sectors. The trend reports and information produced by the company are presented via daily, weekly and quarterly news feeds, and insight reports, and also through its bi-annual publication 'Viewpoint'.

LI EDELKOORT/TREND UNION (www.trendunion.com): Li Edelkoort is a globally recognized, highly renowned figure in fashion and lifestyle prediction. She specializes in 'Long Term' forecasting; predicting lifestyle changes that will affect consumer purchasing habits, in particular focusing on their fashion and lifestyle purchases. Li presents her findings across the world, visiting major capital cities and offering her insights and predictions to important members of the fashion and consumer forecasting industries. Other publications produced by Trend Union include titles such as View and View on Color.

NELLYRODI (www.nellyrodi.com): NellyRodi is a Paris based trend forecasting and consultancy service provider. It is considered to be among the more conceptual and thought provoking trend analysis agencies. Offering eye-catching trend books that contain a rich source of information presented in a tactile format, NellyRodi prides itself on its creativity and ability to be one step ahead in discovering the future. Due to the changing nature of the way that trend prediction services are offered, NellyRodi has more recently developed an online service called www.nellyrodilab.com. This provides constantly updated information on trends, lifestyles, and designers, and reports from all the major international fashion events. NellyRodi has also added to its service: a scent factory in which a scent development service is provided, and a unique marketing intelligence service called Marketing-Style®, where a marketing approach has been developed to assist brands to understand and track consumer behaviour and to then make use of the information to predict future lifestyle, fashion and consumer shopping habits and trends.

For more information see:

Fashion Artist- *Clothing Design* chapter.

Fashion Computing - *Flats and Specs - Women, Menswear, and Childrenswear* chapters.

Fashion Entrepreneur - *Market Research* chapter.

SYSTEMS

Les kids mixent les années 80 pour le côté punk des impressions animales avec les 90's ambiance techno et imprimés digital/fractal. Si les volumes restent simples et graphiques, les détails preppy - collants plumetis ou pied de poule, cabans et manteaux old school sophistiquent le look. La fièvre monte sur le Denim couleur avec une trame intérieure gold en mode disco.

Kids mix the 80's punk look of animal prints with 90's techno and digital/fractal prints. Though shapes remain simple and graphic, preppy details like satin-stitched or houndstooth tights, reefer and old-style school coats make the look more sophisticated. The fever rises in colored denim with a gold weft for a disco style.

KIDS AT GIGS

TONALITÉ 80 CADENCÉE PAR DES ROUGES ET ROSES CLUBBING, DANS UNE GAMME DE SOMBRES COLORÉS. RHYTHMIC 80'S RED AND CLUBBING PINKS IN A RANGE OF COLORED DARKS.

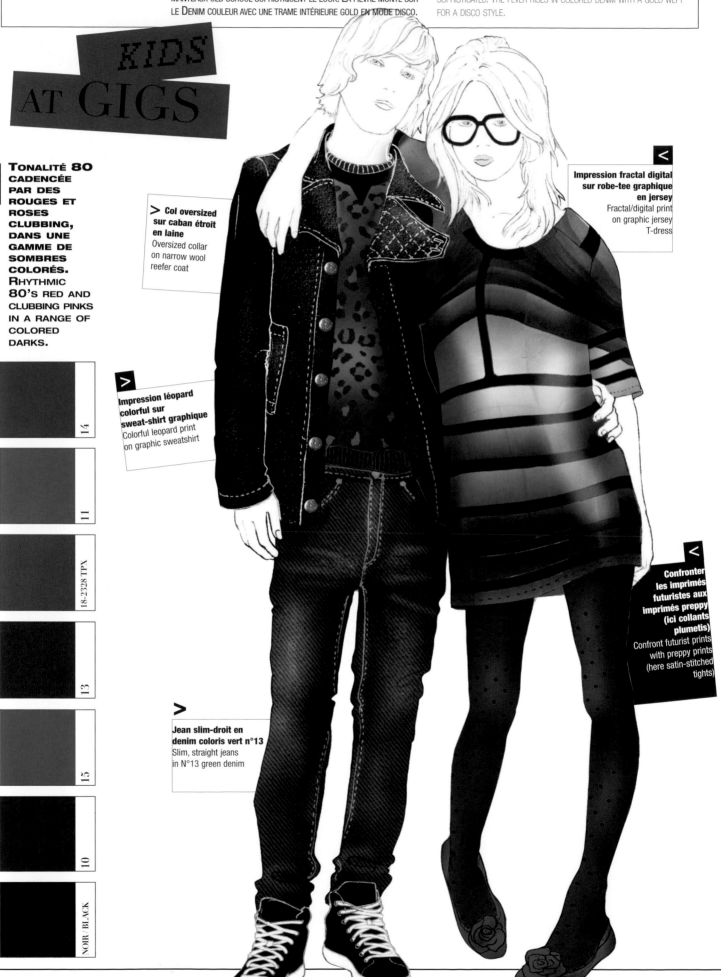

14

11

18-2328 TPX

13

15

10

NOIR / BLACK

> Col oversized sur caban étroit en laine
Oversized collar on narrow wool reefer coat

> Impression léopard colorful sur sweat-shirt graphique
Colorful leopard print on graphic sweatshirt

> Jean slim-droit en denim coloris vert n°13
Slim, straight jeans in N°13 green denim

< Impression fractal digital sur robe-tee graphique en jersey
Fractal/digital print on graphic jersey T-dress

< Confronter les imprimés futuristes aux imprimés preppy (ici collants plumetis)
Confront futurist prints with preppy prints (here satin-stitched tights)

5

Color and Fabric

Theory, Design, Sourcing and Selection

'I translate fabrics into soft and romantic silhouettes, using natural fabrics like silks and cottons, which are kind to the skin.' Akira Isogawa

The colors and fabrics you select for your designs are critical ingredients that need to work together to produce successful fashion products. They help create the appropriate mood of a collection and must be suitable for the particular season. For many designers, the colors and fabrics inspire their initial design concepts and, ultimately, the theme of a new season's collection.

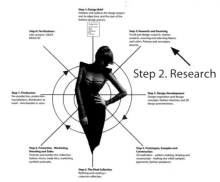

Figure 5.1: *Fashion Design Process (see p.15)*

Research suggests that, in store, a consumer's first response is to the color of a garment, followed by the design, fabric and feel, and then the price. As a designer it is therefore essential that you understand the basics of color theory and the properties and performance of fabrics and materials, as well as understanding your target market's reaction to certain colors and fabrics, as this will influence what you design.

This chapter will present color and fabric under the following headings:
- **Color theory and design** - the color wheel, the language of color, attitudes to color, and creating color palettes for your collections.
- **Fabric -** identifying fabric (types, qualities, construction, characteristics, properties, uses, performance, treatments and finishes).
- **Fabric sourcing and sampling** - selecting, sourcing and sampling suitable fabrics for your designs.

1. Color Theory and Design

This section introduces you to the basics of color theory and design. It will help you understand the 'language' of color and make informed decisions when creating color palettes for your designs and collections.

As a designer, you will consistently work with color when:
- Selecting color palettes for textiles, fashion collections and products.
- Mixing colors to create your fashion and textiles artwork and presentations.
- Working and communicating with those in the fashion and textile industries (textile designers, printers, fabric suppliers, buyers and the media).

Above, Fashion Illustrator Montana Forbes: *Slingback stiletto in leopard print.*

Opposite, Courtesy of **PROMOSTYL Paris,** from their Youth Market - Winter Trends book, theme *Kids At Gigs.*

The Color Wheel: The color wheel or color circle is a useful tool for color identification, selection, and mixing colors. There are several variations and interpretations of the color wheel; here we take one simple version. The following color terms relate to the color wheel (below).

Primary Colors: Refer to red, yellow and blue from which it is possible to mix all other colors of the spectrum.

Secondary Colors: Produced by mixing equal amounts of two primary colors to create orange, green or violet, e.g. red + yellow = orange.

Tertiary Colors (Intermediate): Produced by mixing a primary and secondary color, e.g. red + orange = red-orange.

Complementary Colors: Colors directly opposite each other on the color wheel, e.g. red and green.

Hue: The purest and brightest colors that form the full spectrum of colors ranging from; red, orange, yellow, green, blue, violet.

Value: The lightness and darkness of a color - a color value scale.

Intensity: The brightness (strength) or dullness (weakness) of a color.

Tint: Pure color mixed with white, e.g. red + white = a pink tint.

Shade: A pure color mixed with black or a darker hue, e.g. red + black = a darker shade of red.

Tone: Used to describe a tint or shade.

Temperature: Color can be described in relation to temperature:
• **Warm Colors:** Associated with fire, sun and passion – purples, reds, oranges, and yellows. These colors appear on one side of the color wheel, opposite the cool colors.
• **Cool Colors:** Associated with water, sky, spring, foliage - blues, blue-green. These colors appear on the color wheel opposite warm colors.
• **Warm** colors *advance*, whereas, **cool** colors *recede* (to understand this check out prints, paintings, interiors - everything around you).

Neutral Colors: Not associated with a hue. Neutral colors include blacks, whites, greys and browns.

Harmonious Colors: Also referred to as *Harmonies*, and combinations of colors as *Color Schemes*. These are colors that work together well, e.g. any two colors or two pairs of colors opposite each other on the color wheel.

Contrasting Colors: Two colors from different segments of the color wheel, for example, red is from the warm half of the color wheel and blue is from the cool half.

Psychology of Color

Research has shown that color brings about different feelings and emotions in people – they respond to color intuitively, emotionally and physically. A customer's decision to buy a certain product (garment, shoes, accessory) will be influenced by several factors including; their fashion awareness, culture, gender, age, skin tone, where they live (country, rural, city, seaside) the season, if they are working or on vacation, their type of work. Consider:
• **Warm colors** are said to be stimulating, passionate, fun - perfect for summer clothing, while **cool colors** are said to be calming and peaceful.

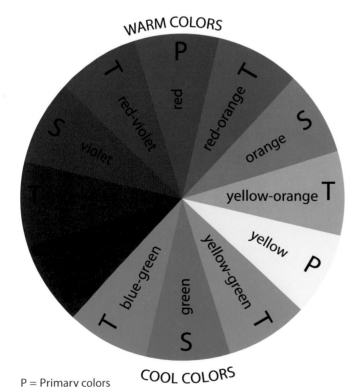

P = Primary colors
S = Secondary colors
T = Tertiary colors

Left and above:
The Color Wheel: *The first color wheel has been attributed to the English physicist, Sir Isaac Newton in 1666, during his experiments with light.*

Fashion Illustrator Sarah Beetson: *'Bike' - a fun wheel!! The colors used reflect the color wheel.*

- **Brights:** Can lift our mood, but too many bright colors together can look cheap, garish or loud.
- **Blues:** Blues and greens of nature can produce a calming effect, but *navy* blue is more sophisticated and classic, and *lime* green produces a more lively feeling.
- **Greys/grays:** Are cool and can either look very drab or professional and business like, whereas **silver**, especially a shiny, metallic silver, is cool like grey but livelier, more playful. Silver can be sleek and modern or impart a feeling of ornate riches.
- **Black:** Almost consistently in vogue, summer and winter. It is a great wardrobe staple as it goes with everything and, therefore, is included as a *basic* in most collections and product lines. Consider the *'little black dress'* which typically exudes sophistication and elegance; the same style, in bright red would appear more *fun* and less sophisticated; while black and red lace lingerie symbolises sexiness.

Color Selection

When selecting your color palettes, apart from being inspired by the colors and considering how they work together, there are several other decision-making factors:

- **Trends:** Color dictates the mood and attitude of the season. See the latest color, yarn and fabric trend reports presented at the various trade shows, forecasting publications and online – color palettes, themes, moods, new yarns etc.
- **Season:** Suitable colors for the season - white and brights typically sell better in summer and in hot climates where people are more relaxed or have a tan.
- **Event:** Suitable colors for a particular event – white wedding dresses would be more popular than black or any other color.
- **Target Market:** Color is directly linked to consumer aspirations. Consider who you are designing for; your customer profiles; their needs and expectations; their response to particular colors.

Color Management

PANTONE, Munsell and *Archroma* are known for their professional color management systems. They have helped set international standards for accurate color communication, matching and manufacturing along the whole fashion and textile chain from the textile mills, designers and brands, to the retailers. These systems are widely used across a variety of other industries; digital technology, architecture, interiors, paint, etc.

Colors are identified using a unique number. This makes accurate communication easier when specifying the exact colors to be used in a print or garment, enabling the printer or dyer to match the colors exactly. This is extremely important in the lingerie business, for example, where different materials and trims (laces, satins, elastic) are used together in a single garment.

Pantone is also known for their trend reports which present forecasted seasonal color palettes and are popular internationally within the fashion and textiles industry.

Left to right, Fashion Illustrator Montana Forbes, and Fashion Illustrator Nadeesha Godumunne: **Sunshine to Rain** - *illustrations present the temperature and psychology of colors - cadmium yellow, red, and orange evoke summer fun, and blues, greys and black a coolness and a more wintery feel.*

© Fashion Designer - Sandra Burke

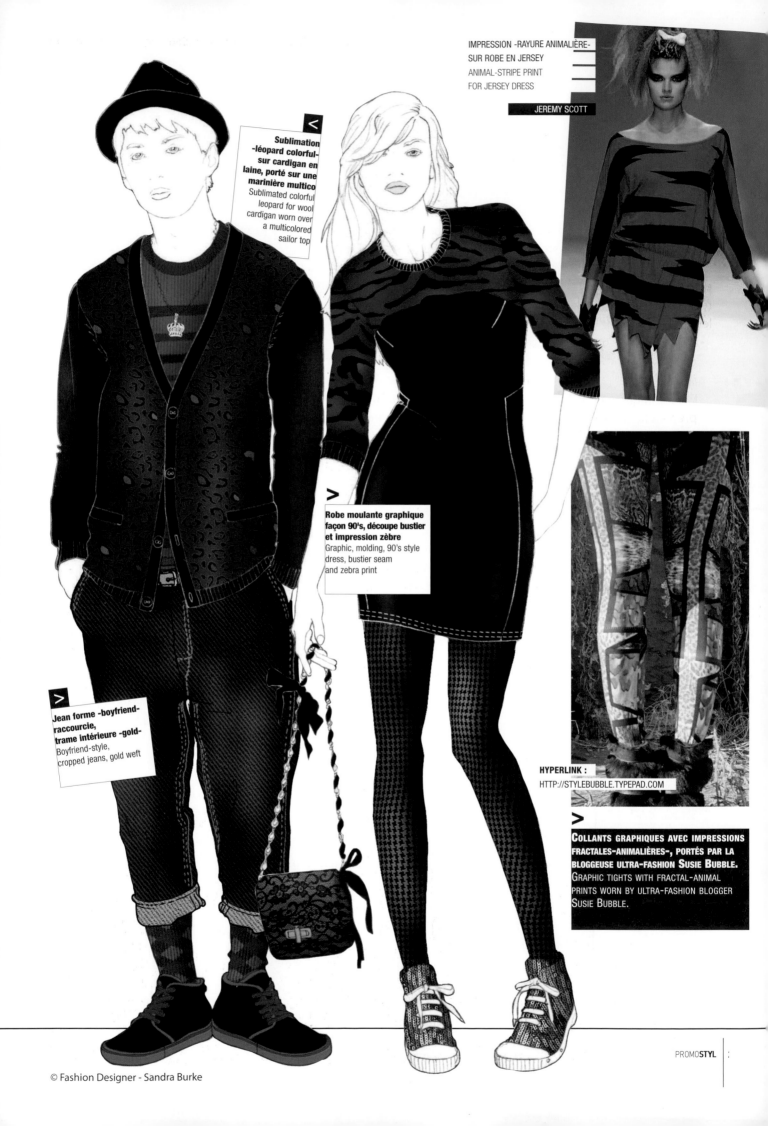

IMPRESSION -RAYURE ANIMALIÈRE-
SUR ROBE EN JERSEY
ANIMAL-STRIPE PRINT
FOR JERSEY DRESS

JEREMY SCOTT

**Sublimation
-léopard colorful-
sur cardigan en
laine, porté sur une
marinière multico**
Sublimated colorful
leopard for wool
cardigan worn over
a multicolored
sailor top

**Robe moulante graphique
façon 90's, découpe bustier
et impression zèbre**
Graphic, molding, 90's style
dress, bustier seam
and zebra print

**Jean forme -boyfriend-
raccourcie,
trame intérieure -gold-**
Boyfriend-style,
cropped jeans, gold weft

HYPERLINK :
HTTP://STYLEBUBBLE.TYPEPAD.COM

**COLLANTS GRAPHIQUES AVEC IMPRESSIONS
FRACTALES -ANIMALIÈRES-, PORTÉS PAR LA
BLOGGEUSE ULTRA-FASHION SUSIE BUBBLE.**
GRAPHIC TIGHTS WITH FRACTAL-ANIMAL
PRINTS WORN BY ULTRA-FASHION BLOGGER
SUSIE BUBBLE.

© Fashion Designer - Sandra Burke

PROMOSTYL

2. Fabrics

The ability to perfectly translate a 2D sketch of a garment into the desired 3D form comes with experience. Most importantly, the fabric must be chosen for its appropriateness and functionality (drape, handle, quality, etc.) as this will affect the silhouette and the whole look of the design.

When sourcing and deciding what fabrics you will use for your collection, you need to consider the following:

Fabric Properties, Characteristics and Quality: This includes the yarn content, construction, weight, texture, handle, drape, stretch, as well as additional performance factors which might include warmth, stain-resistance, ease of care (dry clean only, washable) preshrunk, etc. For example; the fabrics required for performance sportswear are very different to fabrics for general leisurewear.

 • **Labels:** All fashion products have to carry certain labelling; sizing, fibre content, care descriptions (each country will have particular labelling specifications that need to be followed).
 • **Fabric weight:** This is defined as a weight per unit area. The three predominant methods for specifying weight (yield) are measured in ounces per linear yard, ounces per square yard, and grams per square meter.

Suitability: It is important to match the fabrics' appropriateness for an individual design and/or a cohesive collection, including matching to the season, functionality, performance and form, theme and target market (see *Design Brief* chapter).

Textile Technology: Technological developments continuously produce new yarns, blends, finishes, treatments, dyeing and printing processes. Textile suppliers can offer fabrics that are no longer purely season-specific, but rather trans-seasonal fabrics. This is having a huge influence on the fabrics that designers use and the design of new products as they can design nonseasonal items that sell throughout the year.

Planning: Price, availability and delivery dates will also add to the fabric decision making process.

Opposite page, Courtesy of **PROMOSTYL Paris,** from their Youth Market - Winter Trends book, continuation of theme *Kids at Gigs*.

Below, Fashion Designer Nadeesha Godamunne: *'Trompe L'oeil' Collection - inspired by Cubism, experimenting with perspective to fool the eye. By using shift dresses that act as canvases, Nadeesha has created the illusion of many garments which effortlessly overlap each other. Nadeesha hand illustrated these prints.*

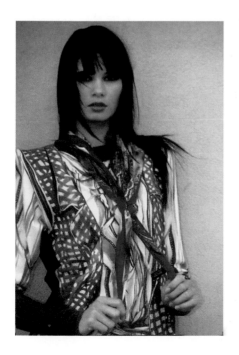
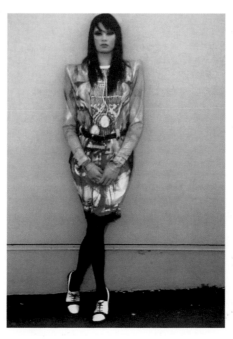
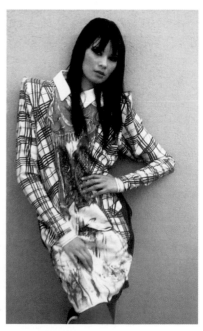

© Fashion Designer - Sandra Burke

Fibre and Yarn

Fibre, *natural* or *man-made,* is the raw material that is made or spun into yarn. **Yarn** is a continuous strand of twisted threads (fibres) used for the production of textiles.

Characteristics of yarn and, ultimately, the fabric are determined by:

• The length of the yarn fibre or **staple.**
• The method of spinning to create the yarn.
• The diameter of the yarn and the additional processes it goes through (twisting several yarns or different types of yarns, novelty yarns, etc.).

Natural Fibre sources are either:

• *Animal* (protein)
• *Plant* (cellulose)
• *Mineral*

Man-Made fibres are classified according to the source of the fibre:

• *Regenerated*
• *Synthetic*

Natural Animal Fibres are from animals' coats or hair. Depending on the type of animal and breed, as well as the climate they live in and what they graze on, different qualities of yarn are produced:

• Wool from sheep (merino), lambs, goats
• Mohair and angora from the angora goat, angora rabbit
• Cashmere from the kashmir goat
• Wool from alpaca, llama, vicuña (all llama family)
• Camel hair (often combined with wool).

Wool has good thermal properties, absorbs moisture, is lightweight, versatile, does not wrinkle easily, is resistant to dirt and is hard wearing.

Natural Protein Fibres are derived from the cocoons of silkworms to produce silk fibres. Fabrics include:

• Spun silk (raw silk), wild silk, Thai silk, dupioni, charmeuse, organza, crepe, chiffon, faille, georgette, marocaine.

Silk is versatile and comfortable as it absorbs moisture, is cool to wear in summer and warm to wear in winter, retains its shape, and is easily dyed.

Natural Cellulose Fibres are derived from plants' seeds, leaves, and stems to produce:

• Cotton - cotton fibres are from the cotton plants' seed pod
• Linen - linen is from flax, a bast (skin) fibre taken from the stalk of the plant
• Hemp, ramie, jute, bamboo - all of these fabrics are similar to linen but the plants are processed differently
• Coir (the rough outer covering of the coconut, and Sisal (leaf fibre) - used for non-apparel purposes.

Cotton is durable, has excellent breathable properties and absorbs moisture; perfect in hot climates.

Linen has similar properties to cotton but tends to crease more easily.

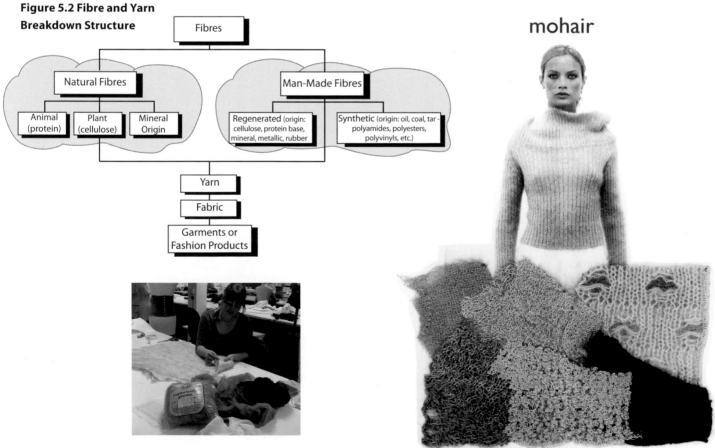

Figure 5.2 Fibre and Yarn Breakdown Structure

mohair

Organic Materials are raised or grown without the use of chemicals or pesticides. Due to the association with sustainability, a growing ecological awareness and environmentally friendly initiatives, this is a developing area globally. There are an increasing number of spinners and manufacturers offering organic fabrics which involve: sourcing materials from eco-friendly sources, devising production techniques which save energy and do not harm the environment, recycled and recyclable developments, ecological dyes, finishings and launderings.

Other natural materials include: Leather (skins and hides), fur, feathers, fish skins (leather), horse hair (for belts, lining).

Man-Made Fibres are made from:
- **Regenerated Cellulose** - extracted from plants and trees. Fabrics include; rayon/viscose (Modal), lyocell (Tencel), acetate, triacetate, (nylon, polyester, acrylic).
- **Synthetic Fibres** - made from oil, coal or coal tar. Fabrics include; Nylon (polyamide), polyester (Trevira®, Terylene®, Dacron®), Acrylic (polyacrylic) (Orlon®, Acrilan®, Courtelle®), Polyurethane (elastane fibres, Spandex, Lycra® for comfort and stretch in jeans, underwear), Polyvinylchloride (PVC leather substitute).

These fabrics have various properties including soft handle, drape, greater strength and durability, and are used for lingerie to outerwear to sportswear.

Fabric Blends consist of two or more different types of fibres twisted or spun together. Blending adds to the quality of the final product which might include; durability and strength to withstand wear and tear and multiple washes, less shrinkage, ease of care, a softer more luxurious feel and more comfortable to wear, crease resistant. Examples of blends include; cotton/polyester, nylon/wool, nylon/acetate, silk/wool, ramie/acrylic, wool/synthetics, wool/cotton/polyester/lycra blends.

From opposite page left to right, Figure 5.2: *Fibre and Yarn Breakdown Structure*

Fashion Design student, AUCB (Bournemouth): *Working on a design brief using organically grown materials for her collection.*

Fashion Consultant Paul Rider *and* Knitwear Designer Erika Knight: 'Mohair' *presentation displays various knit technique/stitches and color story.*

Illustrator Montana Forbes: *Selecting the correct fabric quality is vital when trying to achieve a specific silhouette and overall look of a garment and outfit; Dress features a large bow that stands out from the body - taffeta or satin would be suitable; Top and pant/leggings, body hugging outfit - stretch fabrics are required for an excellent fit - Elastane fibres, Spandex, Lycra® would be suitable; Dress with shrug - faux fur or real fur could be used - feathers could be an alternative. The body hugging dress could be made in stretch satin or silk jersey.*

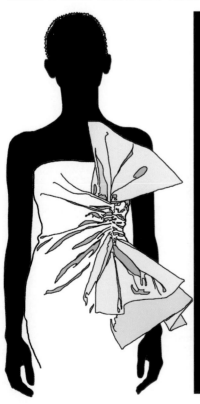 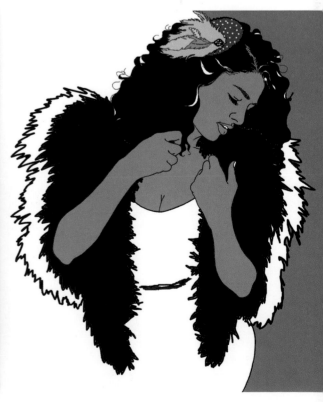

Fabric Construction and Production

Fabrics made from yarns are classified as;
• Woven • Knits • Nonwoven

Woven Fabrics are created by *interlacing* a set of longer threads that run down the length of the fabric, known as the *warp* or *lengthwise grain,* with a set of crossing horizontal threads that weave across the breadth of the fabric, known as the *weft* or *cross grain.*

Cloth is woven on a loom, which holds the warp threads in place while the filling weft threads are woven through them. The way the warp and weft interlace with each other is called the weave. The type of weave, as well as the type of yarn used, will make a difference to the way the fabric drapes, handles and behaves.

The **selvage** or **selvedge** is the lengthwise/warp edges of fabric as it comes out of the loom. It provides a stable edge to the fabric and prevents it from fraying. Garments are usually cut out parallel to the selvedge for stability and structure.

Right Side - Most fabrics have a *right* (outside of garment) and *wrong side* (usually used on the inside of garment).

The **true bias** is the diagonal or 45 degree angle across a piece of woven fabric. *Bias-cut* or *cut-on-the-bias* refers to the way a garment is cut, providing greater elasticity and drape and to accentuate the body lines and curves. Bias cut is used for skirts, dresses, neckties, piping and bound seams.

Weave Types: Most woven products are created with one of the following three basic weaves; *plain weave, satin weave* and *twill weave.*

• **Plain Weave** is the simplest, most common weave; the warp and weft are aligned forming a simple criss-cross pattern**.** Plain weave fabrics include; calico, chiffon, organza, shantung, taffeta, broadcloth and flannel (plain and twill).

• **Twill Weave** is woven with a pattern of diagonal parallel ribs to create the characteristic diagonal pattern. Twill fabrics technically have an obvious front and back, unlike plain weave where both sides are identical. Twill weaves include; chino, drill, denim, gabardine, tweed and serge. Herringbone is a twill with ribs on both sides.

• **Satin Weave** is distinguished by its lustrous sheen or *'silky'* appearance, feels smooth to the touch, has good draping qualities, but a tendency to stretch. Satin weave is created by the relatively long warp yarn floats. Fabrics with satin weave; satin, slipper satin, brocades (the pattern may be satin on a twill ground or twill on a satin ground), and crepe-back satin (satin weave on the face and a crepe effect on the back).

Other types of weaves include:

• **Pile Weave:** A decorative or fancy weave where a pile is formed by additional warp or filling yarns interlaced so that loops are formed on the surface or face of the fabric. The loops may be left uncut (towelling), or they may be cut to expose yarn ends and produce cut pile fabric (corduroy, velvet, fake-fur/ faux fur).

• **Jacquard Weave:** Produces intricate patterns or figures all over the fabric. Woven on a jacquard loom, they can be expensive as the weaving operation is very slow. Fabrics with jacquard weave include; brocade, damask and tapestry.

Far left, Denim Fabric: *Shows* the *warp* or *lengthwise grain,* weft or cross grain, selvage or selvedge, *true bias selvage/ selvedge, right and wrong side.*

Left, top to bottom, Fabric Weaves: *Plain, twill, herringbone, tweed, bouclé (bouclé yarn may be used in both the warp and weft or just in the filling).*

Right, Fashion Designers Natalie Holme, Jinny Howarth and Farah Hussein, photographer Mike Anderson: *FASHION Decoratif Image - nonwovens - inspiring designs using nonwovens.*

Knitted Fabrics

Knitted fabrics are constructed from the *interlocking* of loops of yarn lengths. Horizontal rows are called *courses*, vertical rows are called *wales*.

Weft Knits are made by hand or machine by looping together the lengths of yarn. If a stitch is dropped in the knitting process, or cut, it is likely to ladder down the length of the wale. Weft-knitted fabrics are used for socks, T-shirts and sweaters.

Warp Knits are made by machine using a more complicated method of loops that interlock vertically along the length of the fabric. Warp knits generally have less stretch than weft knits and do not unravel. Typically used for sports clothing, swimwear and lingerie.

Knit Properties: Different yarns, needles and stitches achieve various textures, weights, and structural integrity. The 'open' structure of knits means they tend to 'breathe' keeping the body warm or cool according to the yarn used.

The knitting process creates stretch in both directions and crosswise providing elasticity with good draping and crease resistant properties.

Knitted fabrics include:
- Single Jersey – lightweight and ideal for T-shirts and lingerie.
- Double Jersey and interlock – usually made as a reversible fabric, more stable, good shape retention, cut edges do not curl.
- Ribbing - used to help to shape a garment, pull the fabric in, or used as a trim (on knits and wovens), for waistbands, necklines, cuffs, collars.
- Knit stitch and types - Plain and Purl, Moss stitch, Fair Isle, Intarsia, Aran.

Construction Methods: Knitwear can be constructed into garments using three key ways;
- Cut and Sew - as a fabric length where the garment pieces are cut and assembled.
- Fully fashioned - garment pieces knitted as a shape then sewn together.
- Circular knitting - knitted in three dimensions, a seamless tube, involving little or no seams.

Note: Careful laundering is essential as, due to the construction, knits can lose their shape.

Nonwoven Fabrics and Other

Nonwovens are produced by interlocking or bonding fabrics together, accomplished by mechanical, chemical, thermal processes or by solvents. Generally, made from fibre rather than yarn and do not fray or unravel. Examples include; felt, rubber, PVC, plastic, nonwoven interlining and interfacing, fusible linings (Vilene®).

- **Felt or felting** involves pressing a mat of fibres together and working them until they become tangled. Felt products include; hats, slippers, shoes, bags, skirts, jackets and coats.

The following types of fabric making can also be considered as crafts.
- **Lace:** Made by interlocking threads to create a fine fabric with open holes in the work. Made either by hand or machine - bobbin lace, needle lace, cutwork, tatting.
- **Braiding** or **plaiting** involves twisting threads together into cloth.
- **Crochet** involves looping yarn or thread using a crochet hook (hooked needle).
- **Macramé** involves weaving and knotting cord to form a pattern.
- **Knotting** involves tying threads together, e.g. **macramé**.

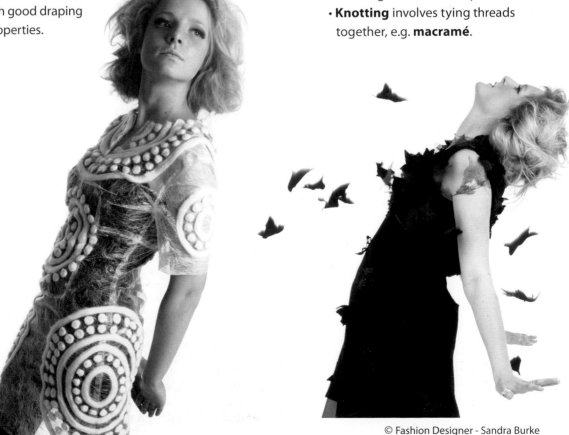

© Fashion Designer - Sandra Burke

Surface Design and Treatments

As the word *Surface* implies, many of the processes (finishes, embellishments) are applied after the fabric has been made and dyed, or the garment has been constructed. This includes:

• Printing (print and pattern)
• Dyeing
• Finishing treatments
• Embellishments and special processes (embroidery, appliqué, cutwork, beading, fabric painting, quilting, smocking, hand-tooled leather, etc.).

Note: Some traditional hand and machine methods, dating back centuries, are still used today and can be considered as crafts.

Printing and Dyeing: Printing is the application of patterns and designs to decorate the surface of a finished fabric or product. Printed designs do not generally penetrate to the back of the material except on certain fabrics (transparent, fine fabrics) where the design might show through; and *duplex* printing, which is a method for printing on both sides of the fabric. Printed fabrics should not be confused with yarn-dyed fabrics where the yarns are dyed prior to weaving or knitting and creating a pattern.

Methods of Printing: The three main fabric print processes are; direct (overprinting), discharge and resist.

Other methods of printing, which might include one of the above techniques are; block printing, roller printing (engraved roller printing), duplex printing, stencil printing, screen printing, transfer printing (heat/paper transfer), blotch printing, jet spray printing, electrostatic printing, dye sublimation printing, photo printing, differential printing, warp printing, batik dyeing, tie dyeing, airbrush painting (spray), digital printing and laser printing.

Other decorative printing techniques for special embellishments using materials such as glues, special inks (expanding inks, glitter), and chemicals include; flock/foil printing, rubber/puff rubber print, burn-out, metallic, Caviar bead printing, gloss, suede.

Types of print include; mono, motif, repeat, one-way, placement prints, logos.

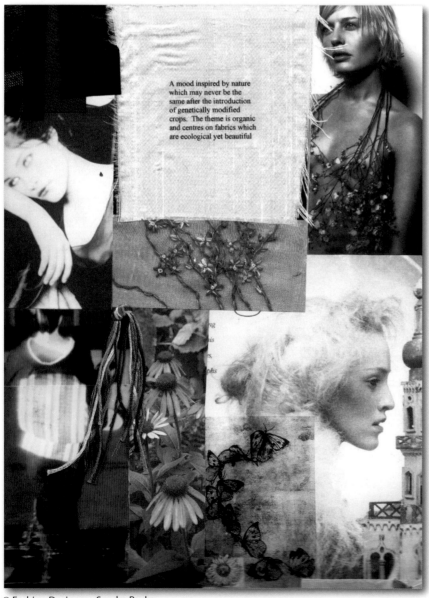

Fashion Designer Kathryn Hopkins: 'Organic' *Mood Board - fabrics and colors include; natural, embellished fabrics, silk chiffon, silks and linens; fabric swatches of fine lightweight linen, embroidered linen, silk embroidery threads for color, lace butterflies.*

Fashion Designer Camilla Ruiz Ramirez: *Tie-dye and batik dresses cotton dresses from her S/S collection. Camilla uses ethical and sustainable local fabrics.*

Fashion Designers Bruno Basso and Christopher Brooke, London Fashion Week, S/S, Ready-to-Wear collection: *Basso & Brooke are renowned for producing unique and inspired textiles and prints. Their aesthetic is based on advanced and complex digital prints which they combine to create a fabric-focussed fashion statement.*

Dyeing: Fabrics are typically yarn-dyed or piece dyed. Piece dyed means the grey goods (or greige goods) can be dyed, printed or finished according to the fashion trend or the manufacturers' requirements. Garments can also be constructed first and then finished (dyed, a special wash etc.). As the fabrics/garments might shrink using this method, tests need to be carried out and, when making the patterns, allowances given for shrinkage. The two main dye types are synthetic and natural dyes.

Dyeing Process: This includes; direct dyeing, disperse dyeing, pigment dyeing, dip-dye or space-dye, and cross-dyeing.

Treatments and Finishes: Many special wash and heat treatments are particularly suited to the treatment of the robustness of denim fabric and denim products but can also be applied to other fabric types and/or garments. These include; bleaching, blasted, sand blasted, glass blasted, blue blasted, snow-washing, stone washing, thrash-washing, creased and wrinkle effects, suede, sanded, brushed, washer (more worn-in look) and for soft finishes.

Innovation: Innovative technological developments in printing methods (machinery, chemicals, inks etc.), and the change from traditional hand design work to the use of *CAD* systems (*Photoshop* and *Illustrator* included) have meant that the textile industry is continuously offering newer and faster processes and, consequently, new yarns, fabrics and treatments.

© Fashion Designer - Sandra Burke

Innovative Fabrics and the Future

Recently many innovative fabrics have been introduced into the market place because of the demand by the consumer for both function and fashion. This demand has been fuelled by current lifestyles - more informality in dress and the increased interest and participation in sport and leisure activities. Consequently, this has helped grow the sportswear and activewear markets, and the streetwear and denim markets. The growth has also been increased due to the arena for competition between fashion and textile designers, manufacturers, and scientists internationally.

Smart and Intelligent Textiles and Phase-Change Fabrics: These are fibres and fabrics that can sense the environmental conditions or stimuli and can also react and respond to those conditions. The fabrics are used in high performance sports/ activewear and outdoor gear (windbreakers, even beanies), and a growing number of fashion products.

Gore-Tex is probably the best known original *smart fabric* due to its excellent waterproof and breathable properties.

The fundamental job of clothes is to keep us warm or cool, but that job has taken on an additional meaning with smart, high-tech fabrics that do everything from moulding themselves to the wearer to generating electricity. There are fabrics and clothing that not only withstand the washing process while still maintaining the garment's properties for longer, but also:

- Have increased resistance to spills, wrinkles and odours (odour eaters with added anti-bacterial properties) and can be worn for longer between washes.
- Have a permanently pleasant smell even when washed; fabrics impregnated with vitamins, insect repellents; with moisturising properties; even hosiery that reduces cellulite.
- Help the athlete to perform better (train harder and recover faster) as in compression apparel products for performance sports.

- Monitor and regulate physiological states including temperature, heart rate, even a person's emotional state - temperature sensitive textiles (heat-modifying textiles).
- Have Internet connectivity - can be connected to a database that analyses the data to work out if the wearer has something medically wrong and to allow the wearer to be monitored.
- Have an in built MP3 player to listen to music.

Performance fabrics include; Polyurethane (PU) coatings, water-resistant taffeta, innovative synthetics, bi-stretch, honeycomb structures, high shine nylon, and metallic flecks.

Fashion: Many of these new fabrics are already in evidence on the chic streets of the world's fashion capitals. Nanotechnology is offering fashion houses a new way of processing fabric and revolutionizing the clothing industry. The future of textiles suggests that smart fabrics will form part of our everyday lives providing comfort, protection and function.

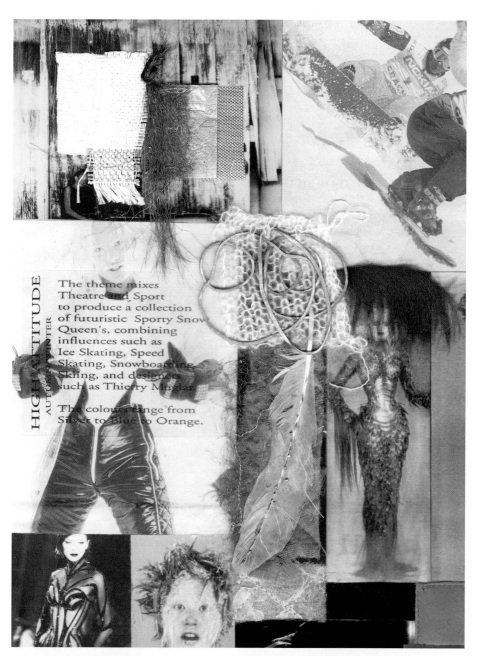

HIGH ALTITUDE
AUTUMN / WINTER

The theme mixes
Theatre and Sport
to produce a collection
of futuristic Sporty Snow
Queen's, combining
influences such as
Ice Skating, Speed
Skating, Snowboarding
Skiing, and designers
such as Thierry Mugler.

The colours range from
Silver to Blue to Orange.

Fashion Designer Kathryn Hopkins:
Designs for the future. Fabric/Color Mood Board themed 'High Latitude'. Features include; metallic threads and fabrics, stretch, woven, knit, bonded and high performance fabrics for sport, leisure and luxe fashion. Mixing natural fabrics and futuristic looks makes the designs available for multiple markets.

Far left to right, Fabric and Textiles - Designers of the Future:

Royal College of Art (RCA) MA *student experiments with plastics, fringing and modelling to create innovative form and function.*

University of Plymouth Colleges Somerset *student experiments with origami pleats and laser cuts using paper, plastic and the printed image to create 3D form.*

RCA MA *student in the textiles printing room experiments with fabric treatments.*

RCA MA *student creates intricate graphics with fine detailing and scroll effects inspired by imposing eagles and nature.*

© Fashion Designer - Sandra Burke

3. Sourcing, Selecting, Sampling

Selecting the fabric you use in your collections is an exciting part of the design process and can stimulate your design ideas for your whole collection. But it can also be the most challenging as you trade-off fabric qualities, budgets and minimums.

Fabric selection: As discussed, fabrics vary greatly in their quality, properties and performance dependant on the yarn and the way they are produced, dyed and treated and this, of course, affects the price. Therefore it is essential that you collect as much information as you can when selecting your fabrics for sampling and production, and also choose the most suitable fabrics for your designs. Your criteria are ultimately:
• Knit or woven
• Fabric construction
• Fabric weight
• Fabric content
• Fabric color
• Fabric price.

In industry, the amount of involvement you have in the sourcing and selection of fabrics will depend on if you have your own small business, or are the sole designer in a company or in a design team. In large companies you might have a fabric merchandiser who will research and source the latest and most suitable fabrics plus take care of the purchasing.

Fabrics and trims can be sourced and purchased through various avenues:
• Yarn, Textile and Fabric Trade Shows
• Textile Mills
• Textile Converters
• Fabric Representatives/Agents
• Fabric Wholesalers
• Fabric Jobbers.

Fabric and Yarn Trade Shows:
Fabric and Yarn trade shows are held all over the world at set times during the year (see the *Fashion and Textiles Calendar, The Final Collection* chapter). Textile mills, manufacturers and agents, forecasting/trend companies, come together to showcase their latest developments and continuing lines of yarns and fabrics. Première Vision (Paris) is one of the biggest fabric fairs. But there are many other events throughout the world; the Turkish Fabric Fair, Texworld (USA), etc. Even if you do not order fabrics from these shows, they are an excellent source of research and inspiration.

Textile Mills: Textile mills produce the fabrics and tend to specialise in specific fabrics. They sell direct to manufacturers and wholesalers or have agents to represent them.

Textile Converters: Textile converters buy unfinished greige goods and dye, print and treat the fabric themselves. They work closely with manufacturers and designers.

Fabric Representatives/ Agents: Fabric reps or agents tend to represent several fabric manufacturers. They do not carry stock but display fabric ranges in swatch form, as swatch cards and as fabric headers, and negotiate orders and deliveries for manufacturers and designers.

Fabric Wholesalers: Fabric wholesalers are suppliers of finished goods from mills and converters. They carry stock, but once the fabric is sold they generally cannot offer the same fabric type or colour again.

Fabric Jobbers: Fabric jobbers purchase leftover stock fabrics and ends of lines from mills, manufacturers and designers. They resell the fabric to retail outlets, markets and small fashion businesses at a low cost and with immediate delivery. This source can be perfect for small business fashion entrepreneurs and students.

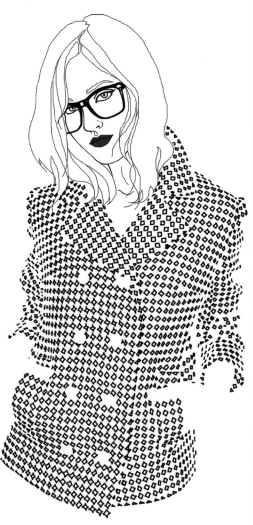

Above, fabric sheet *with sample swatch and relevant fabric details, supplier and quality details.*

Right, Fashion Illustrator Montana Forbes: *Houndstooth, lightweight wool, soft tailored double-breasted jacket; it could look equally stunning in the pinstripe above.*

Swatches and Sample Lengths:
Color and swatch cards from textile companies and agents are available to help make initial fabric decisions. Sample lengths of fabric are then ordered to test out the fabric in the actual sample garment. If the fabric meets the design requirements more sampling fabric would need to be readily available to enable further samples to be constructed to complete the collection.

Minimums: Most suppliers require a minimum order for sampling and for bulk fabric/bulk yardage for production, along with minimum lengths for the various colorways for production.

Purchasing Fabric: Other factors to consider before purchasing the fabrics for a collection include:

• **Lead Times:** Establishing availability and lead times for delivery for bulk fabric, especially if it is not stock fabric and needs to be woven, printed, dyed or treated before being shipped.
• **Price:** The price of sampling is typically higher than the bulk fabric. Prices can be negotiated for bulk fabric for larger production runs.

For more information see:

Fashion Artist- *Fabric Rendering* chapter.

Fashion Entrepreneur - *Design and Production Cycle* chapter.

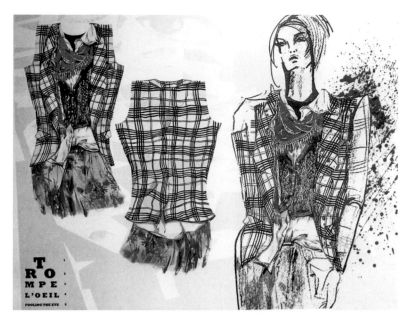

Above, top down, Fashion Designer Nadeesha Godamunne: *This collection features printed geometrics, checks, stripes and graphic shapes on silk.*

RCA, Designer and Professor: *Working on a design brief in the design studio - selecting colors, fabrics and stories for a design presentation.*

Fabric agent and wholesaler: *Sample lengths of denim weights and finishes are kept on the floor for sampling. The fabric headers above represent the various fabric qualities and types that can be ordered as sampling and bulk fabric.*

© Fashion Designer - Sandra Burke

Silhouettes, Styles, Details
the Language of Fashion

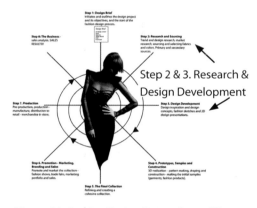

Fashion designers are very aware of the phrase, 'The details make the difference.'

Figure 6.1: *Fashion Design Process (see p.15)*

During the design development process, fashion designers require a portfolio of hand and digital drawing, illustration and design skills to communicate and present their designs. In addition, they need to speak the language of fashion - the terms for various fashion clothing silhouettes, styles and details.

This chapter will present:
- A croquis figure template - to use as a template when sketching your designs.
- Flats - an introduction to flats and how they are used in the fashion industry.
- Clothing styles and details - silhouettes and shapes, drawn as flats. These can be used as guidelines when developing your designs.
- The accepted fashion industry vocabulary and terms to describe these styles and their details.

Opposite page, Fashion Designer and Illustrator Laura Krusemark: Paris Haute Couture *(www.laurakrusemark.blogspot.com).*

Right, Fashion Designer Cherona Blacksell: *This red-carpet dress features a low back draped into a tie sash with soft draped cowl detailing on sides.*

© Fashion Designer - Sandra Burke

1. Croquis Figure Template

Croquis is a French word simply meaning a *sketch*. In fashion design the croquis figure template can be used as a guide when drawing garments during design development, for technical specifications (specs), for production purposes (see *Design Development* chapter).

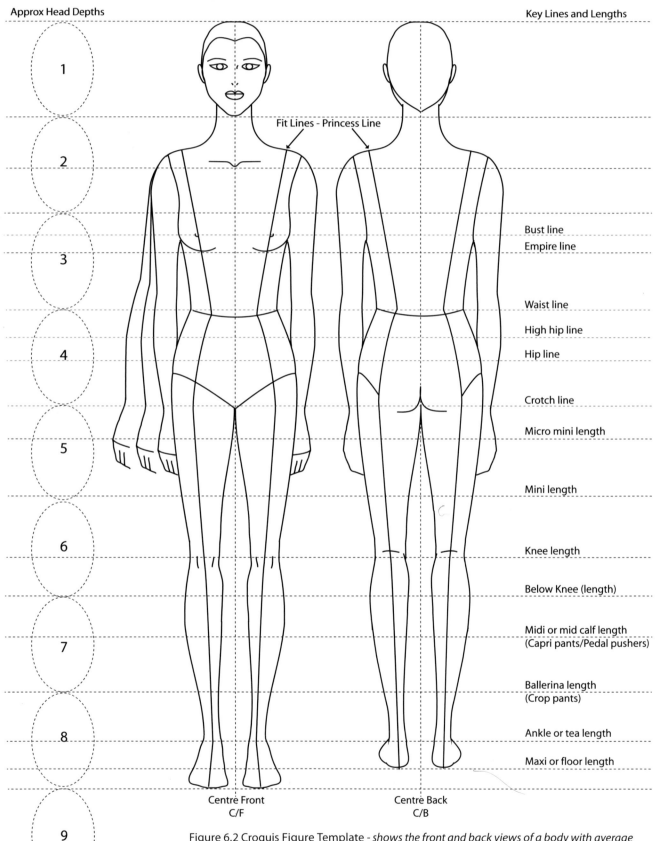

Approx Head Depths

Key Lines and Lengths

Fit Lines - Princess Line

Bust line
Empire line

Waist line

High hip line

Hip line

Crotch line

Micro mini length

Mini length

Knee length

Below Knee (length)

Midi or mid calf length
(Capri pants/Pedal pushers)

Ballerina length
(Crop pants)

Ankle or tea length

Maxi or floor length

Centre Front
C/F

Centre Back
C/B

Figure 6.2 Croquis Figure Template - *shows the front and back views of a body with average proportions (7.5 - 8 heads depth). Note: Every manufacturer produces fashion apparel/garments for a particular target market and, therefore, will have developed specifications of their own in regard to their customer figure type. Consequently there is no one standard - template.*

Croquis Template: Lynnette Cook and Sandra Burke

A standard method for measuring the body is in head depths - 7.5 to 8 heads for a technical template where normal body proportions are required; 9 head depths or more (where the legs are lengthened) for a more stylized fashion sketch or illustration. The croquis figure template, Fig. 6.2 front and back view, reflects normal body proportions. The style lines correspond to the dress form and are the fit and construction lines from which clothing patterns and garments are made; bust line, waist line, hip line, etc.

You can use this front and back croquis as your guide, but as you become more proficient in drawing you will find you do not need to use the template, you might even develop your own version.

2. Flats

Flats (also called working drawings, technical sketches) are self explanatory line drawings of garments. They are normally presented front on, with back and side views where required.

In the fashion industry, flats are a primary visual source to communicate the style and details of a design between designers, pattern makers, sample machinists and the production team. Flat drawings are also used for presentation work , catalogues, and line sheets for the sales, marketing and buying teams (see *Design Presentations* chapter).

Flats are the visual **international fashion language**. Therefore, it is essential fashion designers are able to draw accurate, well-proportioned flats.

Hand and Computer Generated Flats: Generally, a hand drawn flat has a more fluid style of line compared to a flat drawn digitally using the computer. The design brief will state the objective for the flat which will help determine the method used. For example, the end purpose might be for a highly technical spec drawing for production where it is best to use a computer, or a more artistic style for a design presentation where hand drawing is more appropriate.

Technical flats for specifications sheets (specs), used in the manufacturing and production process, are drawn to scale, with no exaggeration of detail as you would find in a more stylized fashion presentation. All construction lines, such as, seams, darts, and styling details (pockets, buttons, and trims) are represented.

Digital flats have become one of the most efficient methods to communicate designs from the fashion designers' desk to the design team and production, and to the buying, merchandising and marketing teams, in-house and offshore.

In the fashion industry (and fashion education) Adobe Illustrator™ has become a popular, vector based, off-the-shelf computer package that fashion designers can use to draw and render their designs.

The following clothing styles/flats have been digitally drawn using Illustrator™ but could have been drawn using other vector based programs (CorelDRAW™, Kaledo [Lectra]) or hand drawn.

See the *Design Development, Design Brief, Design Presentations, Design Studio* chapters, and Appendices *Design and Production Process* for more style and seam details, flats and specs.

ROSINA BELLA TAILORING

Fashion Designer Amy Lappin:
Presentation work where hand drawn flats have been used for a more fluid, artistic style.

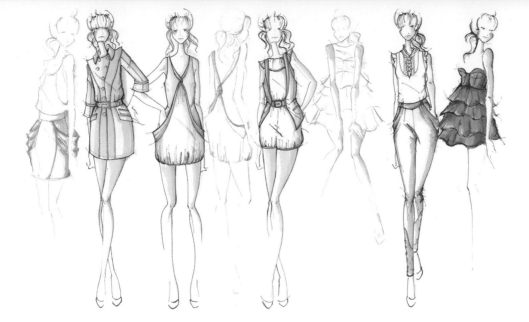

3. Clothing Styles and Details

The following flats present basic garment/fashion styles and details. As a starting point, these can be used for reference to help you develop your own designs and technical drawings. Design changes can be made to them by altering the silhouette, styling details, shape and fit lines.

See the *Design Development* chapter and the sections on *Design Elements* and *Design Principles*.

Guidelines for Drawing Flats

• Start with the silhouette or outline, followed by the details.
• Draw from the top down to help achieve the correct silhouette.
• A ruler and French curves aid accuracy of line when hand drawing.
• To achieve symmetrical left and right sides of the garment, draw one side and then copy to other side. When hand drawing use semi transparent/tracing paper fold down the middle and trace.

On computer using *Illustrator*: Select>copy>paste in place>reflect.
• To help achieve correct proportions draw on graph paper or a grid.

Bikini/Lingerie

One-piece Tankini Two-piece Bikini

Flats courtesy of Penter Yip, Fashionary - http://fashionary.org

Bikini/Lingerie: These bikini/swimwear styles and silhouettes could also form basic styles for lingerie or underwear. Terms would include; bodysuit, camisole and hipster brief, sports bra and hi-leg brief or panty, triangle bra and tanga.

Top, Fashion Designer Cherona Blacksell: *Line up for a womenswear diffusion range.*
Middle, Fashion Design Instructor Shari Schoop: *Tee shirt grid example*

Dresses

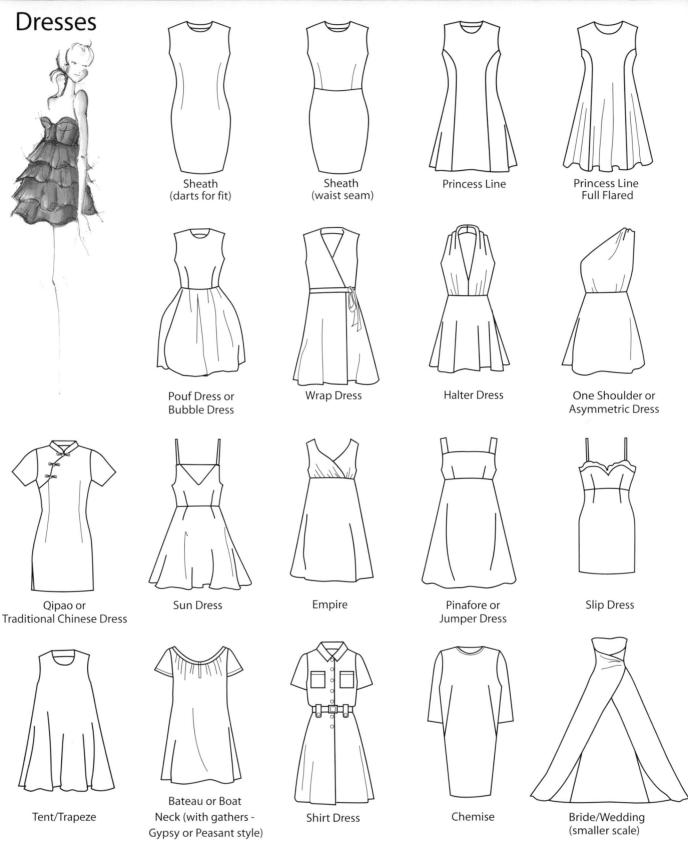

Sheath (darts for fit)

Sheath (waist seam)

Princess Line

Princess Line Full Flared

Pouf Dress or Bubble Dress

Wrap Dress

Halter Dress

One Shoulder or Asymmetric Dress

Qipao or Traditional Chinese Dress

Sun Dress

Empire

Pinafore or Jumper Dress

Slip Dress

Tent/Trapeze

Bateau or Boat Neck (with gathers - Gypsy or Peasant style)

Shirt Dress

Chemise

Bride/Wedding (smaller scale)

Flats courtesy of Penter Yip, Fashionary - http://fashionary.org

Dresses: These dress styles and silhouettes include the following details:

Fit - darts, flare, princess lines, waist seams, asymmetric, wraps, tucks, draping, empire lines, gathers.

Collars and necklines - round neckline, halter neck, mandarin collar, square neckline, boat neck, shirt collar.

Sleeves and cuffs - sleeveless, set in sleeve, straps.

Features - tied wrap, frog fastening, bound neckline, shirt style details, strapless and shaped inserts/detailing (bride).

Shirts and Tops

Plain	Pleated/Pin Tuck Front	Bib Pin Tuck Front	Tuxedo	
Ruffle Front	Fitted or Shaped Shirt	Cowboy	Military	
Camp Shirt (Hawaiian Shirt when in printed fabric)	Bowling	Knit Polo	Fitted Vest or Waistcoat	Peplum
Henley or Grandpa Top	Gypsy or Peasant	Smock	Cossack	Sailor

Flats courtesy of Penter Yip, Fashionary - http://fashionary.org

Shirts and Tops: These shirt, blouse and top styles and silhouettes include the following details:

Collars and necklines - shirt collar, rounded shirt collar, stand wing, polo, round neckline, stand collar, sailor collar.

Sleeves and cuffs - shirt sleeve, flared sleeve, raglan sleeve, dropped shoulder, buttoned cuff, turn back/wing cuffs, elasticated sleeve hem, double ruffle, bound hem, piping detail.

Pockets - breast pocket, patch pockets with flap, patch pockets with button detail.

Features - pin tucked fronts, ruffled button front, flared peplum, tie neckline, asymmetric side button plackets, elasticated finishes.

Skirts

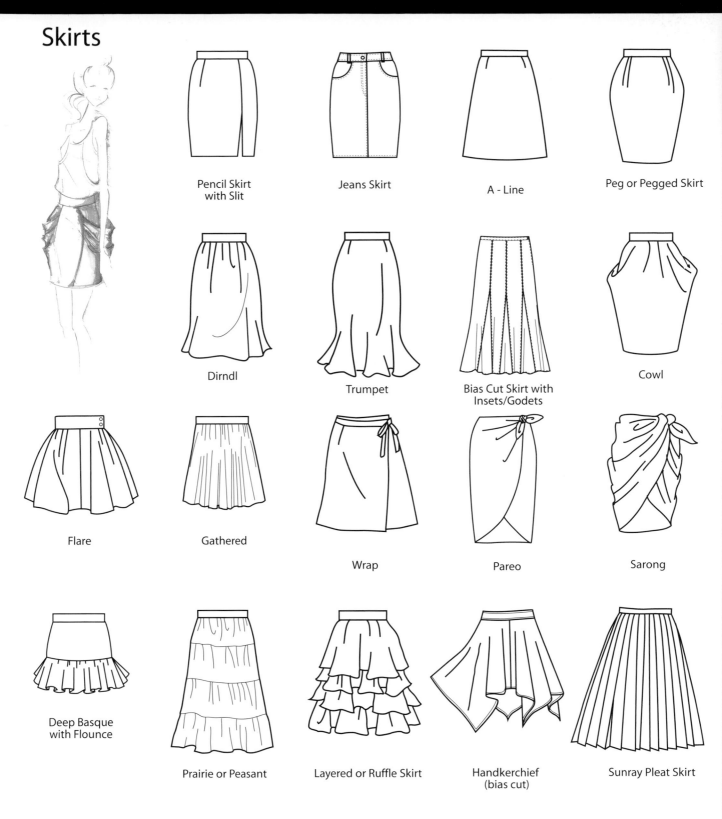

Pencil Skirt with Slit

Jeans Skirt

A - Line

Peg or Pegged Skirt

Dirndl

Trumpet

Bias Cut Skirt with Insets/Godets

Cowl

Flare

Gathered

Wrap

Pareo

Sarong

Deep Basque with Flounce

Prairie or Peasant

Layered or Ruffle Skirt

Handkerchief (bias cut)

Sunray Pleat Skirt

Flats courtesy of Penter Yip, Fashionary - http://fashionary.org

Skirts: These skirt styles and silhouettes include the following details:

Shape and fit lines - darts, gathers, tucks, pleats, drape, bias cut, godets and knife pleats.

Waistbands - standard waistbands, deep waistbands, grown on waistbands.

Pockets - front hip or front curved pockets, draped pockets.

Closures and fastenings - front zip fly, side buttoned waistband, tie belt, tied front wrap.

Features - side front slit, topstitching, jeans styling details, side tie wrap fronts, handkerchief hemline.

Pants

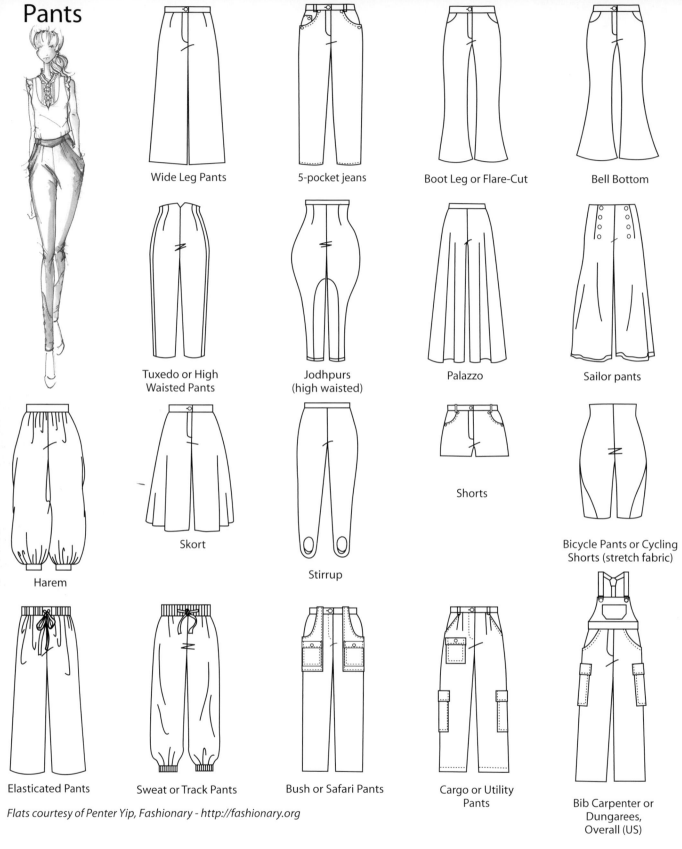

Wide Leg Pants

5-pocket jeans

Boot Leg or Flare-Cut

Bell Bottom

Tuxedo or High Waisted Pants

Jodhpurs (high waisted)

Palazzo

Sailor pants

Harem

Skort

Stirrup

Shorts

Bicycle Pants or Cycling Shorts (stretch fabric)

Elasticated Pants

Sweat or Track Pants

Bush or Safari Pants

Cargo or Utility Pants

Bib Carpenter or Dungarees, Overall (US)

Flats courtesy of Penter Yip, Fashionary - http://fashionary.org

Pants: These pant styles and silhouettes include the following details:

Waistbands - high waisted grown on waistbands, elasticated waistbands.

Pockets - front curved, slant, cargo, patch pockets with flaps.

Closures and fastenings - zip front, button front fastening, drawstring/ties.

Features - topstitching, jeans rivets details, gathered hem into cuff, elasticated pant hems, brace/dungaree straps and buckle fastening.

Jackets

Tailored Single
Breasted Jacket

Tuxedo

Nehru

Chanel

Bell Boy or
Cropped

Spencer

Denim Jeans
Jacket

Bomber

Military

Biker

Quilted

Sweat Top or
Hoodie

Zip Front Sweat
Top or Hoodie

Parka

Norfolk

Shooting Jacket

Peacoat

Tailcoat

Flats courtesy of Penter Yip, Fashionary - http://fashionary.org

Jackets: These jacket styles and silhouettes include the following details:

Collars and necklines - tailored/notched/rever collars, peak, stand/nehru collars, round neckline, rolled collars, hoodies.

Sleeves and cuffs - set-in sleeve, tailored two piece sleeves, one piece sleeves, raglan sleeve, buttoned cuffs, elasticated cuffs.

Pockets - flap pockets (with buttons), pleated, straight/slanted jetted and welt pockets, kangaroo/pouch pocket.

Front fastenings and closures- single breasted button front, double breasted, asymmetrical front, concealed zip front, button front fastening.

Features - topstitching, quilting, belted fastenings with belt loop/holders, drawstrings.

Necklines and Collars

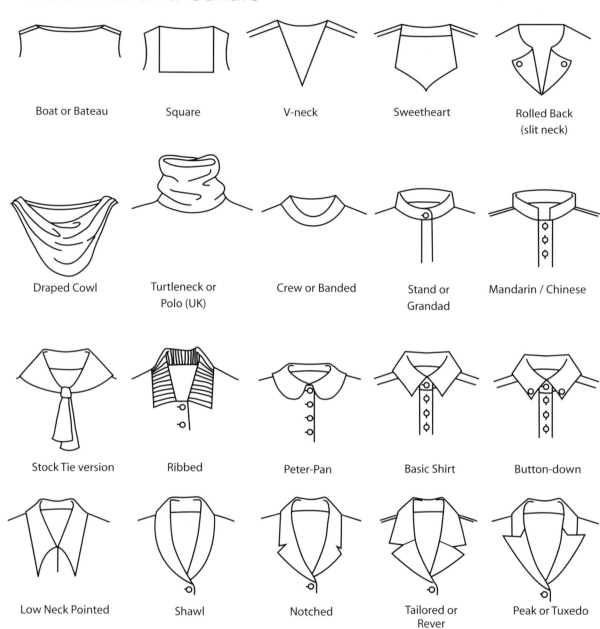

Boat or Bateau

Square

V-neck

Sweetheart

Rolled Back
(slit neck)

Draped Cowl

Turtleneck or
Polo (UK)

Crew or Banded

Stand or
Grandad

Mandarin / Chinese

Stock Tie version

Ribbed

Peter-Pan

Basic Shirt

Button-down

Low Neck Pointed

Shawl

Notched

Tailored or
Rever

Peak or Tuxedo

Cuffs

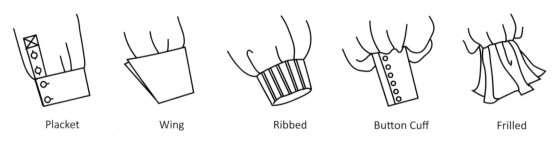

Placket

Wing

Ribbed

Button Cuff

Frilled

Flats courtesy of Penter Yip, Fashionary - http://fashionary.org

Pockets

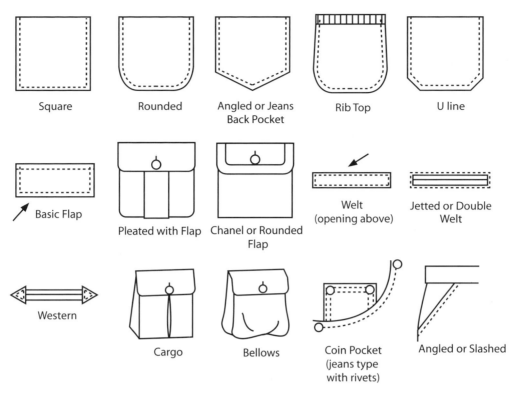

Square

Rounded

Angled or Jeans
Back Pocket

Rib Top

U line

Basic Flap

Pleated with Flap

Chanel or Rounded
Flap

Welt
(opening above)

Jetted or Double
Welt

Western

Cargo

Bellows

Coin Pocket
(jeans type
with rivets)

Angled or Slashed

Flats courtesy of Penter Yip, Fashionary - http://fashionary.org

For more information see:

Fashion Artist- *Clothing Design* chapter.

Fashion Computing - *Flats and Specs* - Women, Menswear, Childrenswear chapters.

Fashion Entrepreneur - *Appendices*.

RESEARCH/DEVELOPMENT

Fashion Designer Amy Lappin: *Presentation work featuring a mixture of photos of garments and styling details, some of which have been hand traced to create an artistic effect.*

Photos of designs are commonly used to together with technical drawings to help show proportion and detailing, and are also used in marketing brochures, look books, etc.

REQUIEM

SUR L'AUTOROUTE DE L'ENFER, LES ÉMOKIDS ENFOURCHENT LA MOTO DU DIABLE. VOLANTS ET COL FRAISE À RUCHERS POUR LES FILLES QUI JOUENT UNE ESTHÉTIQUE XIXÈME MODERNISÉE PAR UN PORTER TRASH. BLOUSON RACING ÉPAULÉ AVEC APPLICATIONS DE FLAMMES, DENIM SOUPLE CHAHUTÉ DE DÉTAILS MOTARD (GENOUILLÈRE MATE-LASSÉE, LAÇAGES SUR NÉO-PERFECTO DENIM OU CUIR POUR LE GARÇON.

ON THE HIGHWAY OF NO RETURN, EMOKIDS TAKE OFF ON THE DEVIL'S MOTORCYCLE. RUFFLES AND RUFF COLLARS FOR GIRLS WHO PLAY UP A 19TH CENTURY ESTHETIC MODERNIZED IN A « TRASHY » LOOK. BIG-SHOULDERED RACING BLOUSON WITH APPLIQUED FLAMES, SUPPLE DENIM JOLTED BY BIKER DETAILS (QUILTED KNEE BANDS, LACED NEO-PERFECTOS IN DENIM OR LEATHER FOR BOYS).

HIGHWAY TO HELL

LA GAMME EST LYRIQUE, COMME NOIRCIE : LES 3 PASTELS NEUTRES, BIEN QU'ENSEVELIS DANS LA PRO-FONDEUR DU MARRON / NOIR, SONT ÉCLAIRÉS PAR LE JAUNE LUMINESCENT. A NOTER, UNE NOUVELLE HARMONIE ROSE/JAUNE.

THE COLOR RANGE IS LYRICAL AND APPEARS BLACKENED : 3 NEUTRAL PASTELS BURIED UNDER DEEP BROWNS AND BLACKS, LIGHTENED UP BY LUMINOUS YELLOW. WE NOTE A NEW, PINK/YELLOW HARMONY.

12-0642 TPX

02

01

00

03

Col renaissance noué
Knotted Renaissance collar

Applications "flammes" sur blouson motard en cuir
« Flame » appliqués on leather motorcycle blouson

Robe en mousseline, doublure contrastée
Chiffon dress, contrast lining

Impression Émo/Black métal sur sweat-shirt couleur
Emo/Black metal print on a colored sweatshirt

Jouer les détails motard sur le jeanswear : genouillères matelassées, laçages...
Play biker details on jeanswear : quilted knee bands, lacings …

The Fashion Market
and the customer

'I work with structure, but I go outside the box and give it my own spin. I adore the challenge of creating truly modern clothes - where a woman's personality and sense of style are realized.' Vera Wang

Globally, the fashion market is an extensive, broad based, diverse industry. It consists of different sectors, market levels, clothing and product categories, with different types of customers.

To appreciate its full extent, this chapter will explain the market under the following headings:

- The fashion market
- Haute couture, ready-to-wear, mass market
- Clothing and product categories
- Market segmentation
- Designing for the market.

With such diversity in the fashion market means that fashion brands, and fashion designers, tend to specialise in a certain area of fashion, developing their expertise by focussing on a niche market and a particular customer type.

Understanding the extent of the fashion market will help you to identify where you might find your particular area of interest and your niche.

Opposite, Courtesy of **PROMOSTYL Paris,** from their Youth Market - Winter Trends book, theme *Requiem - Highway to Hell.*

Right, Fashion Designer and Illustrator Lidwine Grosbois: *Balenciaga RTW.*

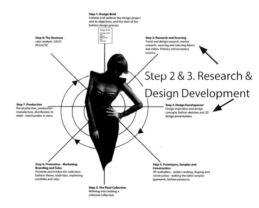

Figure 7.1: *Fashion Design Process (see p.15)*

© Fashion Designer - Sandra Burke

Fashion Designer and Illustrator Jesse Lolo: *Illustration of a haute couture design. Many established designers design collections for more than one level;* Karl Lagerfeld (Chanel), John Galliano (Dior), and Martin Margiela (Maison Martin Margiela) *design both haute couture and ready-to-wear.*

1. The Fashion Market

The fashion market can be broken down under four distinct headings:
- Market Levels
- Market Sectors
- Clothing and Product Categories
- Demographics.

Market levels comprise of three distinct levels:
- Haute Couture
- Ready-to-Wear (Prêt à Porter)
- Mass Market.

These levels range from haute couture, the most exclusive, offering the highest level in creativity and quality in design and, therefore, maintaining the highest price point, to the most commercial level with less exclusivity in design, and the lowest price point, mass market.

Market sectors comprise of three distinct sectors:
- Womenswear (the largest)
- Menswear
- Childrenswear.

Clothing and product categories include many subdivisions; the three most obvious for womenswear being daywear, eveningwear and lingerie.

The final heading, **demographics**; this is an important consideration for all brands to better understand their target market and the different types of customers' needs and desires.

Fig. 7.2 graphically explains a simple breakdown of the fashion market. It includes a *design brief* showing how the brief is developed from a unique combination of the four key variables - market levels, market sectors, clothing and product categories, and demographics.

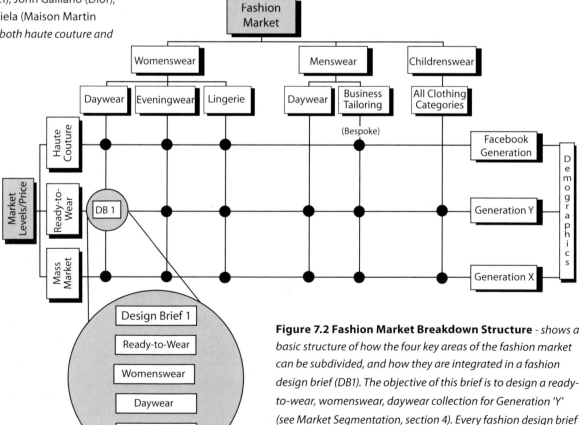

Figure 7.2 Fashion Market Breakdown Structure - *shows a basic structure of how the four key areas of the fashion market can be subdivided, and how they are integrated in a fashion design brief (DB1). The objective of this brief is to design a ready-to-wear, womenswear, daywear collection for Generation 'Y' (see Market Segmentation, section 4). Every fashion design brief would comprise of its own unique combination.*

2. Haute Couture, Ready-to-Wear, Mass Market

Haute Couture (is French for *'high sewing'*): Haute couture is at the absolute top end of the luxury fashion market - the most prestigious level of fashion. Exclusive designs are custom-made for affluent clients, using the highest quality fabrics, and cut and sewn by the most highly skilled artisans (pattern cutters, seamstresses, and specialists in lace, beading and embroidery, etc.). Without haute couture many of these exclusive skills and crafts would be lost.

To qualify as an official 'haute couture' house, the designer/company must be a member of the *Chambre Syndicale De La Haute Couture*, a Paris-based body of designers governed by the *French Department of Industry* that includes international designers.

The Paris haute couture shows are held twice a year in January and July, with outfits for day and evening wear. Chanel, Christian Dior, Givenchy, Jean Paul Gaultier, and Valentino are some of the notable couture houses and haute couture designers.

With an outfit costing many thousands of dollars, only a select number of affluent, mostly mature women worldwide can afford haute couture today. Even with such a limited customer base it is an extremely important part of the industry, pushing the boundaries of design, creativity and innovation. And, for the fashion house, it is an avenue for marketing and promoting the brand's portfolio of other fashion products (ready-to-wear collections, cosmetics, perfumes, accessories, diffusion ranges and licenses).

Ready-to-Wear (RTW) (Prêt-à-Porter) and Designer Collections: This level of design is more affordable for a wider market, and for those who desire a high standard of fashion, style, originality and quality (fabric and design). The designs are not specifically made for individual clients, so are produced in a standard size range and in larger numbers, making RTW far less expensive to manufacture than haute couture. Haute couture fashion houses also produce ready-to-wear collections as the volume in sales increases their market. This level includes the super brands through to independent RTW designers.

The RTW collections are shown twice a year after the haute couture collections in the key fashion capitals, New York, London, Milan and Paris, during their individual *Fashion Weeks*. Increasingly, other cities throughout the world (Hong Kong, Sydney, Cape Town, etc.) also host their own RTW shows. There is an enormous amount of competition at this level as there are many RTW fashion designers.

- **Luxury super brands** and global conglomerates include; LVHM (Louis Vuitton, Moët Hennessy) and the Gucci Group. These companies have expanded their empires owning numerous fashion brands, including many of the couture houses, as well as cosmetics, perfumes and accessories.

- **Mid-level brands and designers** are established names but do not have the 'super power' brand status. They might present their collections on the runway and also work with the high-street stores. Their merchandise would be sold through wholesale, concessions (department stores), or their own retail stores. Examples include Ann Taylor (US), and Julien Macdonald (UK).

- **Independent designers** typically work in a small team, or might be a fashion designer/entrepreneur working on their own. Independent designers are often involved in the whole cycle, from design, to production, sales and marketing. During *Fashion Week* they might show their collections on the runway, have an exhibition stand, and/or promote through an agent.

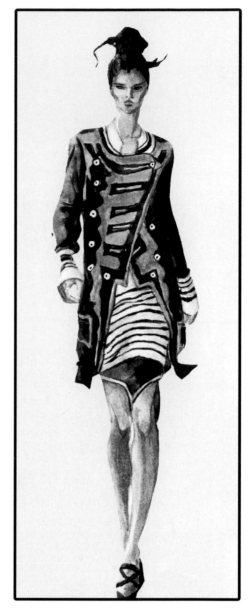

Fashion Designer/Illustrator Laura Krusemark: *Illustration presents a* Vivienne Westwood *RTW design.*

Savile Row, London, Home of Tailoring: *Branding logo from '40 Savile Row' - makers of fine garments for discerning customers - tailoring, made-to-measure.*

© Fashion Designer - Sandra Burke

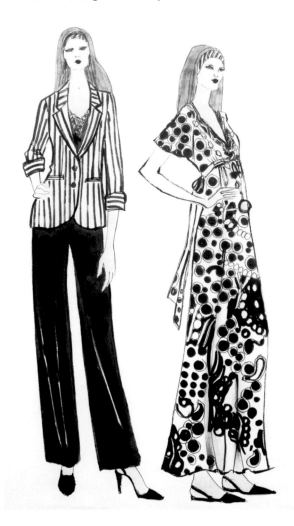

Mass Market: This includes *fast fashion, high-street* fashion, through to the *supermarkets.* This is by far the largest market. Due to the use of less expensive materials and mass production methods (large production runs) the products are more affordable, appealing to a much larger group of consumers.

The fashions are more instant as fashion designers at this level look to the runway shows and can pick up on trends and react immediately. And, due to the manufacturing process, the designs can go straight into retail within a few weeks. This short design and production cycle is typical of *fast fashion* - Zara is an excellent example of a company using this process.

Table 7.1 expands on these three distinct levels. As you become more aware of the diversity in the fashion market so you will appreciate and understand the relevance of the other subdivisions.

Note: *As haute couture, ready-to-wear designers, and also super brands capture more of the market by getting involved with designing for less expensive levels, definitions that describe the market levels are not always as clear cut.*

Fashion Designer Linda Logan: *Mid-level collection presents effortless elegance with soft tailoring and flowing maxi dresses.*

Fashion Levels	Price	Brand/stores	Styling/Target market
Haute Couture	Very Expensive	Chanel, Dior, Lacroix, Givenchy, Jean Paul Gaultier, Martin Margiela	Quality in every aspect - generally a more mature clientele
Ready-to-Wear, Designer	Expensive	Lanvin, Prada, Dolce and Gabbana, Calvin Klein Collections, Comme de Garçons	Quality fabric, high end fashion, affluent clientele
Luxury Brands	Expensive, but also include more affordable luxury product lines	LVHM (Louis Vuitton, Fendi, Pucci, Givenchy), Gucci (Yves St Laurent, Boucheron, Alexander McQueen, Stella McCartney), Burberry	Quality, luxury, affluent clientele
Mid-Level (UK), Bridge (US)	Less than RTW	Concessions, Franchises, Own Stores, DKNY by Donna Karen, Lauren by Ralph Lauren	Good fabrics, upscale design, good design profile
Independent Designer, Indie Labels	Expensive	Boutiques, Department stores - Selfridges, Saks	Good fabrics, upscale design, often a bit more edgy
Contemporary (US)	Less than RTW	Bisou Bisou, Betsey Johnson	Trend driven, avant garde - younger market
Better (US)	Lowest price for 'designer' label	Jones New York, Liz Claiborne	Good fabrics, fashion moderate
High Street (UK), Casualwear, Moderate (US),	Moderate	Topshop, Zara, French Connection, Levis, H&M, Gap, Mango	Fashion filtered down from top end for mainstream fashion, fashion-forward/trend driven
Supermarkets, Budget, Mass Market	Inexpensive	George at Asda, Cherokee at Tesco, Target, Sears (US)	Derivations of popular styles - broad base consumption - low quality, throw away fashion
Discounters	Lowest price for Designer/ upmarket products	TK Maxx (UK), TJ Maxx (US) - designer labels	Discontinued, unsold stock from known labels or specifically designed for the store using left over fabric (cabbage) - for people who prefer labels but might not have the disposable income

Table 7.1 Market Levels - *expands on the three key levels of fashion*

3. Clothing and Product Categories

Within the fashion market there are different clothing and product categories, from casualwear, jeanswear, denim wear to footwear, accessories etc.

Table 7.2 shows some of the key clothing and product categories and how they fit into the three key fashion market levels. These clothing categories could be further sub-divided into Petites, Missy, Junior, Plus Sizes etc., or individual garment types (dresses, tops, skirts, etc.).

This table also presents where, as a fashion designer, you might find your niche and specialise.

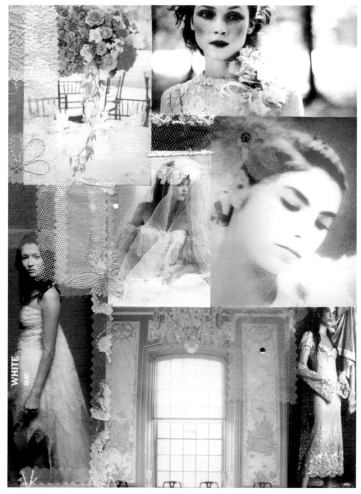

Fashion Designer Kathryn Hopkins: *Bridal wear mood board. With celebrity weddings making headlines, many brides-to-be are spending vast amounts on their own weddings; this market remains strong and is supported by numerous Bridal trade events globally.*

Area/Product Categories	Fashion Market Levels
Women's Day Wear	Haute Couture, Ready-to-Wear, Mass Market
Women's Evening Wear/Occasion Wear	Haute Couture, Ready-to-Wear, Mass Market
Women's Lingerie/Intimate Apparel	Haute Couture, Ready-to-Wear, Mass Market
Casualwear, Sportswear (US)	Ready-to-Wear, Mass Market
Jeanswear, Denim wear, Streetwear	Ready-to-Wear, Mass Market
Sportswear / Activewear, Swimwear, Beachwear	Ready-to-Wear, Mass Market
Knitwear	Ready-to-Wear, Mass Market
Outerwear	Ready-to-Wear, Mass Market
Bridal wear	Haute Couture, Ready-to-Wear, Mass Market
Accessories, Bags, Belts, Eyewear, Jewellery, Millinery	Haute Couture, Ready-to-Wear, Mass Market
Footwear	Haute Couture, Ready-to-Wear, Mass Market
Menswear	Bespoke Tailoring, Ready-to-Wear, Mass Market
Juniors, Girls' Wear, Boys' Wear, Childrenswear/Kidswear, Toddlers	Ready-to-Wear, Mass Market
Other Specialist Product Areas - Career wear, Resort, Cruise wear, Holiday, Weekend wear, Coordinates, Performance Sportswear, Surfwear (all sports), Maternity, Corporate, Special Needs, Plus Sizes, Tall/Short Sizes, Youth/ Street, Student & Graduate	

Table 7.2 Product Categories and Levels Breakdown - *shows the relationship between some key clothing and product categories/fashion areas and the associated fashion market levels.*

4. Market Segmentation

Market segmentation is simply the process of dividing the market into *segments* to identify the different groups of **customers**, their needs, desires, and buying power. Segmentation is an important part of a company's marketing and sales strategy. It provides a more defined way to identify, analyse and understand the target market (customer) and predict potential company growth. It is the job of market researchers to analyse the market and produce these statistics.

Marketing companies are constantly looking for new ways to analyse the market; the following are just a few popular subdivisions:

Demographic Segmentation: This is based on measurable statistics and is the study of the population. It can be divided into gender, age, income, occupation, education, ethnicity, location and lifestyle. For example, an eighteen year old single working woman will have different fashion needs, wants and income compared to a forty year old, professional, single woman.

Generation demographics and, in particular, the youth market is of prime significance for marketers, so will be presented first.

Youth Market: Typically between the ages of 12 to 24. This is an important segment of the market because this highly fashion conscious market often sets the trends that are then adopted by other demographic groups. Although they might have a smaller disposable income, they tend to spend a larger proportion of it on fashion products.

More specifically, the youth market can be broken down into:

• Tween Market - typically ages 8 to 12
• Teen Market - typically ages 13 to 19
• College Market - typically ages 18 to 21
• Young Adult Market (young professionals) - typically ages 22 and above.

Other demographic studies include:
• Facebook Generation, or Generation F: Those who have grown up with Facebook and social networking through an electronic medium.
• Generation Y (Millennials, Echo boomers, Net Generation): Born between 1977-1998
• Generation X, (Gen X, Baby Busters): Born between 1965-1976
• Boomers or Baby Boomers: Born between 1946-1964
• Silver surfers, the Grey/Gray Market: Born before 1945.

Note: *These dates can differ depending on the author.*

Geographical Segmentation: This is based on region, size, population, climate - those from urban areas will have different needs and wants to those from the country or rural areas.

Psychographic Segmentation: This is based on consumer attitudes, lifestyle preferences, interest, values and opinions.

Right, Fashion Illustrator and Designer Nadeesha Godamunne: *A smart/casual, classic look flirts with androgynous charm - this demographic is a professional aged 22 plus.*

Far right, Courtesy of **PROMOSTYL Paris,** from their Youth Market - Winter Trends book, theme *Requiem - Highway to Hell.*

Behavioural Segmentation: This is based on consumer behaviour towards a brand's products as a first time buyer or regular customer, and includes; brand loyalty, usage, benefits required, readiness to buy (perhaps weekly, or only for certain occasions). The consumers could be:

• Fashion followers, loyal or returning customers who trust a particular brand to have the best merchandise for them, perhaps the complete look or outfit. Companies encourage this behaviour with customer store reward cards and offers of special discounts.

• Trend setters or fashion leaders who keep track of the latest trends, even what the celebrities are wearing. They happily put their own look together, perhaps introducing a new trend. They are not brand loyal, but buy from different levels and brands, from Gucci to Zara; vintage stores to market stalls.

• Early adopters or, in contrast, late adopters of fashion trends.

Market researchers are constantly looking for different ways to improve information to help their clients' grow or maintain their market. For example, they might research the desires and needs of the working woman, women working from home, or plus-size women.

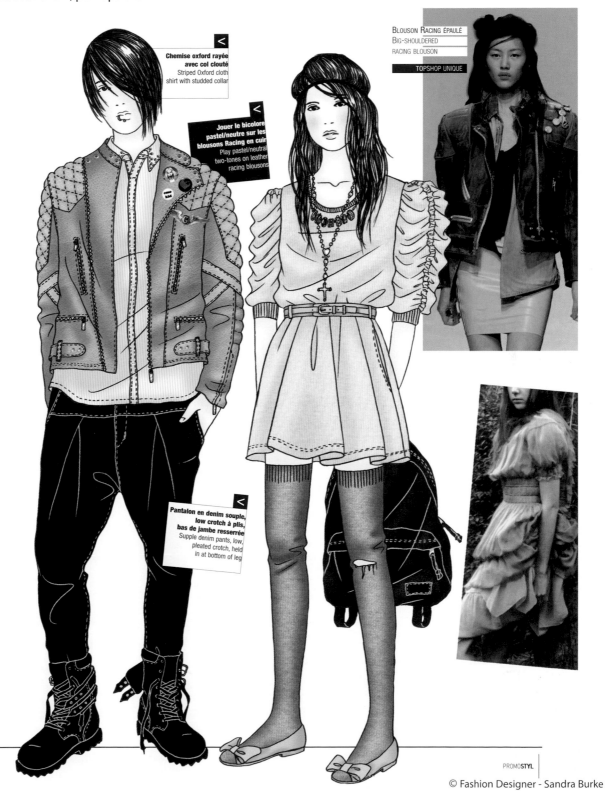

Chemise oxford rayée avec col clouté
Striped Oxford cloth shirt with studded collar

Jouer le bicolore pastel/neutre sur les blousons Racing en cuir
Play pastel/neutral two-tones on leather racing blousons

Pantalon en denim souple, low crotch à plis, bas de jambe resserrée
Supple denim pants, low, pleated crotch, held in at bottom of leg

BLOUSON RACING ÉPAULÉ
BIG-SHOULDERED RACING BLOUSON
TOPSHOP UNIQUE

PROMOSTYL

© Fashion Designer - Sandra Burke

5. Designing for the Market

In the previous section we looked at demographics. This section highlights a few more points to help you further identify the target market and customer.

A great deal of planning, creative input, resources and finance go into designing and producing collections so, as a fashion designer, it is essential to understand who you are designing for and why, as this will help you make more informed design decisions. Most importantly, you need to ensure that the merchandise you design is a success and 'flies off the shelves'. When designing you need to consider:

- What the customers or clients want or need, or *think* they need. They might want the latest Chanel bag, but do not need it.
- Why would they want the product? Is it because of the marketing, have they seen celebrities wearing the product, have they bought similar merchandise from the brand before?
- What price are they willing to pay? Do they have a top price limit?
- Where do they shop? What location? Are they private clients that come to you? Do they purchase through retailers, online, catalogues?
- When do they buy - in season, a particular time of month - on pay day, special occasions?

• **Sales Figures and Analysis**: Analysing the company sales figures, gathering information through in-store questionnaires, focus groups, reports from the customer service department, and using a marketing research company to come up with broader reports and statistics (market segmentation) all helps further identify the target market and understand how the customers respond to the merchandise.

• **Fashion Retail and the Competition:** Fashion retail is the *'shop window'* of fashion and the last link in the supply chain, from the fashion design concept to the consumer (see Fashion Entrepreneur, *Fashion and Textile Supply Chain*). The fashion retail business involves the buying, selling, and display of fashion merchandise. It is essentially the link between the product, the manufacturer and the customer. The *'shop window'* could be a retail store, design studio, market stall, catalogue (mail order), and, increasingly digital or virtual. The aim of fashion retailers is to know their market, and to persuade and entice customers to buy their merchandise.

Fashion Designer Georgia Hardinge:
Shows her ready-to-wear collections in London and Paris. Her designs are for women who appreciate form, sculpture and, as Georgia says, designs '... targeted for the creative eyes.'

MY WHITE DRESS SS

styling Ellie Cumming and shot by Sarah Piantadosi.. dress georgia hardinge

ON/OFF PARIS SHOW ROOM

Paris Fashion Week, georgia hardinge

ON/OFF PARIS SHOW ROOM

georgia hardinge

Paris Fashion Week, georgia hardinge

MY WHITE DRESS SS

As part of your design research, store visits will help you to understand the market, what is available and what customers are buying, and what the competition is offering; the type of merchandise, the designs, colors, fabrics, and prices. During your 'shopping' research you might spot an opportunity, a gap in the market for a new design or innovative product or collection. This means you could gain part of the competition's market share (*competitive advantage*) by producing a better or totally new product.

Fashion retailers can be part of the high street shops, retail parks and shopping centres/malls, from all levels, and include:

- Independents and boutiques
- Multiples, department stores and chain stores
- Flagship stores, concessions, store within a store, franchises
- Discounters, factory shops/outlets
- Markets, designer markets
- Catalogues, mail order, virtual - online/Internet shopping, eBay.

• Fashion Fads to Classic Fashion: As you identify the market and customer behaviour you will begin to understand the differences between fashion fads, fashion trends and classic fashion - the fashion trends life cycle (Fig. 7.3).

Knowing where your products fit in with this life cycle will influence the way you design your collections, and how you develop the product mix. For example, if you balance your range to include some basic or classic styles along with trend driven designs, you should be able to fully maximize your sales potential and customer base.

Prada *have their own stores and also sell their merchandise through various retailers (independent stores etc.), as do many other brands.*

Figure 7.3 Fashion Trends Life Cycle - *shows a sales and trends profile and how fashion is adopted by the consumer.*

1. *A* fashion fad *quickly becomes fashionable and, just as quickly, goes out of fashion.*

2. Fashion trends *tend to emerge and last a few seasons, then re-emerge much later with certain changes (the way it is put together as a look, and fabrication, prints, colors, etc.).*

3. Classic styles *remain in fashion for longer and continue to sell even though they are not the height of fashion; styling details would be updated (fabric, colors). If the styles go out of fashion they tend to re-emerge several seasons later (trench coat, tailored suits, little black dress).*

For more information see:
Fashion Entrepreneur - *Opportunities in the Fashion and Creative Industries,* and the *Market Research* chapters.

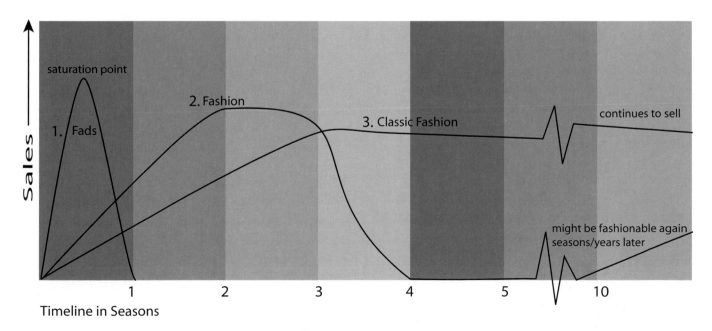

DÉSIR NOIR
Black desire

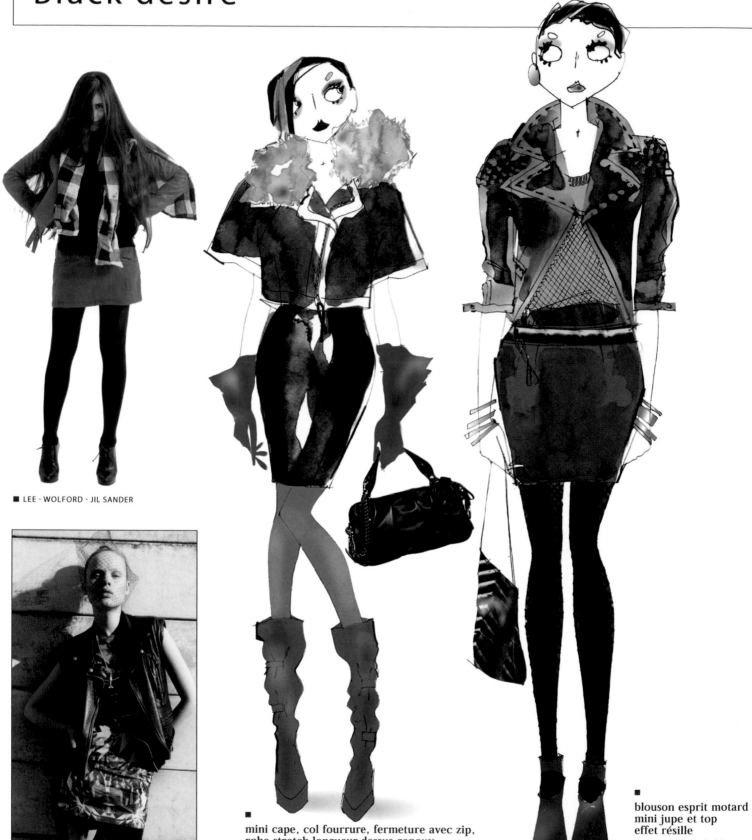

■ LEE - WOLFORD - JIL SANDER

■ ALEXANDER McQUEEN

■
mini cape, col fourrure, fermeture avec zip,
robe stretch longueur dessus genoux
mini cape, fur collar, zip closure, above-knee
stretch dress

■
blouson esprit motard
mini jupe et top
effet résille
motorcycle style blouson
mini-skirt and top
with netting effect

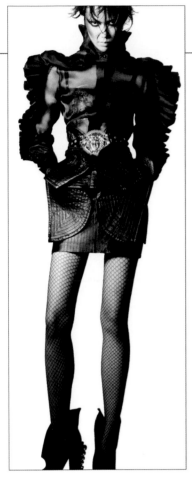

8

Design Development

Elements and Principles of Design

'Fashion is architecture. It is a matter of proportions.' Coco Chanel

The *Design Development Phase* integrates market and trend research and its analysis, with creativity and innovation skills, to create marketable designs. To aid this process, as in every art form, there are certain guidelines that all professional designers use whether consciously or sub-consciously, and these are known as *Design Elements* and *Design Principles*.

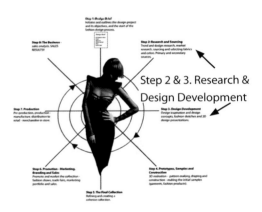

Figure 8.1: *Fashion Design Process (see p.15)*

As part of the *Fashion Design Process*, this chapter will explain how to develop a fashion design by initially introducing you to these design guidelines which are essential to help you structure your thinking and develop your collections. It will then present the visual process of design development in 2D format.

Topics include:

• Design Elements: silhouette, color, line and texture.
• Design Principles: proportion, balance, rhythm, emphasis, graduation, contrast, harmony and unity.
• Developing a Design: The fashion croquis, drawing tools and the fashion croquis sketchbook.
• Design Development examples: Dress, top, pant, suit and coat that could, potentially, become part of a successful fashion collection.

Left, Courtesy of **PROMOSTYL Paris,** from their Youth Market Winter Trends book, theme *DÉSIR NOIR.*

■ KARL LAGERFELD

Fashion Designer Lidwine Grosbois: *After silhouette, color creates the most immediate and visual impact when the model hits the runway, then it is the line and texture that creates impact.*

Opposite, Fashion Designer Georgia Hardinge: *The four key design elements are presented in her 'Cage' collection:*

• *Silhouette* • *Color*

• *Line* • *Texture*

When designers present their collections, it is the silhouette of the design that creates the first impression followed by color.

1. Design Elements and Design Principles

To appreciate the difference between *Design Elements* and *Design Principles* we will take a simple fashion *makeup* analogy, where the objective is to take the 'nude' face of a model and create several dynamic looks. The **elements** are the ingredients - the makeup; the foundation, mascara, eye shadow, liner, lipstick etc. The **principles** are the directions of how to use the makeup to create the different looks.

Note: Attitudes regarding design differ between the schools of thought that influence design, and between individual practising designers. This chapter looks at the most appropriate for fashion design.

1.1 Design Elements

The four key ingredients are:
- Silhouette
- Color
- Line
- Texture

Silhouette: This is the overall outline of a garment, or *'look'*, and includes its shape, volume and form. This is the most **obvious** visual element of a garment - the silhouette is what is seen in the first instance as a model steps on to the fashion runway. It creates the initial impact before any other details are noticed.

As discussed in the *History and Culture* chapter, throughout each decade or era as trends develop so different fashion silhouettes evolve. The silhouette might compliment the shape of the body or be exaggerated to accentuate a different part of the body, perhaps introducing a new area of focus or new trend. For example, the fashion for boyish figure shapes, with little shoulder or waist definition, might develop into a trend towards more shapely silhouettes - an hourglass figure with padded shoulders, small waist, and shapely hip lines.

Color: After silhouette, color creates the most visual impact when seen from a distance (on the runway), and it is what customers respond to initially in store. Color can present very different moods and feelings (see *Color and Fabric* chapter).

Line: The line of a garment relates to its cut and style lines; its construction. These lines break up the space within the outline of the garment and create shape (the seam lines, the darts, gathers, pleats, tucks); the details (pockets, cuffs, buttons, zips, belts). A line can be hard or soft; it can emphasise a feature and make a vast difference to the appearance of the body. Consider;
- Vertical lines tend to lengthen the body and make it appear slimmer.
- Horizontal lines tend to widen the body or make it look shorter.
- Curved, or bias cut seam lines give shape and a feminine curvaceous look.
- Straight lines give a more masculine feel or suggest a crispness as in tailored garments.

Texture: The fabrics and materials used for a design can produce very different effects. They must be chosen to match the mood, style and desired look. Compare a jeans jacket made in denim and one made in silk - each jacket will hang on the body in a different way and present a very different look (see *Color and Fabric* chapter).

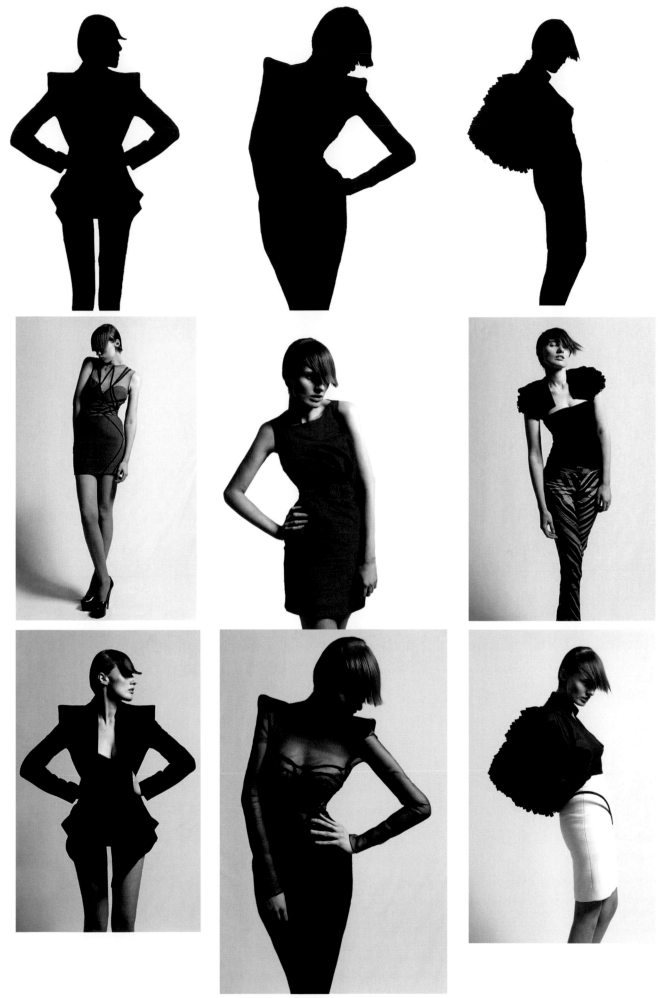

1.2 Design Principles

The eight key directions are:
- Proportion
- Balance
- Rhythm
- Emphasis
- Graduation
- Contrast
- Harmony
- Unity

Proportion: Proportion (scale) refers to the relative size and scale of the details in a design and how they relate to each other in part or as a whole. For example, the length of a dress in proportion to its width; the size of a pocket on the front of a shirt; the depth of a ruffle on the neckline of a dress - all need to be carefully proportioned.

Balance: Symmetrical balance in fashion design places style lines and details evenly on the garment; for example, buttons evenly distributed on the centre front line, pockets evenly sized and positioned either side of the centre front. An asymmetrical example of balance would be the one-shouldered dress, popular in eveningwear. It is obviously off-centre and not symmetrical in regards to the shoulder line but, as a whole, it should be designed to be well-balanced.

A well-balanced design means that each style detail, the colors and the fabrics work well together - one does not overpower the other but, if it does, it does so in a way that it is pleasing to the eye.

Rhythm: Rhythm is based on **repetition** and involves the repeated use of line, detail, trims, color and pattern. For example, a 'little black dress' (LBD) might have a beaded trim around the neckline, armholes, and along the hemline; a top might be embellished with several ruffles down its front and on its sleeves.

Emphasis: Emphasis or *'main point of focus'* is what draws the eye to a garment or outfit. It could be the silhouette or color, but also a particular detail or embellishment, a belt, a piece of jewellery.

Graduation: Graduation relates to diminishing or increasing features. An example is an embroidered motif on a dress that gradually reduces in size as it spreads from the shoulder seam diagonally across the front body to finish at the hem.

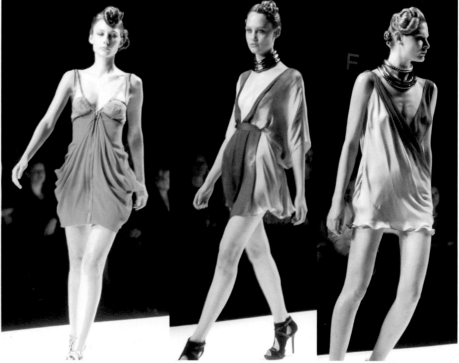

Contrast: Contrast relates to color, texture or shape and draws attention to a specific design detail. It relieves the otherwise 'normality' of a design. Examples would include; a simple black dress worn with a contrasting white belt, or a simple *Chanel* jacket worn with multiple strings of oversized pearls.

Harmony: Harmony is created when the design elements blend together as opposed to stand out in contrast. For example, the use of soft colors and softly draping fabric in a design.

Unity: Unity is created when all the design elements and design principles of a design work together and create an overall completeness and cohesiveness. This can apply to an individual garment, an outfit or a collection. For example, in a collection this could be seen as the simple mixing and matching that allows each garment to be worn with another.

Successful Design

A successful design is achieved when the design elements and principles come together to produce a cohesive look, visually well presented with the right amount of creativity, innovation and style, with perhaps a new twist. Perhaps even a *Signature Style* could evolve.

As a designer, once you appreciate the use and relationship of design elements and design principles you will start to see evidence of these in every garment and in every designer collection. This should help you design anything from the simplest of products to an entire collection.

Fashion Knitwear Designer Craig Lawrence: *Exhibits his S/S collection at Somerset House,* London Fashion Week.

Excerpt from his press release for LFW: Design background: Studied at Central Saint Martins. He created the knitwear for Gareth Pugh for the first six seasons.

Career highlight: *'Tilda Swinton wearing my designs on the special edition front cover of Another Magazine.'*

What is your signature style? *'Knitting with unconventional materials.'*

Opposite and below, left to right, Fashion Designers Bora Aksu and Amanda Wakeley, and above, Craig Lawrence: *The eight key directions are presented here in the designers' S/S collections at London Fashion Week:*

• *Proportion*	• *Balance*	• *Rhythm*	• *Emphasis*
• *Graduation*	• *Contrast*	• *Harmony*	• *Unity*

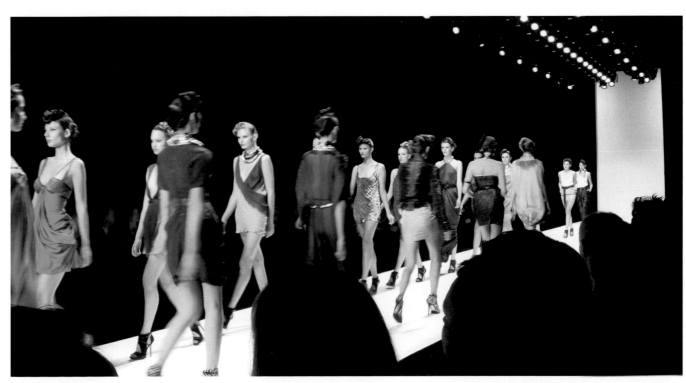

© Fashion Designer - Sandra Burke

2. Developing a Design

This section will present the design development process of sketching the initial design concept for a dress, top, pant, suit and coat, including several design options for each.

It will put into practice the *design elements* and *design principles* from the previous sections.

In the fashion industry a designer would work to a design brief. This practice will be explained in the *Design Brief* chapter where you will learn how to take design development further and design a collection for a specific client or target market.

Fashion Croquis: The fashion croquis is a quick sketch of a design on a fashion figure (female, male, child). The fashion croquis design lacks specific details, but presents good proportions of the body and the overall silhouette and design of the garment, together with a sense of style and flare.

This method of design development should encourage you to sketch designs quickly while not getting too concerned with the absolute finite details. As you become more practised and experienced in sketching, these drawings should only take a few minutes each.

Drawing Tools: Black fine liners, pigment liners, graphite pencil and mechanical pencil are perfect for sketching the key lines and details.

The designs can be quickly coloured using felt tips, brush felt tips or colored pencils to represent the fabrics and colors of the design. Markers are perfect for quick sketches and adding color - a 'marker' paper can be used as there is often a bleed through on certain paper.

Alternatively, the line drawings could be scanned into a computer and edited using a digital image editing application, such as Photoshop, and color and fabric details added digitally.

Note: Some designers sketch using digital pads - this is acceptable depending on your skills and your preferred method of working.

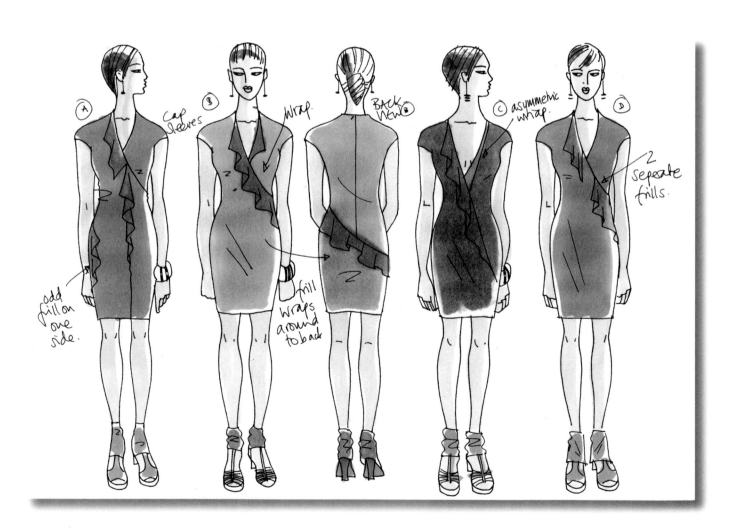

Selecting the Croquis: Initially you need to sketch a suitable fashion figure/croquis to use as a template; one that is not too overly stylised, otherwise you might find you have difficulty in achieving good body proportions. And not too realistic, otherwise you might lose a sense of flow in your work. (See *Silhouettes, Styles, Details* chapter for a basic croquis template you could use as a starting point; also *Fashion Artist* and *Fashion Computing* - in this *Fashion Design Series*). Sketching several croquis in various poses allows you to select the most appropriate one to best present your designs:
• Full figure; front, back and side view
• Half figure; upper and lower torso.

The Fashion Croquis Sketchbook: Some designers prefer to create a croquis sketchbook as opposed to sketching on separate sheets of paper. This way the sketches progressively show the stages of design development - an acceptable way to present design ideas to the design team or buyers.

The Sketchpad or Sketch Paper: Until you are familiar with drawing a particular fashion pose you should use your croquis as a template. Therefore, you need to choose a suitable sketchpad or single sheets of paper that are slightly translucent so that you can trace over your template. This allows you to concentrate on sketching the design rather than drawing the figure correctly for every new design.

Croquis Sketchbook and Design Development Sheets: The following design development examples demonstrate how the design elements - silhouette, color, line and texture - have been used, and the design principles - proportion, balance, rhythm, emphasis, graduation, contrast, harmony and unity - have been applied to produce creative and successful design options.

The designer would typically be working to a design brief and offering several style solutions. It can be assumed that the designer has started with a theme, fabric and color in mind for each initial design in the following design development examples. (Researching trends, colors and fabrics has been covered as part of the *Design Process* in all previous chapters.)

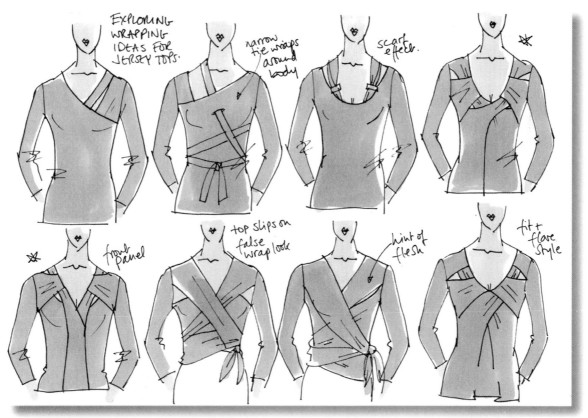

Opposite and this page, left to right, Fashion Croquis Design Developments by Fashion Designer and Illustrator Lynnette Cook:

Silk jersey dress with asymmetric frill/ruffle detailing in a soft color palette of blues, purples and dusky pink - design options for placement of the frills and colors.

Silk jersey tops with playful details of cross wrapping - design options include changing 'line' while maintaining the fit of the garment, and experimentation with the eight 'design principles' previously explained.

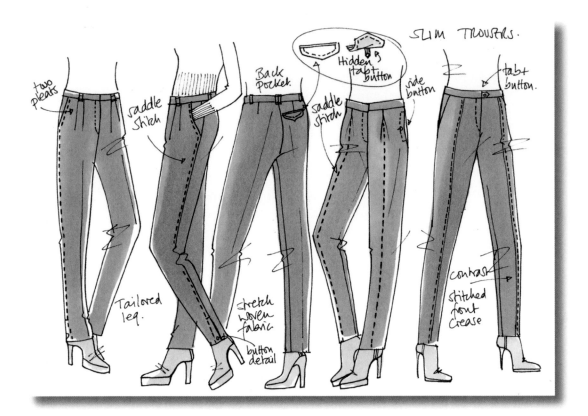

Developing the Designs: As you sketch your designs you should progressively develop each design, incrementally changing design details such as line and proportion; not digressing too much from the original design, but rather maintaining the silhouette and balance as you work with the fabric.

Note how these design developments, from the silk jersey dress to the silk check coat, offer various style options.

You might sketch up to perhaps 20 design options based on a single style, and perhaps one or two of them might form part of a collection.

You can also attach your swatches of fabric and a color story/palette to the designs.

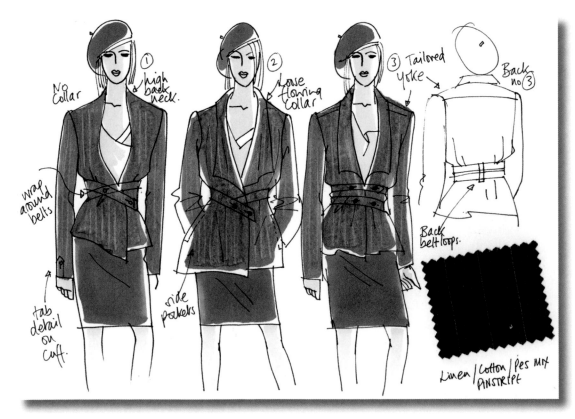

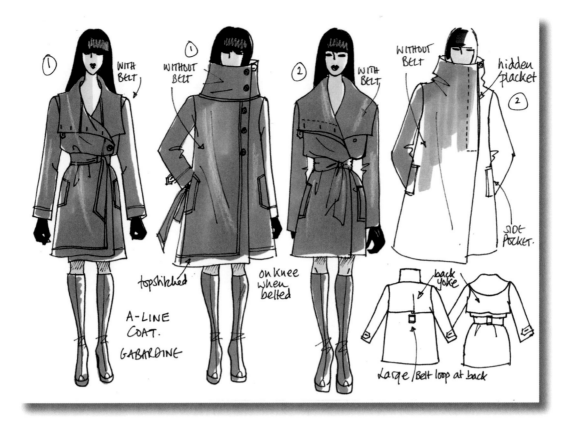

Initially, your objective should be to explore your design ideas but not be too precious or critical about the drawings and designs. As you become more experienced you will develop your own style of sketching – practice does make perfect!

From your design development sketches, the final designs can be selected then redrawn more accurately and flamboyantly for presentation purposes, or styles can be selected from the croquis to be made up as sample garments.

Fashion Croquis/Design Developments by Fashion Designer and Illustrator Lynnette Cook

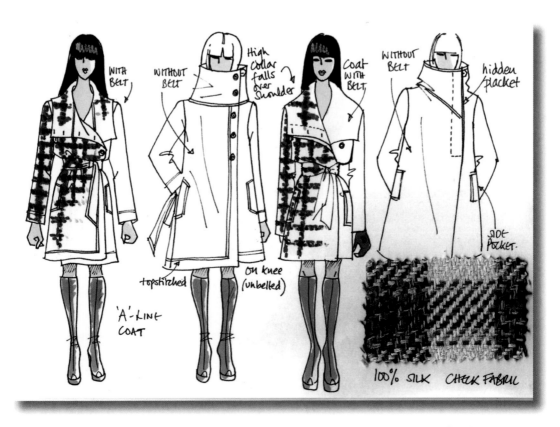

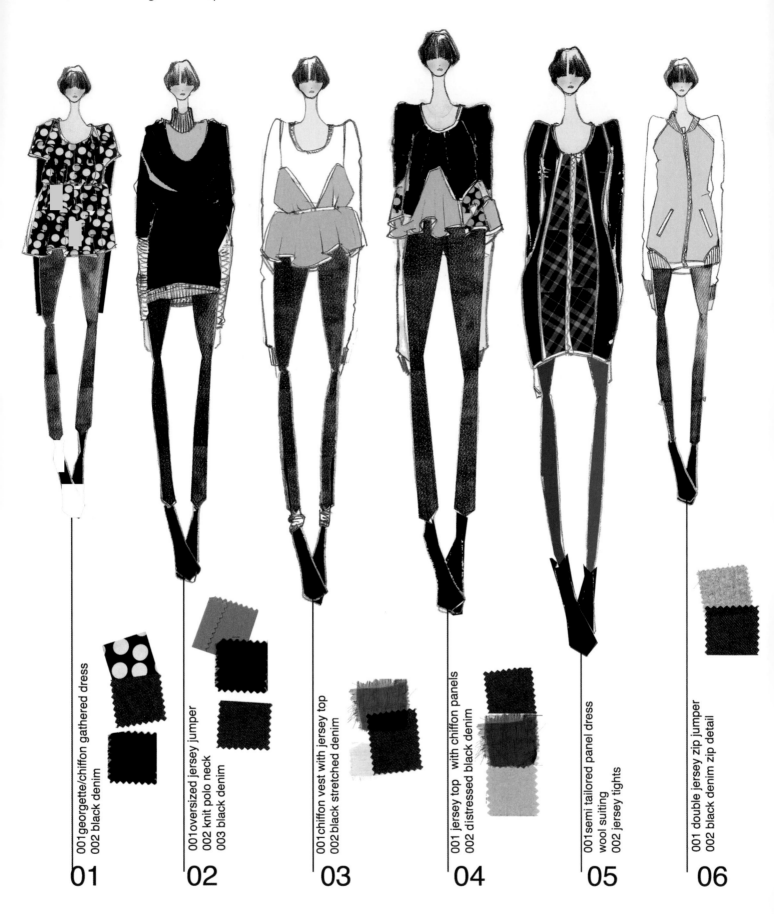

001georgette/chiffon gathered dress
002 black denim

01

001oversized jersey jumper
002 knit polo neck
003 black denim

02

001chiffon vest with jersey top
002 black stretched denim

03

001 jersey top with chiffon panels
002 distressed black denim

04

001semi tailored panel dress
wool suiting
002 jersey tights

05

001 double jersey zip jumper
002 black denim zip detail

06

Fashion Designer Aina Hussain: *This design presentation shows the development of the fashion croquis presented as a collection. The designer has utilised her design research and creativity by experimenting with design elements and design principles to produce several styles from which a buyer might select all or part of the collection. These items can mix and match to form different outfits; from babydolls, tunics and various dress shapes, to short gathered and ruffled skirts, skinny pants, jeggings, leggings, opaque tights, and jackets; parka jackets and soft tailored jackets.*

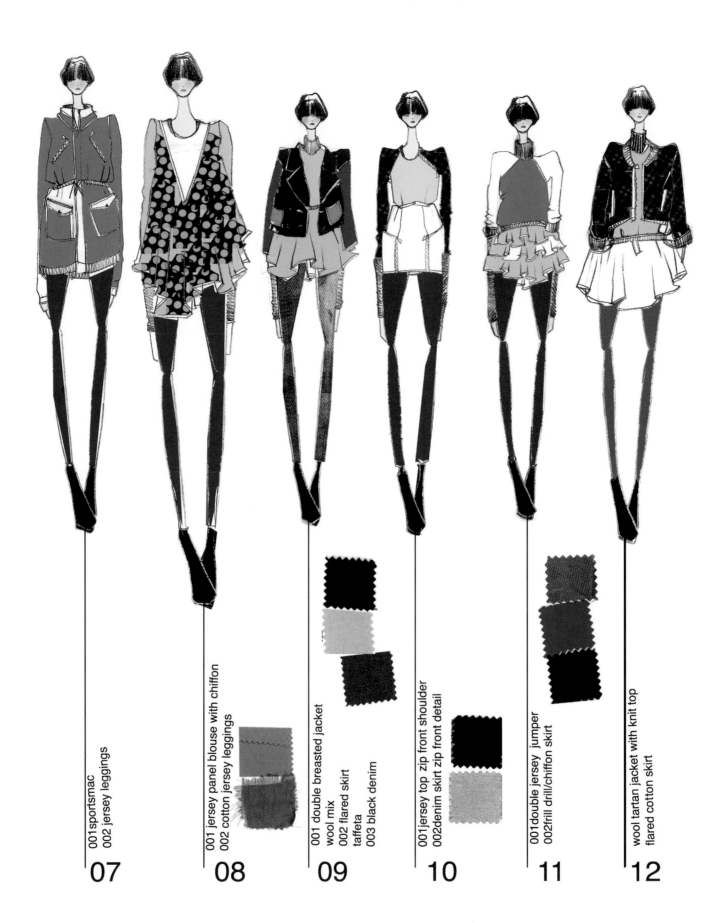

001 sportsmac
002 jersey leggings

07

001 jersey panel blouse with chiffon
002 cotton jersey leggings

08

001 double breasted jacket
wool mix
002 flared skirt
taffeta
003 black denim

09

001 jersey top zip front shoulder
002 denim skirt zip front detail

10

001 double jersey jumper
002 frill drill/chiffon skirt

11

wool tartan jacket with knit top
flared cotton skirt

12

For more information see:

Fashion Artist- *Art Kit, Sketch Books, Clothing Design* chapters.

Fashion Computing - *Flats and Specs* - Women, Menswear, Childrenswear chapters.

Fashion Entrepreneur - *Appendices.*

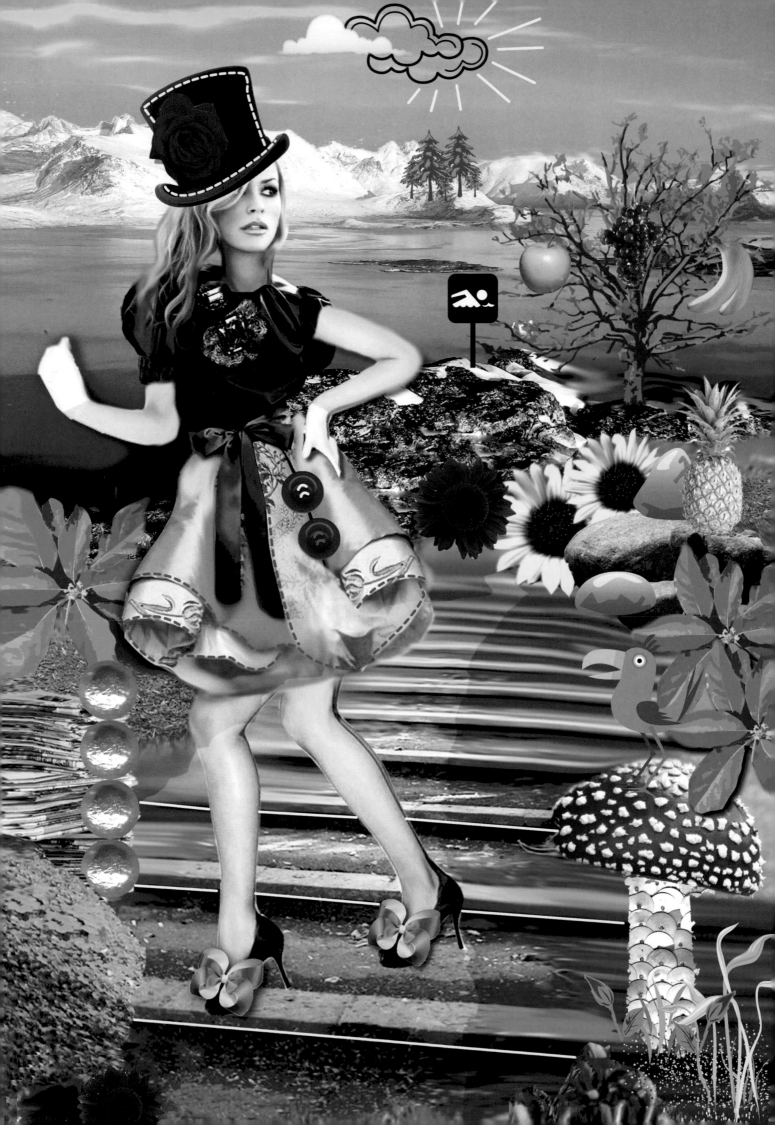

Design Presentations
and Fashion Portfolio

As a fashion designer it is important to be able to communicate and present your design ideas in a creative and dynamic 2D format as presentation boards. The fashion industry uses these boards (physical and digital) to effectively present design concepts to designers, buyers, clients and customers. Most companies use some form of presentation board to develop, promote and/ or sell their products. This chapter will explain the difference between the types of presentation boards and how they are inter-related within the fashion industry.

The previous chapters have discussed research for design inspiration and creativity, choosing color palettes, fabric selection and sourcing, and design development. This chapter will show how these design ideas can be presented in a professional, visual, 2D format as part of the design process and a *Fashion Design Portfolio*.

Topics include:

• Fashion presentations - fashion industry presentations
• Presentation board types - mood/concept/story, color, fabric, styling, etc.
• Presentation formats - layouts.
• Fashion Portfolio - layout, content, academic and professional/industry.

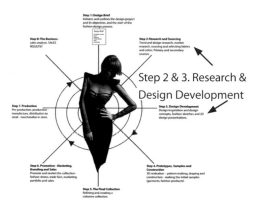

Step 2 & 3. Research & Design Development

Figure 9.1: *Fashion Design Process (see p.15)*

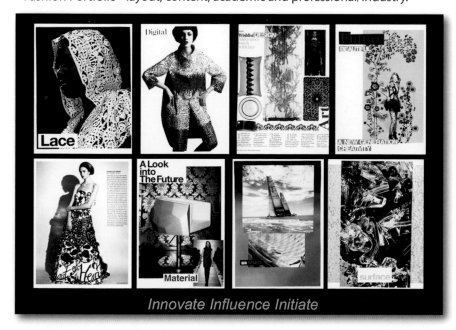

Opposite page, Fashion Designer Jessica Haley: 'Alice in Wonderland' *mood board; Alice takes a stroll in the footsteps of Vivienne Westwood with all the allure of luxury and glamour, humour, audacity and adventure - inspired by nature and treasures from grandma's secret attic. The styling would be daring, liberated and energetic, with a freshness for all generations.*

Left, Lucy Jones, UEL, Subject Director Fashion Textiles: From PowerPoint presentation - Fashioning the Future - Capturing the Zeitgeist. *Innovate, Influence Initiate; presents key trends defining fashion - luxury/nu luxury, communication, culture, lifestyle, identity.*

1. Fashion Presentations

Design Brief: The design brief will outline what type of presentation boards are required to achieve the design objectives. These presentations might be required for meetings with:

• The design team
• Individual buyers or buying team
• Merchandisers, brand managers, stylists etc.
• Clients and customers
• Global fashion industry audience (trade fairs, exhibitions, fashion events and conferences).

Above and below, Fashion Designer Priyanka Pereira: 'Bones' mood boards. *The theme and the overall color palette in the board above carries over the same mood to the board below showing the styling concept. The above has been both collaged and digitally enhanced in Photoshop; the second board has hand sketched illustrations which were then scanned and the layout edited in Photoshop.*

Opposite page**,** Fashion Consultant Paul Rider: 'Wonderland - Eco-Friendly', and 'Conceptual Design' mood boards. *These forecasting trend mood boards present nature and environmental aesthetics combined with architecture and interiors, textures, prints and colors as themes for the upcoming season.*

In design meetings, where the designers and the buyers are discussing a new collection, line or range plan for the forthcoming season, boards might include:

• A design concept (story or mood) to present the new season's themes and could include; color palettes, fabrics and basic styling concepts.
• A styling board to present flats and fashion illustrations showing

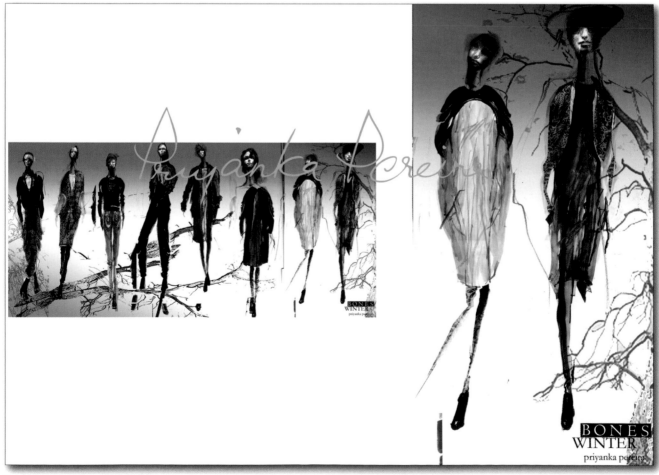

individual styles and choices, or a complete collection.
• A product development board presenting innovative concepts for a new type of handbag, shoe or head wear.

Presentation boards can be used for display for forecasting, promotional and marketing material for:
• A showroom
• Exhibition, trade fair, fashion show
• Website
• Trend books and reports.

Presentation boards are often presented together with fabric sample hangers and relevant garments or products, to further emphasise a theme or concept, the colors or the styling.

As the name suggests, presentation boards can be mounted on a board, but also can be presented in a book format or, increasingly, presented digitally and created using *Photoshop, Illustrator, InDesign* and *PowerPoint, Flash and* multimedia etc.

Creating presentation boards in digital format could be more applicable, for example, if the presentation is to be presented to a large audience, to be uploaded to the Internet, or attached to an email to target a global market. But, it is worth considering that physical objects, such as a presentation board with tactile items (fabric swatches, beads, etc.), perhaps even with the addition of suitable sound, even aroma (think floral, perfume, coffee), tend to have a higher impact on people.

2. Presentation Board Types

Mood Board or *Inspiration Board, Concept Board, Theme Board, Story Board:* These presentations are a more formal collation of your research and design concepts to present a particular theme through pictures and objects; (magazine tears, photographs), fabric swatches, trimmings (buttons, braids etc.).

To be effective, the presentation board should present a clear and cohesive visual statement, carefully considered with a strong layout to enable the 'viewer' to understand the direction of the theme being presented.
• Theme examples - Black Ice, Graphical Fascinations, Rockstar, Patchwork, Metallic.
• Layout - this type of presentation board would typically be collaged with each item having a common link.

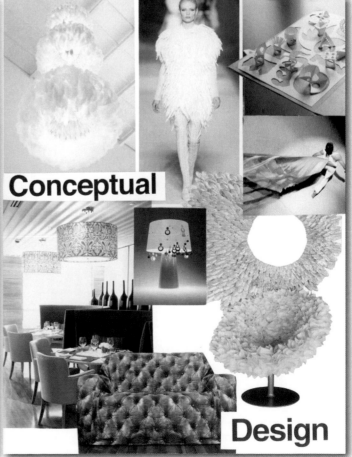

Color Board, and Fabric Board
(*Color* and/or *Fabric Presentations*)**:**
These would present predominantly
the colors and fabrics for a particular
season and include coordinated color
palettes and fabric swatches. They
could be enhanced with a fashion
illustration, flats and/or a suitable
background, but the colors and
fabrics would be the main focus.

These boards are widely used at
fabric and yarn fairs, and fashion
trade shows, where they are
displayed together with fabric
lengths (see *Fashion Forecasting* and
Color and Fabric chapters*)*.

Styling Board or *Category Board,
Design Board, Customer Board,
Concept Board, Commodity Boards*:
These boards could be presented to
a general audience, or specifically
targeted to an individual client,
customer profile or specific brand, or
be part of a buyer's *range* or *buy plan*,
and would show in detail:

• A selection of styles based on a
 particular category - styled shirts,
 e.g. suiting shirts, casual shirts,
 woven shirts, satin shirts, etc.,
• A cohesive collection – the
 complete range of garments in a
 single story with a particular theme
 or season, or market sector.

They could include the following
elements:

• Flats – (working drawings) front and
 back views.
• Fashion illustrations – designs on
 the fashion croquis.
• Colorways - the print, plus the
 coordinating color palette.

• Fabrics – coordinated fabric story,
 labelled with content, weight, etc.

Styling boards are an economical
method for initially presenting
designs to the design team or buyers
before producing a single garment.
The samples or prototypes could
subsequently be made based on
the styling and details presented
and discussed so that, at the next
meeting, everyone knows more or
less what to expect.

Successful Presentations: The
key to creating successful design
presentation boards is to keep to the
objectives of the design brief - which
means a strong theme throughout
and with the essential focus on
the particular season, customer or
market.

Designers use various creative
methods of presentation as can be
seen in the following pages and
throughout this book.

Left, Fashion Designer Paul Rider and Erika Knight: *This board presents the
colors, fabrics and overall mood for a knitwear collection .*

Below, Fashion Designer Lucy Royle: *Styling board for S/S shows a cohesive
collection based on the theme, Gray's Anatomy.*

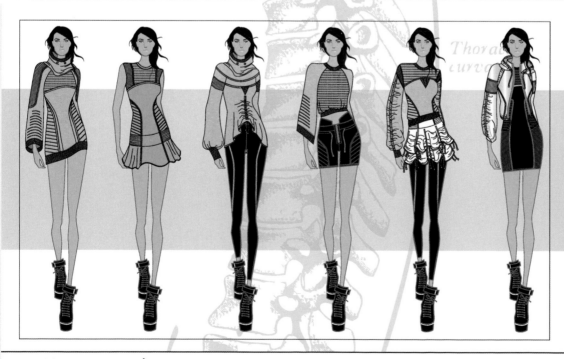

Gray's Anatomy S/S Lucy Royle

3. Presentation Formats

Design Elements: Individually, the elements for a presentation can look flat, but if all the right ingredients are grouped together in a well planned layout, the overall theme and look will be strong, interesting and commercially successful.

These linear presentation examples suggest presentation formats that include the placing of; the theme or title, fabric and color swatches, fashion illustrations, flats and descriptions.

To develop a good design layout considerations include; the grouping of similar elements, a degree of white space, and an overall harmonious balance of all the elements.

© Fashion Designer - Sandra Burke

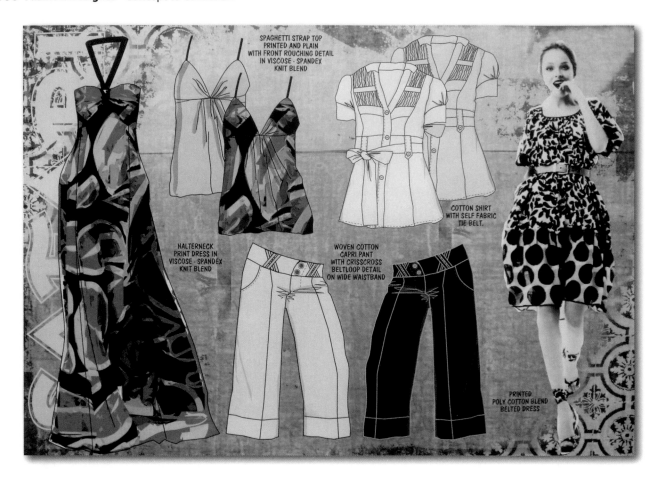

Fashion Designer Anton Lotz: *Theme 'Safari', styling boards. These have been targeted for a specific demographic and type of customer and for a specific brand. These styling boards present the mood and concepts for the collection/line and include; strong silhouettes, concepts for colors, fashion Illustrations and flats.*

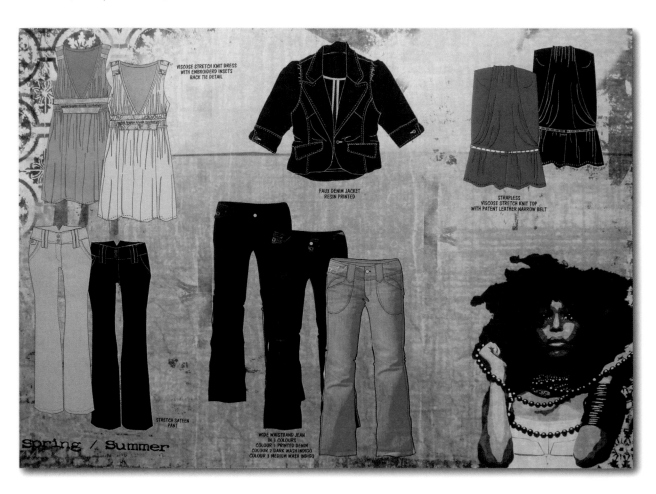

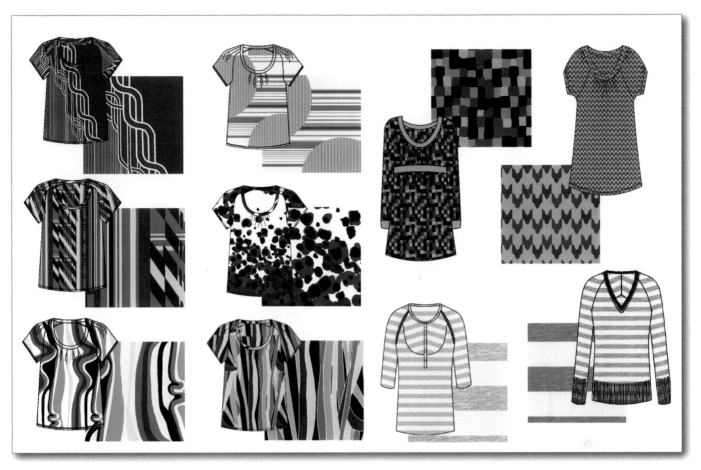

Textile Designer, Eva Snopek: *Print boards targeted for a specific brand - present the definitive prints for the collection or line and include; strong silhouettes, colors and prints, fashion styling as flats - created using CAD.*

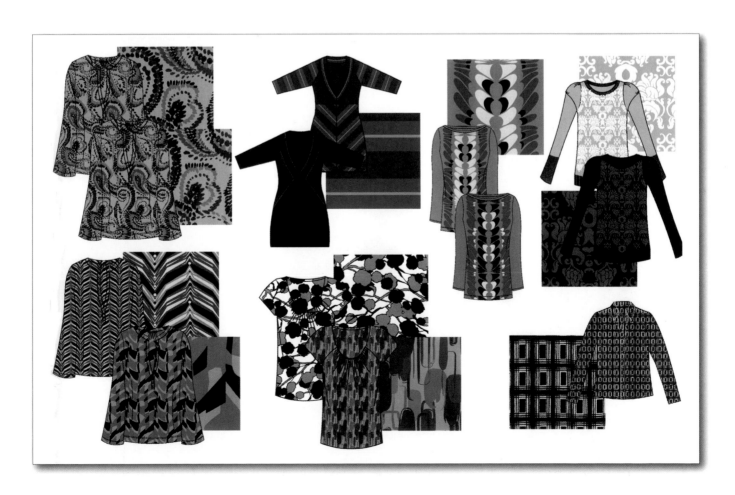

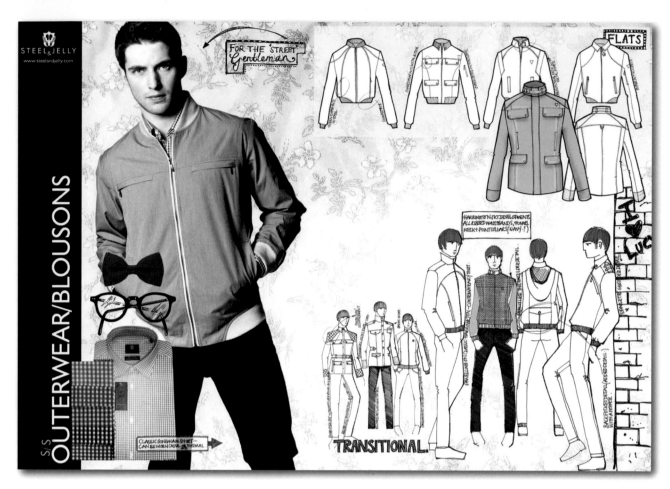

Fashion Designer Amy Lappin: *Presentation boards for menswear, targeted for a specific client/brand - the identity (logo, trademark) can be incorporated within the board. These styling boards present the concepts for the collection or line and include; strong silhouettes, concepts for colors and fabrics, fashion Illustrations and flats.*

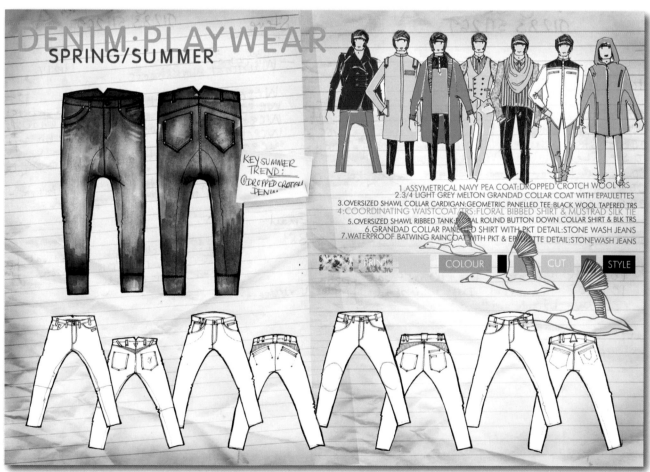

4. Fashion Portfolio

Throughout your studies and as you develop your career in fashion, your fashion portfolio will be invaluable. It is not just a collection of your work but an example of your talent, and your principle marketing tool.

A creative and well planned portfolio provides visual evidence of your capabilities expressing your unique qualities, range of demonstrable skills and your expertise in; design, creativity and innovation, technical drawing, illustration and presentation, as well as your technical skills (pattern drafting, sewing etc.). Your portfolio should be constantly updated, throughout your studies and career. It is your passport to success and career development.

Portfolio Contents and Layout:
Presentation boards can form part of an academic portfolio or a sales and marketing portfolio, together with sketch books, look books, press kits and line sheets.

When presenting or displaying boards from the three categories, they would typically be presented in the following order:
• Mood Board
• Color Board, Fabric Board
• Styling Board.

An academic portfolio in particular will be used to present assignments and design briefs. For your graduate portfolio you will need to be more selective and present only the absolute best work, including photographs of your designs and your graduate collection and any press reviews.

A professional or industry portfolio would include press cuttings with press reviews and photographs of collections, fashion stills and runway shots of your work. If you have been working in the industry, depending on your job, you would probably only have current fashion sketches and technical drawings of designs to present rather than fashion illustrations.

Interview portfolio for a position in the industry: your portfolio should be targeted to the specific market, customer/client or company and be consistent throughout, displaying work that would specifically interest the interviewer while also displaying your talent and skills. It can be presented either in physical form or as a digital portfolio.

For more information see:

Fashion Artist- especially the *Design Presentations* and *Design Portfolio* chapters.

Fashion Computing - especially the *Design Presentations and Digital Portfolio* chapters.

Fashion Designer Priyanka Pereira: *Presentation of fashion shoot to promote her capsule collection - edited in Photoshop presents the flats and garments on the model.*

© Fashion Designer - Sandra Burke

10

Design Brief
Designing a Collection

'Every season is very thematic, so I always look for inspiration in art or design, so it's either a product or the artist himself or the technique or just a part of design that's usually not seen in clothes but that translates into a print then into clothes.' Mary Katrantzou

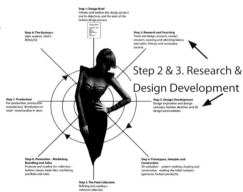

Step 2 & 3. Research & Design Development

Figure 10.1: *Fashion Design Process (see p.15)*

The starting point for any design project is the **Design Brief**. Designing a fashion collection or completing a fashion assignment involves creative solutions and visual thinking, and has all the characteristics of a project. This means it requires planning, coordination and management to ensure all the objectives are met. As a fashion designer you need to explore the design possibilities of the brief, which includes the design constraints, parameters, and design trade-offs, to be able to produce creative and marketable designs.

This chapter will present:
- Types of design briefs - academic, competition, company/client brief.
- Working to a design brief - the requirements and objectives, the delivery.
- Design brief case studies - design briefs that have been developed in 2D format to present the finished design and collection.
- The fashion design project - a barchart to help plan and control fashion projects and ensure that the design process is completed on time.

1. What is a Design Brief?

The design brief initiates the design project and the start of the fashion design process. It identifies the scope of the project and is used to guide the designer and design team through the whole project. The brief outlines and identifies;
- The client's aims and objectives or problems that need to be solved.
- Deadlines - key dates (start and completion dates).
- The constraints (design, budgets, etc.).
- Specific tasks, requirements and outcomes.

Opposite page, Fashion Designer Lidwine Grosbois: 'Printemps, Eté, Automne, Hiver' *Designing for the specific seasons.*

Right, Fashion Designer Skye Pengelly: 'The Customer,' *It is important that a fashion designer understands the needs and requirements of the target market and the customer.*

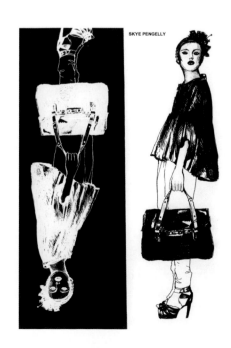

SKYE PENGELLY

Fashion Designer Cherona Blacksell:
Innovative dress design as part of her S/S collection - showing her unique sense of style and excellence in fashion sketching and illustration (see Silhouettes, Styles, Details *chapter).*

'If I were to advise somebody of how to start or get a job in the industry, I would definitely say that competitions have played a big role in my journey. I would advise they enter lots of competitions, those that offer great opportunity for 'exposure' and 'financial reward'. You really cannot do it without either of these two things.'
Frances Howie, High End Womenswear Designer

2. Types of Design Briefs

There are several types of design briefs that you might be assigned as part of your academic learning or your career within the fashion industry. These briefs include academic design briefs, competition briefs and company/client briefs.

Academic Design Brief: As a fashion student you will be required to work through many academic design briefs, some of which might be sponsored by external companies. The design brief presents the project or assignment. It forms an important part of academic learning, helping you to acquire particular skills within the design process (design development, pattern making, construction, etc.). The design projects are marked according to the criteria in the brief and go towards assessing your progress and ability.

Competition Design Brief: This type of brief is typically offered by established brands to encourage and support new and emerging fashion designers. Competitions are an excellent way of encouraging innovation, networking and gauging one's ability against the competition. As a fashion student you might have the opportunity to take part in various competitions. Prizes are often awarded; these might be bursaries, internships in industry or lucrative rewards (possibly to help start a fashion business). For the companies themselves, the competition brief is an excellent way to promote their brands, discover new talent and support education.

Company/Client Design Brief: A professional fashion designer is assigned work as a series of design briefs set by the company or the client. The brief will often be collaborative, requiring input from the design team. These briefs will require merchandise to be designed for a specific target market or client. Success will be rated on the marketability and the resulting sales of the merchandise, and on positive feedback from the 'satisfied' customer.

3. Working to a Design Brief

For your graduate collection, you are unlikely to be constrained by a design brief but, rather, encouraged to explore your unique design sense and be innovative. Possibly, this will be the most creative freedom you will ever have as a designer.

In industry very few fashion designers ever have this luxury as the majority of designers will work in the most commercial sector the 'mass market' - the largest area of fashion. This market, typically, brings with it more design constraints in regard to price and quality, especially when compared to designing for ready-to-wear and the luxury brands. Successful designers that are at the leading edge of change, such as, John Galliano, Marios Schwab, Martin Margiela are just some of the few designers who, to a degree, are able to express more of their individual creativity as their market is generally more trend and quality driven and is willing to pay far more for a designer label.

The design brief outlines what is required - this will influence what you design (see Table 10.1 which explains the aims and objectives of a typical design brief). Depending on the company, the involvement that you have in all sections of the brief might differ; for example, the fabric department might source all materials and trims, and the assistant designer might develop the spec sheets.

Delivery of the Brief: Academic briefs are documented and set out in a format for the student to digest and work through but, in the fashion industry, the brief is often given informally in a design meeting.

Fashion Design Brief	
Project Name	Identifies the project by; Company Name, Theme, Season, e.g. Gucci Spring 2015, Ready-to-Wear Collection.
Brief Number and Date Issued	The brief's number and date issued identifies and registers the brief within the company. This means it can be easily filed (archived) and easily retrieved.
Client	The client could be the buyer, company, private customer.
Responsibility	Identifies who is responsible for the project - this could be the designer or design team. When design changes occur it is important to be able to identify who is accountable for the change. This is particularly important in large companies and in large teams where there could be numerous projects in progress at any one time.
Season or Event	Establishes the particular season and date, event or occasion; Spring/Summer, Fall, Autumn/Winter, Transitional, Mid Season, year, fashion show, music awards evening, celebrity wedding.
Objectives	The objective of the brief could be to produce a cohesive collection of 50 pieces or outfits, a range of dresses, or an individual outfit for a private client. This could also be called the scope of work, identifying what should result from the project.
Target Market	Outlines the market, level, product and demographic. The project might be for a womenswear, a ready-to-wear or evening wear range, or for a menswear, high street, sportswear collection (see *The Fashion Market* chapter).
Price Points	Outlines the need to design to a specific price point. Price points are, ultimately, determined by what the customer is prepared to pay (see *The Fashion Market* chapter and *Appendices Design and Production Process* [cost sheets]).
Key Dates, Deadlines	Outlines the design project's schedule and includes the key dates and the completion date of the project, which can be presented as a bar chart (see Fig. 10.2) which includes: • Styling meetings to discuss and present the initial design concepts (themes, fabric, colors, silhouettes), design boards, the samples/prototypes, the final collection. • The marketing, production and delivery to stores. • Anything made specifically for the project, and especially made off-shore, will require longer lead times to allow for shipping - this includes; fabric sampling and bulk, printing, prototypes, production.
Design Requirements Styles, Silhouettes, Colors and Fabrics	Outlines particular design requirements - styling, colors, fabrics. In a company whose target market is highly trend-driven there will be a much broader scope to adopt new fashion trends, colors and fabrics compared to a company whose customers prefer more classic styling. Based on these design considerations, most fashion companies will identify a stock item or best seller that continually sells well every season and is included in all collections. This could be the little black dress, white shirt, black pant, five-pocket jean. The company might update the design or trial it in a new fabric.
Design Presentations	The designs might need to be presented as 2D presentation boards, a design portfolio and/or a PowerPoint show or media presentation. 2D presentations might include; a mood board, a color and fabric board, a styling board with flats and fashion illustrations showing a co-ordinated collection.
Samples/Prototypes (Collection, Line, Range)	The designs might need to be presented as 3D samples/prototypes, or as a finished cohesive collection (line or range). The number of designs required will be identified and if they are to be presented informally on mannequins or on a clothing rack, on an in-house model or hired models as a mini fashion show, etc.
Approvals, Presented To, Where and How	Describes to whom, where and how the project or collection is to be presented: • To the creative director, design team, buyers, or client. • How and where could be in-house, at an exhibition, on the runway (Fashion Week, Trade Fair), in-store, at the buyer's premises, or at the design agent's/rep's showroom. In the academic forum the presentation will be made to teaching staff, and could include the sponsor, company, professional designer, etc., if it is an outside project.

Table 10.1 The Fashion Design Brief - *shows how the fashion design brief initiates the design project and the start of the fashion design process. It identifies the scope of work, outlining and identifying the aims and objectives, and specific requirements, tasks and outcomes.*

4. Design Brief - Case Studies

The fashion design brief requirements have been visually presented as 2D presentations in the following case studies. From these presentations the next step in the design process would be to make the samples or prototypes, from which the final collection can be produced (covered in the following chapters).

Design Brief 1

Project Name: French Connection, Intimate Expressions - Diffusion Range.

Brief No./ Date Issued: Feb 2015.

Client: FC Design Director.

Responsibility: Head Designer of Womenswear Design Team.

Season: Spring/Summer.

Objectives: Design a range that presents romance, softness mixed with elements of structure, body shape and form.

Target Market: Womenswear, fashion forward women 20 to 35 years, looking for a quirky spin on design. Middle market, quality and affordable garments.

Price Points: $$ to $$$.

Deadlines: 2nd April design boards, 20th July final collection.

Design Requirements: **Styling** - structured denim styles; update last season's best selling denim skirt styles; ruffles, layering and topstitching details. **Colors** - soft with bright accents.

Fabrics - denim, silk, chiffon and lace.

Design Presentations: Mood and inspiration boards, and design development boards to present the proposed collection.

Present to: Fashion Buying team, in-house as board presentations.

Fashion Designer Cherona Blacksell: *The fashion design process starts with the trend research, sourcing and sampling fabric, selecting color palettes, design development, then making the patterns and samples. These presentations show how fashion designer Cherona Blacksell worked through the design stage of planning the collection to produce a mood board, trend and inspiration board, and two design development boards. These would then be shown to the head of the design team before patterns and samples are made.*

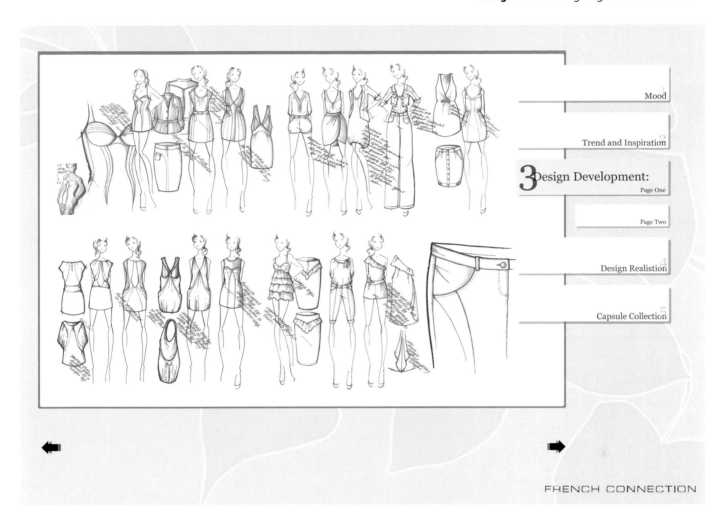

Mood 1

Trend and Inspiration 2

3 Design Development:
Page One

Page Two

Design Realistion 4

Capsule Collection 5

FRENCH CONNECTION

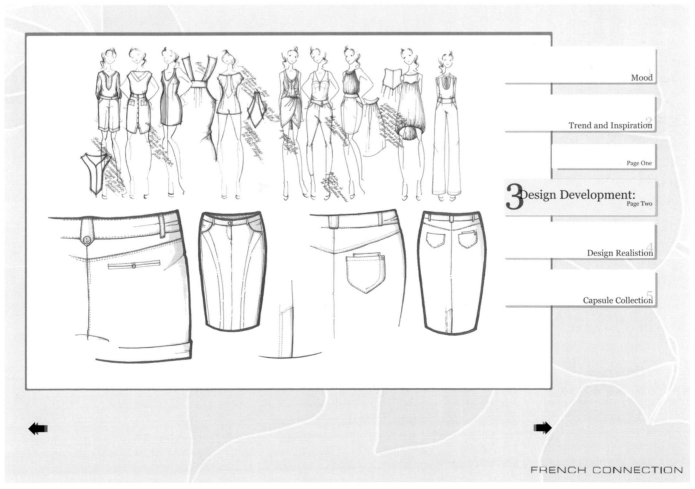

Mood 1

Trend and Inspiration 2

Page One

3 Design Development:
Page Two

Design Realistion 4

Capsule Collection 5

FRENCH CONNECTION

© Fashion Designer - Sandra Burke

Design Brief 2

Project Name: Rosina Bella, Careerwear Tailoring Collection.

Brief No./ Date Issued: Feb 2015.

Client: Harvey Nichols Womenswear Careerwear Buyer.

Responsibility: Head Designer of Women's Careerwear Design Team.

Season or Event: Spring/Summer.

Objectives: Design a collection of co-ordinated careerwear that present contemporary tailoring, soft separates with casual wovens.

Target Market: Modern career women, 20 to 35 years, looking for a mix of smart, sophisticated and casual feminine styling. Middle level.

Price Points: $$ to $$$.

Deadlines: 2nd April design boards, 5th August final collection.

Design Requirements: Styling - soft tailoring, crisp shirting styles, soft tunics and tops, dresses, skirts, pants and shorts; tucks, pleats, gauging details.

Colors - white, indigo, raspberry, greys.

Fabric - jersey knits (dress and top weight), crepe, wool blends, cotton blends.

Design Presentations: Mood and inspiration boards, and design development boards to present the proposed collection.

Present to: Harvey Nichols Womenswear Careerwear Buyer, and buying team at Harvey Nichols.

Fashion Designer Amy Lappin: *These three presentations show how fashion designer Amy Lappin worked through the design stage of planning the collection to produce a mood/trend board with the branding, color and prints presented, the illustrated line-up of the collection, and a style board presentation showing the flats with the styles in detail. These presentations would then be shown to the buyer to approve before patterns and samples are made.*

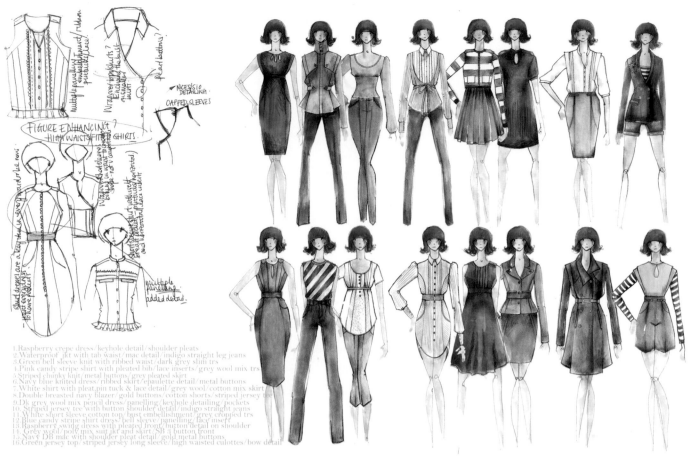

1. Raspberry crepe dress/keyhole detail/shoulder pleats
2. Waterproof jkt with tab waist/mac detail/indigo straight leg jeans
3. Green bell sleeve knit with ribbed waist/dark grey slim trs
4. Pink candy stripe shirt with pleated bib/lace inserts/grey wool mix trs
5. Striped chunky knit/metal buttons/grey pleated skirt
6. Navy blue knitted dress/ribbed skirt/epaulette detail/metal buttons
7. White shirt with pleat,pin tuck & lace detail/grey wool/cotton mix skirt
8. Double breasted navy blazer/gold buttons/cotton shorts/striped jersey tee
9. Dk grey wool mix pencil dress/panelling/keyhole detailing/pockets
10. Striped jersey tee with button shoulder detail/indigo straight jeans
11. White short sleeve cotton top/bust embellishment/grey cropped trs
12. Blue candy stripe shirt dress/bell sleeve/panelling/lace insert
13. Raspberry swing dress with pleated front/button detail on shoulder
14. Grey wool/poly mix suit jkt and skirt/SB 3 button front
15. Navy DB mac with shoulder pleat detail/gold metal buttons
16. Green jersey top/striped jersey long sleeve/high waisted culottes/bow detail

ROSINA BELLA TAILORING
S/S

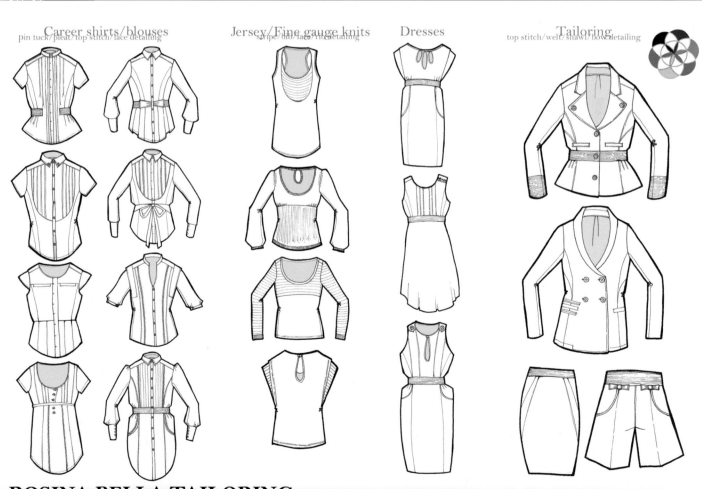

Career shirts/blouses
pin tuck/pleat/top stitch/lace detailing

Jersey/Fine gauge knits
stripe/bib/lace/ribbed detailing

Dresses

Tailoring
top stitch/welt/shawl/bow detailing

ROSINA BELLA TAILORING
S/S

Design Brief 3

Product Development

Project Name: Tremlett & Taylor Promotional Launch.

Brief No./ Date Issued: Feb 2015.

Client: Design Directors T&T.

Responsibility: Design Team T&T

Season: Spring.

Objectives: Design four outfits to promote the new design business of the bespoke contemporary innovative work of Tremlett & Taylor, and statement pieces that complement the reproduction, French antique furniture from 'Sweetpea & Willow'. Produce a selection of promotional photos taken in an outdoor location.

Target Market: Fashion forward women 20 to 35 years, looking for innovation in design - high end and bespoke, quality and exclusivity.

Price Points: $$ to $$$.

Deadlines: 2nd Jan design boards, 20th March final outfits and photo shoot complete.

Design Requirements: Styling - eccentric silhouettes and styling; ruffles, layering, quirky but feminine.

Colors - white, soft pinks and black.

Fabrics - Silk, satin, organza and lace.

Design Presentations: Mood and design development boards.

Final collection of 4 outfits.

3 final photos for press release.

PowerPoint presentation of complete project, concept to realisation.

Present to: Sponsors of T&T and design directors of 'Sweetpea & Willow' on location (tbc).

Photographer Rae Hennessey
Hair stylist Casey Coleman
Make up artist Jazmine Ali

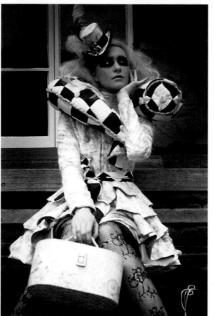

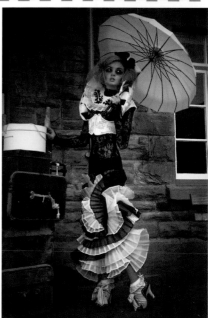

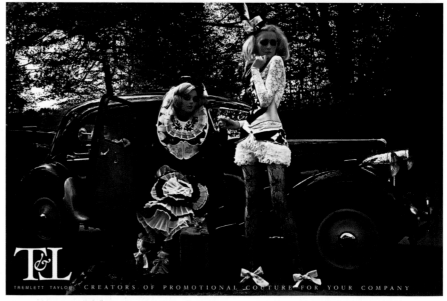

Fashion Designers Claire Tremlett and Rachel Taylor: *Tremlett & Taylor promotional launch campaign. The above shows the designers' concept board and the final outfits and promotional photos shot on location.*

Design Brief 4

Project Name: Steel Jelly Tailoring range.

Brief No./ Date Issued: Jan 2015.

Client: Design Director.

Responsibility: Head Designer of Menswear Design Team.

Season: Spring/Summer.

Objectives: Design a range that presents quintessentially English classic style. Combine contemporary tailoring with 'on trend' casuals. Inspiration derived from 1950s tailoring.

Target Market: Menswear, males 20 to 40 years. RTW, designer market, quality garments.

Price Points: $$ to $$$.

Deadlines: 2nd March design boards, 20th June final collection.

Design Requirements: **Styling** - **Tailored** styles, jackets, pants and waistcoats, shirts and ties.
Casuals - leather jackets, hoody jackets, anorak, pants, shirts, knitwear.
Details - bonded seams, raglan sleeves, belt detailing, quilting, jet pockets.

Colors and pattern - Grey, tonal and accent colors.

Fabrics - Surface interest textiles, contrast linings (poly/viscose). Double faced cotton, waterproof fabrics, waxed cotton, poly mix/cotton linings Bold checks, contrast and pattern.

Design Presentations: Mood and inspiration boards, and design development boards to present the proposed collection.

Present to: Fashion Buying team in-house.

Fashion Designer Amy Lappin: *Menswear presentations show a mood board and two style boards presenting the flats and specific styling details, colors and fabrics.*

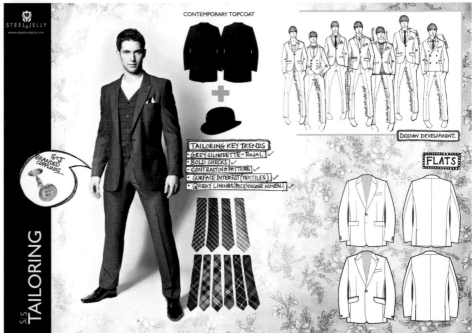

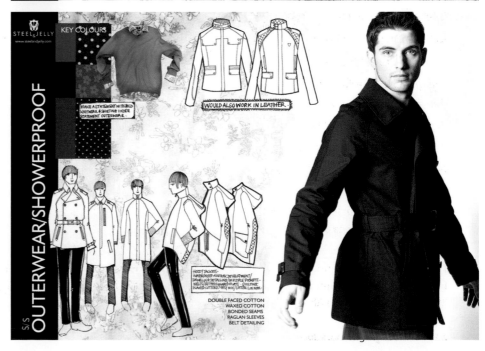

5. Fashion Design Project

The barchart, Fig. 10.2, is a helpful project management tool for planning and controlling fashion projects for communicating information and instructions to the design team and interested stakeholders. The barchart shows the design cycle, the procurement, the resources and the budgets on one document. When the design project starts, the barchart can be used to show progress and used to control the project. The barchart shows:

• The scope of work [1] against a timeline (along the top of the diagram) [2].

• Column [1] shows the sequence of the work against the timing of the work - start and finish dates [3] and [4].

• Milestones or key dates/deadlines [5] represented by the diamonds.

• Who is responsible for the individual tasks [6].

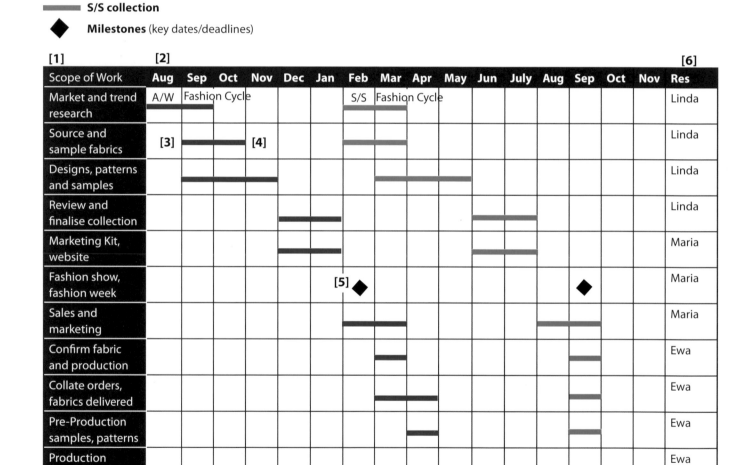

[A/W (Fall) collection]

[S/S collection]

Milestones (key dates/deadlines)

Scope of Work	Aug	Sep	Oct	Nov	Dec	Jan	Feb	Mar	Apr	May	Jun	July	Aug	Sep	Oct	Nov	Res
Market and trend research	A/W	Fashion Cycle					S/S	Fashion Cycle									Linda
Source and sample fabrics	[3]			[4]													Linda
Designs, patterns and samples																	Linda
Review and finalise collection																	Linda
Marketing Kit, website																	Maria
Fashion show, fashion week						[5] ◆								◆			Maria
Sales and marketing																	Maria
Confirm fabric and production																	Ewa
Collate orders, fabrics delivered																	Ewa
Pre-Production samples, patterns																	Ewa
Production																	Ewa
Shipping, deliver to store, COD																	Ewa
Collect Payments																	Maria

Figure 10.2 Barchart - Fashion Design Project – shows how the barchart can be used to plan a fashion design collection from design, sales, and manufacture to distribution.

Note how the A/W and S/S design cycles overlap. This example is for the northern hemisphere - due to the difference in seasons, those in the southern hemisphere will be designing their S/S collections when the northern are designing A/W for example.

Figure 10.2 Barchart - Fashion Design Project : Linda [6] starts the A/W design cycle in August with market/trend research, sampling fabric, designing and making the samples. The collection is finalised in January, along with the sales and marketing material (brochures, line sheets, look books and website).

In February, the collection is launched at a fashion show during 'Fashion Week' [5]. Sales orders are taken in February and finish end March when they are collated. During March the orders for the raw materials are confirmed, along with the confirmation of the production schedule with the CMTs (cut, make and trim factories). By the end of April all fabrics and trims for production are delivered.

During April the pre-production patterns and samples are approved. Production takes three months from 1st May to end July. The goods are shipped/distributed to the stores during August. Payments are collected as COD (Cash on Delivery) in August, and further payments are collected during the months of October and November.

While the Autumn/Winter design and manufacturing cycle is in progress so the next season, Spring/Summer's fashion cycle begins, and so the design cycles are repeated and overlap.

This cycle could be repeated several times a year depending on the type of fashion business (fast fashion etc.) and how many collections, or projects are being carried out.

'In our design team, we work with a 'critical path calendar' to note all the special events. This means that we are always aware of any special holidays like Chinese New Year, the fabric and trade fairs, and we can then plan who is going where. This is critical especially when there is a really big event on - it means we can spread the load as to who goes where and who covers what event.

We would then have a debrief session where we all meet up after our different shopping trips and fabric shows to present what we have found - what's in trend, the new fits in design and new ideas.

The important fabric shows for myself and the other designers in the team have always been PV (Première Vision) and Texworld; we might also go to the Shanghai and Hong Kong fairs and the London Turkish fabric fair.'

Fashion Designer Louise Davies.

As most fashion collections are seasonal, fashion designers typically design six months ahead of the particular season. With 'instant fashion' lead times will be shortened to enable a quick turn around from the initial design concept to store. Some companies, by contrast, might be working even a year ahead especially if they require exclusive fabrics, prints, and colors.

Due to public demand for new styles and faster fashion, the turnaround times and design cycles from research to distribution are getting faster and shorter. Some companies might have a signature or core range and follow the design cycle as in fig. 10.2, for example, the ready-to-wear collections show every six months. But they might also have several shorter design cycles in between where they bring out smaller ranges and pre-collections.

For more information see:

Fashion Artist - *Clothing Design, Design Presentations, Men, Children* chapters.

Fashion Computing - *Flats and Specs Women, Menswear, Childrenswear, Design Presentations* chapters.

Fashion Entrepreneur - Design and Production Cycle, *Project Management Skills* chapter.

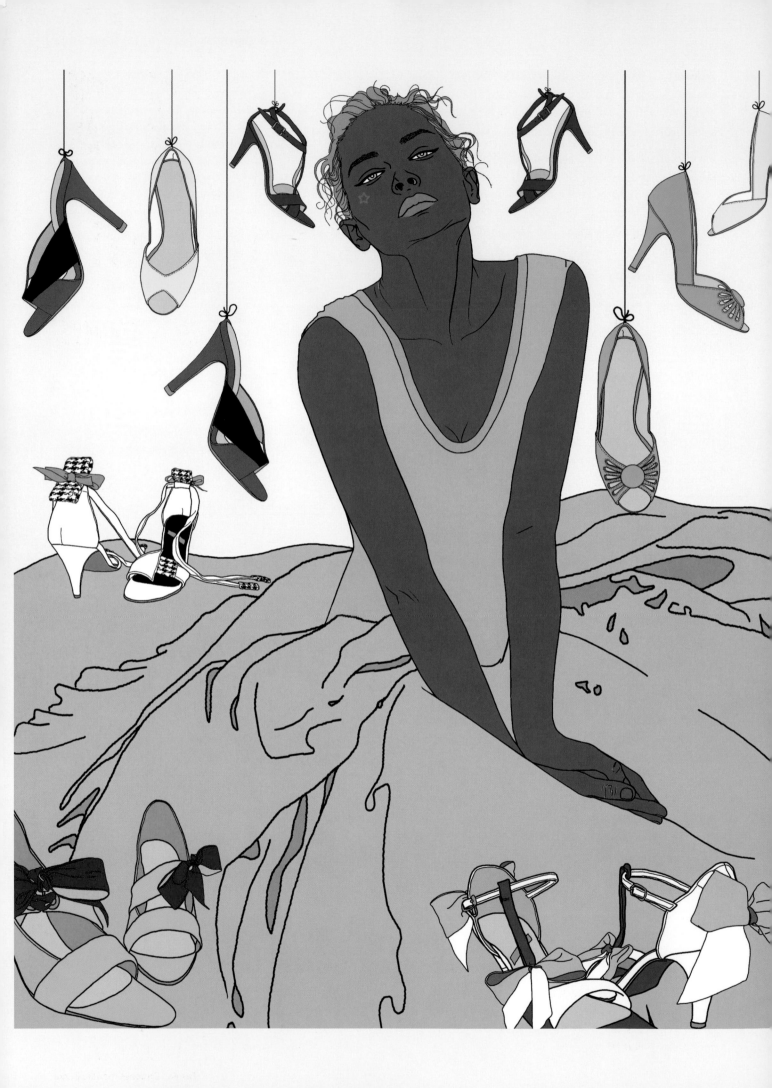

11

The Design Studio
Construction, Samples, Prototypes

'About half my designs are controlled fantasy, 15 percent are total madness and the rest are bread-and-butter designs.' Manolo Blahnik

As a fashion designer, one of your key challenges is to translate your 2D fashion sketches and conceptual designs into 3D prototypes or samples. As discussed in the previous chapters, the fabrics you select for your designs, as well as the elements and principles applied will affect the overall silhouette and look of the styles.

It is crucial that you have an adequate understanding of construction and a degree of technical skill to be able to produce your designs. This means that even if you do not actually make the patterns or samples yourself once you are working in the industry, you will at least be able to communicate clearly and knowledgeably with the specialists of the trade; pattern makers, sample machinists, production team, and factories/CMTs. It also means that, if you choose to start up your own small entrepreneurial business, you can be more 'hands on' and have competitive advantage over those designers who might lack these skills.

This chapter introduces you to:
• The design studio - tools and machinery.
• Making the patterns - drafting and draping.
• Construction - making the samples and prototypes.
• Seams, details and finishes.

Left and right, Fashion Illustrator Montana Forbes: *Promotional illustrations present the final fashion products.*

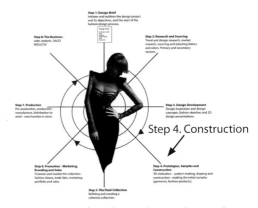

Step 4. Construction

Figure 11.1: *Fashion Design Process (see p.15)*

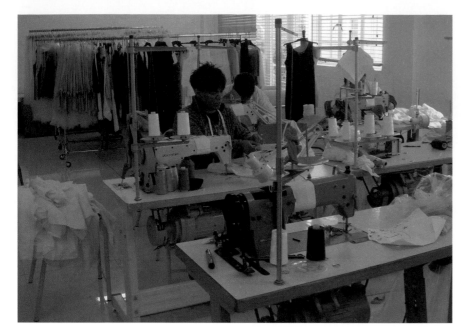

1. The Design Studio

In the design studio you might be working alongside pattern makers, sample machinists and a team of fashion designers, or you might be in your own studio doing everything yourself. In the academic environment there is often a technician to give advice and support with pattern and sewing skills.

Machinery and Tools of the Trade:
Typically the equipment would be industry-standard but could include certain domestic equipment, especially in a small entrepreneurial business:
• Pattern cutting table
• Dress form (stand, mannequin)
• Industrial flat bed (sewing) machine
• Overlocker, coverstitch (seam coverer and binder)
• Buttonhole and button sewer machine
• Steam iron/industrial iron, pressing table (vacuum), fusing press.

Extras could include; embroidery machine, knitting machine, specialist equipment if making accessories, hats, footwear, bags, etc. Also, dedicated areas for; CAD (computer-aided-design - creating patterns), laser cutter and digital printer (fabric).

Pattern Drafting and Sewing Kit:
• French curve (for drawing and measuring curves)
• Set square
• Tracing wheel
• Metre/yard rule
• Tape measure
• Paper shears (scissors), fabric shears
• Rotary cutting knife
• Small scissors
• Awl/Spike
• Notcher
• Hole Puncher
• Tailor's chalk, pins, needles, thread, bobbins/spools for sewing machine, pencils and markers.

2. Making the Patterns - Drafting and Draping

Specification Sheets: Before drafting the first pattern a specification sheet is created with a technical drawing of the design and its relevant details. This spec sheet will be used throughout the sample and production process, and updated as required.

The design is drawn to scale with construction lines and styling details, front and back views, specifications and key measurements, including; label positions, stitching details, fabric and trim details, and any special requirements (embroidery, printing fabric treatment, etc.). These sheets are the fashion designer's primary source of communication and liaison with the pattern makers, sample machinists, and production team (see A*ppendices - Design and Production Process*). Before the design goes into production, the information on the spec sheet must be absolutely accurate to ensure that the manufacturing team (fabric and trim buyers, and production) know exactly what specifications they must follow to avoid costly mistakes.

Top, Design Sample Room: *These sample machinists are working on flat bed industrial sewing machines to create the sample collection. The room is set out for several machinists. These specialists also sew small production runs.*

Below, Pattern Drafting Tools: *These pattern drafting tools include a French Curve (flat with curved edges used for drawing curves - armholes, necklines), metal ruler/square.*

Opposite page, top to bottom, FEDISA: *Flat pattern making in progress.*

Fashion Designer, Georgia Hardinge: *Sketch to modelling on the dress stand.*

Software for Technical Drawings: A drawing package, such as *Illustrator* or *CorelDraw,* is ideal for drawing up the final design for your specification sheets (see *Costing Sheet,* A*ppendices - Design and Production Process*).

Standard Size: In the fashion industry, standardized sizing for pattern-drafting, grading, and even labelling procedures are continuously being perfected. The USA uses the imperial system of measurement (yards, feet and inches) but most other countries use the metric system (metres, centimetres and millimetres). When drafting a pattern for a standard body/figure size you would need to consult with the company or manufacturer that you are working with to ensure you make the patterns using their specifications. A sample size for womenswear in the USA would typically be a size 8 or 10 model (missy), and in the UK a size 8, 10 or 12.

First Pattern: This is the pattern from which the first sample garment is cut and sewn. It is made to fit a standard sample size. The pattern could be drafted on the stand or as a flat pattern (hand or computer generated).

The Dress Form: A dress form is an essential aid for the designer and pattern maker. It is modelled on the human form with style lines corresponding to the fit and construction lines from which patterns and garments are made.

There are various forms available; women, men, children (girls, boys, toddlers), maternity, torso, trouser, and with features such as adjustable height, retractable shoulders and flexible or detachable arms or legs.

Draping/Modelling: This technique uses the dress stand to help create patterns. It is used especially for couture, evening wear, creating soft flowing designs (jersey, silk fabrics), working 'on the bias', and creating complex shapes. By draping muslin, calico, or the actual fabric for the garment, it allows the designer and pattern maker to check the proportions and lines of the garment, and evolve or alter the design during the process. Every piece is carefully marked (centre front, centre back, side seams, shoulder and fit lines) then removed and copied on to a pattern paper or card.

Flat Pattern: Flat patterns are drafted from a *block* or *sloper* (US). Blocks or slopers are the basic foundation patterns (bodice, sleeve, skirt, dress, pant, tailored jacket) that are drafted from a set of specific measurements to perfectly fit a standard size. The *standard* blocks are used for each new style and adapted by swinging darts and adjusting seam lines. Every company should have its own standard block.

In *Couture* or *Bespoke Tailoring* customers will have blocks drafted specifically for their body measurements. These are kept 'on file' so that customers can return to have further garments made to their measurements without new blocks having to be made.

Fashion Designer, Georgia Hardinge:
Sketch to 3D form draping on the dress stand. Draping is a creative way of designing a garment by sculpting the fabric, experimenting with silhouette, line, texture and form by folding, tucking, pleating, cutting, slashing and pinning the fabric to create the desired shape.

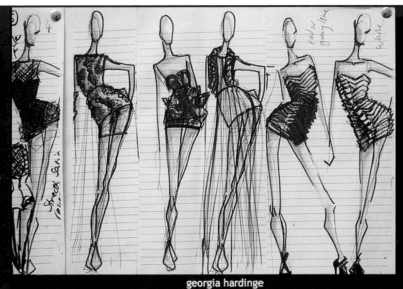

georgia hardinge

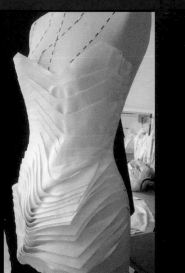

© Fashion Designer - Sandra Burke

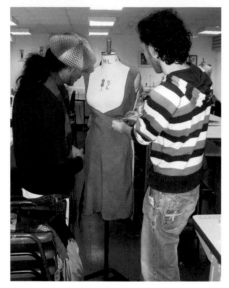

Above, top to bottom, RCA *expert machinist helps create the samples and collections; Bournemouth University Professor and student draping fabric/ garment on the dress stand.*

Below, Footwear Designer Sophia Grace Webster: *Developing her prototype footwear at the RCA. Specialist machinery is required to stitch the materials/leather and lasts are used for shaping.*

3. Construction - Making the Samples

First Samples:

The first sample garment, also called a *toile* or *muslin,* is usually made in an inexpensive fabric such as calico, or a fabric that is similar in weight and characteristic to the intended fabric of the final garment. By using substitute fabrics it is possible to see how the styles will look (fit, hang, drape) and any fitting or design alterations can be made to the sample without wasting expensive fabric.

In the fashion industry, the samples are made by sample machinists who should be expert at making an entire garment and also be knowledgeable about production methods. In many companies, the first sample might be made in the factory where the production will be handled. This could be offshore which reinforces the need for accurate detailed specification sheets to avoid costly misinterpretations of designs.

Fitting: The next step is to check the sample garment for fit on a model (real body). In addition, comfort and ease of movement as well as design are considered to confirm:

• The garment can be put on easily - check zip lengths, neckline measurement, button openings.
• The model can walk in the garment easily - a long straight skirt might need a side or back slit, bigger hem circumference.
• The model can comfortably move both arms especially if the sample has sleeves - check the armholes are not too deep, shallow, tight.
• The model can sit down in the garment easily.
• The garment does not fall off the shoulders during movement. Some strapless and backless dresses are a problem and might need boning (corsetry), thin tape, ribbon or a transparent, light fabric to hold the garment in place.

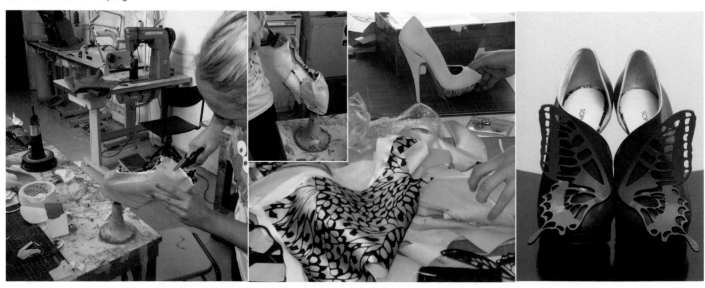

Final Sample: Alterations are made to the first sample and the patterns. Possibly one or two more samples will need to be made to perfect the fit. On approval the sample can then be cut in the actual fabric for the collection.

Pre-cost: At this stage the sample might be sent to the costing specialist who will establish the cost of making the garment for production, and suggest ways of making it more effectively or to a better standard - perhaps improving the method and speed of construction, or the fabric rating (how much fabric it takes to make the garments for production). A small alteration could mean a vast saving during the manufacturing process. For example, the fabric could constitute 60% of the garment price. Trimmings, printing, etc., must also be allowed for. In RTW the mark up can be 120%, and the retailer might add their mark up of maybe 100% to 150% onto this.

Marking and Cutting the Sample Fabric: When laying and marking the pattern pieces on the fabric the correct grain line must be used - (straight, cross, bias). There might also be other considerations, for example, if using:

- Plaids; they must be matched - side seams, hems, the lapels for example must match left and right.
- Fabrics that have a pile, such as velvet or corduroy, will need to be cut with the nap going in the same direction (top to bottom, or shading will occur depending on which way the fabric is laying).
- Fabrics that are soft and light or stretch, such as satins, silks, knits, jersey, need to be carefully laid and marked so that the fabric is not pulled out of shape.

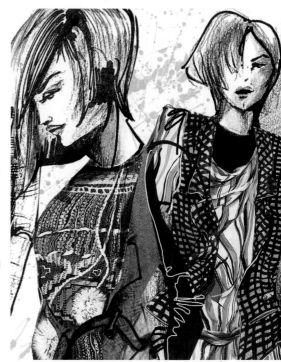

Above, Fashion Designer Nadeesha Godamunne: *Illustration of silk, soft tailored outfit - plaids must be matched across lapels, pockets and side seams.*

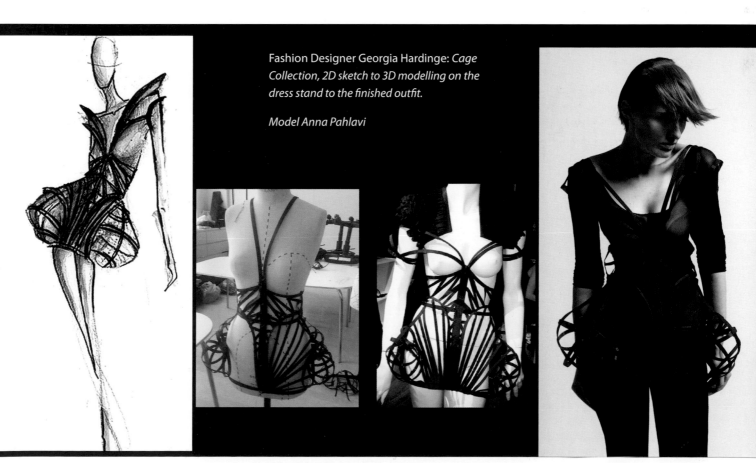

Fashion Designer Georgia Hardinge: *Cage Collection, 2D sketch to 3D modelling on the dress stand to the finished outfit.*

Model Anna Pahlavi

© Fashion Designer - Sandra Burke

4. Seams, Details and Finishes

In the fashion industry there are various seams, details and finishes that are used to sew garments depending on the garment and fabric type. Most are created by machine, but hand finishes and details are used for haute couture and bespoke clothing.

The flat bed machine is used for much of the construction process with additional feet and fittings, and needle widths as applicable.

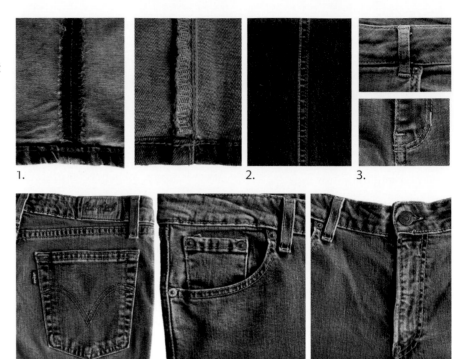

1. 2. 3.

4. 5. 6.

Classic five pocket jean with contrast stitching: Top row, left to right:

1. Inside - straight seam or running seam with overlocked finish. *The most popular seam suitable for most fabrics. Stitched using a flat bed machine. The seam allowance (inside garment) can be pressed open or pressed to one side and topstitched.*

2. Right side - run and fell or welt seam. *The most popular seam for denimwear (jeans, jackets, etc.). The right side will often have twin needle topstitching. This seam has one row of contrast topstitching.*

3. Front - waistband *shows bar tack on belt loop, and metal rivet where pocket meets;* front fly *with bar tack to reinforce zip ending and twin needle stitching.*

Lower row, left to right:

4. Back jean - *back pocket/five point pocket features Levi's branding - stitching on pocket, branded rivets and leather patch, side winder (label) or tab.*

5. Front jean - *coin/ticky pocket with twin needle contrast stitching and rivets.*

6. Front jean - *twin needle zip placket, key hole buttonhole and branded stud button.*

Below, top to bottom:

7. Rib and silk - *cover seam with spreader or flat lock.*

8. Knit and rib - *cover seam with spreader or flat lock.*

Model wears leather and knit jacket with leather and stretch/Lycra wool pant.

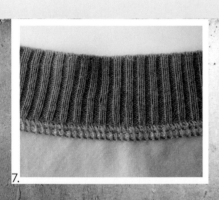

7.

8.

Menswear Designer Beekay: Independent designer - Ready-to-Wear, Winter *Collection mixing leather and stretch to produce his unique signature style.*

Right, and below, left to right; finer details for silk, lingerie, bespoke, haute couture finishes.

1. Fashion Designers Clements Ribeiro, London Fashion Week - *clean silhouettes with decorative detailing using zippers and sheer fabrics to create an innovative motif and embroidered effects.*

2. French seam and pin hem - *used for fine and transparent fabrics where a higher end finish is required; luxury fabrics, silk garments, lingerie.*

3. Narrow self binding *for neck, armhole and edge finishes.*

4. Intricate bespoke pattern *created with single zip and sheer fabric.*

5. Lined lace garment - *hem and slit stitched as a single layer.*

6. Silk top - *back neck key hole opening with narrow binding and rouleau loop fastening, and covered button.*

7. Black narrow piping *used to highlight a waistband detail on a dress (cuff, side seam, collar edge).*

8. Embellished bejewelled *petersham/braid and chain neck decoration.*

For more information see:

Fashion Computing - *Flats and Specs* chapter.

Fashion Entrepreneur - *Design and Production Cycle* chapter, and Appendices.

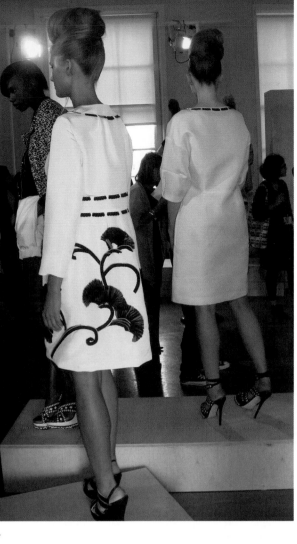

1.

2.

3.

4.

5.

6.

7.

8.

© Fashion Designer - Sandra Burke

MASCULIN-FÉMININ
Masculine-feminine

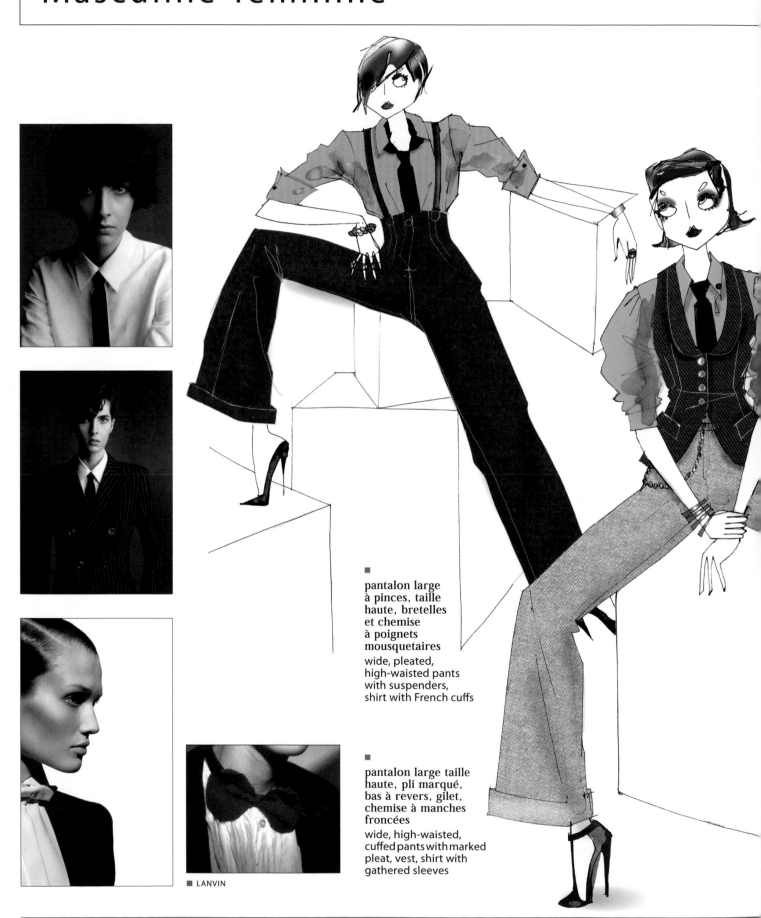

pantalon large à pinces, taille haute, bretelles et chemise à poignets mousquetaires
wide, pleated, high-waisted pants with suspenders, shirt with French cuffs

pantalon large taille haute, pli marqué, bas à revers, gilet, chemise à manches froncées
wide, high-waisted, cuffed pants with marked pleat, vest, shirt with gathered sleeves

■ LANVIN

12

The Final Collection
Promotion and Sales

'Fashions fade, style is eternal.' Yves Saint Laurent

Once the samples and prototypes are made, the next step in the fashion design process is to edit and finalize the collection. The responsibility of designing and putting together a cohesive collection (fashion line or range) is a key part of the designer's role, but not necessarily the end of the fashion design cycle; the collection must be promoted, which means it must be marketed, branded and sold through fashion shows and trade events, to buyers and clients. Every business relies on promotion to create interest and sales.

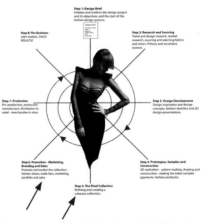

Step 5 and 6. The Final Collection, Promotion - Marketing, Branding, Sales

Figure 12.1: *Fashion Design Process (see p.15)*

This chapter will discuss:
• Design and range meetings - meeting the objectives of the design brief, editing the line to achieve a cohesive collection.
• Marketing, branding and sales - methods and tools to promote and sell the fashion collection or fashion product.
• The fashion and textiles calendar - schedule of global shows and events.
• Fashion and trade shows - the presentation of fashion collections and fashion products to promote, communicate and create sales.
• Collections, product ranges and sales.

Opposite, Courtesy of **PROMOSTYL Paris,** from their Winter Womens Trends book, theme *Masculin-Féminin.*

© Fashion Designer - Sandra Burke

Above, Footwear Designer Sophia Grace Webster: *Illustration from the designer's innovative shoe collection.*

Below, Fashion Designer Jesse Lolo: *The final collection should be focussed on the target market, have a clear theme and silhouette, and be well co-ordinated.*

1. Design and Range Meetings

In the fashion industry regular design/range meetings will take place to determine the progress of the design brief. Who is involved in the meeting and the purpose is dependant on the point that has been reached in the design process. The meeting might be with the:

• Design/Creative director and design team to discuss looks, themes, styling details, colors and fabrics, and progress.
• Production team to discuss production requirements, costings, planning.
• Marketing, branding and sales teams to discuss promotion and sales strategies.
• Merchandisers or buyers to discuss range planning, buying budgets, delivery dates for merchandise.

The Final Collection: Deciding what styles are to be included in the final collection could be a design team or management decision. You might even be making the decision independently, especially if you have your own small business. The design brief, table 10.1, presented the requirements and objectives and acts as the guideline to help with the decision-making process.

Stages in Editing: There are several stages in editing a collection:

Stage 1: At the toile or muslin stage, before the garments are made in the final fabrics or materials.

Stage 2: Editing once the samples are made in the correct fabrics.

Stage 3: Editing once all styles have been finally costed in the correct fabric, by which stage, each will need to be evaluated with an increased critical eye, checking out fit, balance, proportion, etc.

Stage 4: Editing even once the products are being sold - if an item looks like it will not sell it can be taken out of the range so that it will not detract from the sales of the rest of the collection.

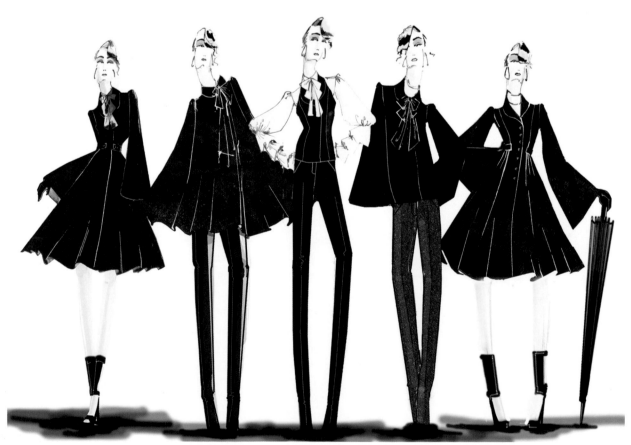

Considerations when editing:

- **Quantity:** How many pieces are required for the collection? The size of a collection will vary. An independent designer might produce a capsule collection of about twelve items that, when mixed and matched, produce about twenty different looks/outfits. Larger established brands, for example, Lanvin, Chanel, Gucci, Stella McCartney, might include 100 to 200 or more outfits in their shows. In the academic forum ten outfits might be the optimum.

- **Stand Alone:** Can the collection stand on its own? Have you got the right combination of styles to produce several outfits? Do you need another top or bottom piece to balance the collection?

- **Price:** Are all the garments within the right price range for your market and the target customer? Do they look the price? Will the customer see value for money? It might be necessary to go over your costings again with the costing specialist or the factory that will be making the production to establish smarter ways of making the products.

- **Fit:** The collection needs to establish professionalism and quality to match the price - well made, good fit, clean and presentable (no unnecessary loose threads, well pressed if that is the appropriate look), correctly labelled.

- **Concise:** Your collection should be focused, well co-ordinated and cohesive. It should have a clear theme and silhouette. When you look at the overall collection you will need to be ruthless. Research has shown that, if there are too many products to choose from, it is overwhelming and difficult to make a decision. You might find that a third or more of the samples could be rejected as they do not work or fit the design objectives.

- **Extra Samples:** Duplicate sets of samples might be needed, particularly if there are agents or reps selling the range concurrently, or if press samples are required. Samples made in the definitive colors and fabrics of the collection might also be required.

Once the collection is finalised, marketing, branding and sales is the next step in the design process.

This page, Fashion Designer Beekay: *Creating the 'right' image is a key factor when producing a fashion collection. Beekay presented his menswear collection at London Fashion Week (LFW) backed up with a professional photo shoot to promote his brand.*

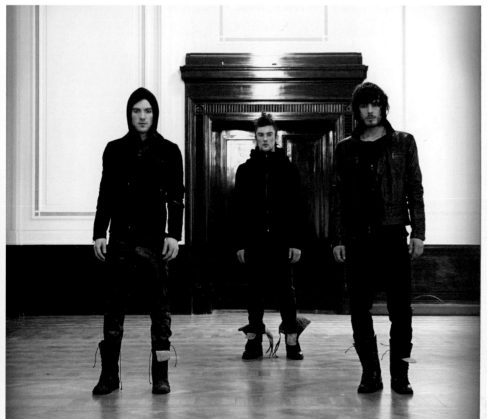

© Fashion Designer - Sandra Burke

2. Marketing, Branding and Sales

The marketing, branding and sales process gets the product out there to the media and the customers. This includes the methods and tools used to promote, advertise and sell the products using traditional means, e-marketing, and viral marketing through social networks.

As a fashion designer you might have an input into designing any of the following:
• Press kits, sales kits, look books, line sheets
• Business cards, labels, swing tickets, stationery, packaging
• Brochures, product postcards, promotional mailers
• Website, (also Facebook, Twitter, LinkedIn, YouTube, etc.)
• Fashion show, trade shows and events

Branding: This includes the signature or brand logo that will appear on the marketing material and products. *'Brand recognition'* is of significant importance when producing a marketable product - fashion collection or product line. Established fashion companies take time to grow a brand and develop the recognition and trust from their customers. Consumers have become much more *'brand conscious'* (aware of a brand's perceived status and reputation) so it is important to create the *'right'* image.

Logos: These are an important part of the *'brand image'* because they are easy to recognise. Identifiable logos can be based on symbols, images, design details, colours and even catch phrases.

Business Cards: Exchanging business cards is almost a ritual when meeting new clients, customers and suppliers at business meetings, fashion shows, trade fairs and exhibitions. Your business card is often the first opportunity you have to convey an image of yourself or your company. It should contain all relevant contact details; name, company, position, telephone number, contact details (email, website, etc.), together with your logo (perhaps an image of your product).

Garment Labels, Swing Tickets, Company Stationery and Packaging: Brand identity should follow through to the garment labels (sew-in labels, swing tickets) and the company stationery including digital (letterheads, perhaps order forms and invoices); also on clothing hangers, note pads and packaging (paper bags, carrier bags, tissue paper, gift wrap).

Brochures (Catalogues), Product Postcards, Promotional Mailers: These are used to present information about a business and its products. They include the business details and logo, and product details and visuals (stylish artwork/photographs) of the latest products. They can be mailed, sent digitally and handed out at trade fairs, etc., to interested buyers and customers.

Press Kits, Sales Kits, Look Books and Line Sheets: This is the portfolio approach to introduce a company and its products to buyers and the press. Presentation could be in the format of a two-pocket folder containing:

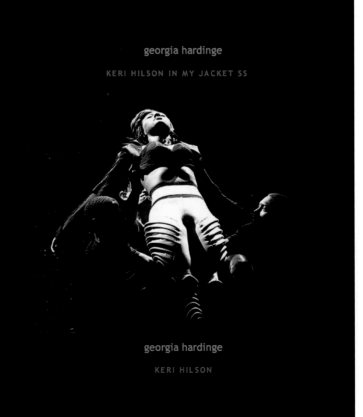

georgia hardinge
KERI HILSON IN MY JACKET SS

georgia hardinge
KERI HILSON

an introduction to the company and the brand, business card, a *'look book'* (photographs or fashion illustrations of the collection) and/or line sheets (detailed drawings of the products), a description of the products (fabrics, color range, sizes, availability and price), and copies of the latest relevant press coverage. Extensive kits can be expensive to produce so are usually given only to serious customers/ buyers, or the press who are going to review the collection. It is becoming increasingly common for these kits to be presented in digital format on a disc, sent as a PDF email attachment or downloaded from a website.

Website/Social Networking Sites: The Internet has become a key marketing platform for all businesses to display the business details, its products or services and make sales. A website will present the brand image, clear visuals and information. It might be used simply to promote the collections with links to stockists, or as a site for online sales, e.g. www.style.com.

PR (Public Relations) and Press Coverage: Fashion companies and designers will often have a PR company to represent them. They are responsible for making the contacts with the press and media to inform them of the next collection and any other relevant information - contacting the fashion editors (directors, beauty editors, creative director, etc.), press and photographers. Press coverage includes; reviews, interviews, fashion shots, for newspapers, radio, television, the Internet, blogs, Facebook, Twitter.

Branding: *Logo recognition - established fashion brands put much effort into their branding to create 'brand recognition'. Their logos are instantly recognisable and associated with the style, designs and products of the particular companies.*

Below far left to right, Fashion Designer Georgia Hardinge: *2D concepts to 3D creation and promotional material - Georgia's innovative styling is endorsed by singer* Keri Hilson; *promotional fashion shots. Georgia Hardinge is inspired by architectural shapes and sculpture, and experiments with cut to create beautifully structured garments, many of which have gathered a following amongst celebrities, including* Little Boots, The Saturdays *and* Erin O'Connor.

FILM STILLS FROM AW COLLECTION

MY FILM PROMO ... STILLS AW

AW IDEO PROMO

© Fashion Designer - Sandra Burke

3. Fashion and Textiles Calendar

Lists some of the key trade shows in the International Fashion and Textile calendar and typical dates.

The four major fashion capitals are acknowledged as New York, London, Milan and Paris. Twice a year, over a four week period, each city consecutively hosts *Fashion Week* during which the main ready-to-wear (womenswear) fashion show schedule takes place for retail buyers, the media and editors. To fit in with the fashion and textile industry cycle the shows are presented for Spring/Summer and Fall (Autumn)/Winter. For example, Spring/Summer Designer Collection shows for womenswear usually start in the middle of September after the stores have received their Autumn/Winter (Fall) lines that would have been shown the previous February/March.

A/W = Autumn/Winter

F/W = Fall/Winter

S/S = Spring/Summer

Table 12.1: *This calendar is a guide only as dates vary slightly each season; the events are far more extensive with new shows occurring globally. Confirm all current data on the Internet (see Internet Resources).*

FASHION and TEXTILES CALENDAR	
Jan	Milan Menswear Collections A/W
	Paris Menswear for A/W
	Paris Pre-collections RTW Fall/Winter
	Texworld USA Spring - New York
	Florence Pitti Filati Yarn Show (Knitwear)
	Paris, Haute Couture S/S
Feb	New York Fashion Week and Menswear Collections Fall
	London Womenswear Designer Collections/Ready-to-Wear A/W
	Milan Womenswear Designer Collections - RTW A/W Milano Collezioni Donna
	Paris Première Vision (Expofil, Indigo) Fabric Show (Colour Trends and Yarn)
Mar	Paris Womenswear Designer Collections/ Prêt à Porter Paris, and Exhibition A/W
Apr	
May	Inter-seasonal/Pre-collections
Jun	Florence Pitti W_Woman Pre-collection S/S
	London Graduate Fashion Week (Student Catwalk Shows)
	New York Resort
	Milan Menswear Designer Collections S/S
	Paris Menswear Collections S/S
Jul	Florence Pitti Filati Yarn Show (Knitwear)
	Paris, Haute Couture A/W
Aug	Las Vegas Magic Show (Fashion Accessories and Sourcing)
	New York Menswear Collections S/S
Sept	New York Fashion Week S/S
	London Womenswear Designer Collections/Ready-to-Wear S/S
	Milan Womenswear Designer Collections/ RTW S/S
	Paris Première Vision Fabric Show and Paris Expofil (Colour Trends and Yarn)
	Paris Womenswear Designer Collections/Prêt à Porter Paris, and Exhibition S/S
Oct	Hong Kong Interstoff Asia Essential Fabric and Textile Fair
	China, Intertextile Shanghai Apparel Fabrics

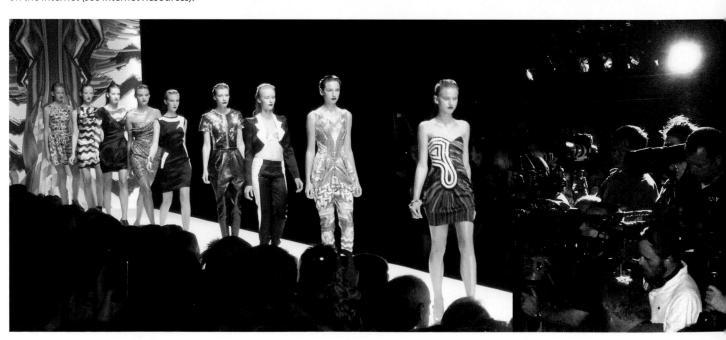

Textile events are held a year ahead of the new seasons' designs being delivered to the stores. To this calendar can be added the growing list of other cities hosting their own fashion weeks; Sydney, Cape Town, Auckland, Hong Kong, etc. and the innovative and indie events that emerge and grow to become key events, such as, On|Off (London), Bread and Butter (Barcelona).

4. Fashion and Trade Shows

The runway shows are an unmistakable cultural phenomenon. Fashion shows provide an excellent and exciting platform for showcasing established and emerging fashion designers and brands. They can be a very successful public relations (PR) exercise as the press and media cover the collections en masse with runway shots and details on all the designer shows and events, providing a massive amount of publicity as well as hype and entertainment.

Some designers are choosing to present off runway; still using models, but more of a mannequin event where the models simply stand and pose while the audience (buyers, photographers, etc.) walk around the room, take note and observe.

Virtual and Live Streaming: The trend for online virtual fashion shows and runway live streaming has become increasingly popular thanks to the web and e-commerce.

For Ralph Lauren, Gucci and a growing number of other brands, the virtual fashion shows are becoming an excellent method of marketing new collections. They can even be a simple runway presentation, with editorial talking points to simulate 'real' front row chatter from magazine fashion editors, directors, etc., or with the online guest being able to 'chat' to others online.

When Burberry, in 2010, launched their new collection the show was broadcast live to 25 of its stores worldwide. The invited customers were able to browse the collection on iPads and buy selected outerwear and handbags immediately for a seven week delivery time. This has helped reinforce the need to shorten the traditional six-month cycle of buying and production.

Prada, Dolce & Gabbana, and Gucci, amongst many designers, are streaming live video of their shows on their Web sites and Facebook pages to encourage and attract sales.

Tradeshows: Tradeshows attract hundreds of interested buyers from all over the world, looking for the latest ideas and merchandise including emerging talented designers as well as those who they might have already done business with. The key advantage to exhibiting at a trade fair is that the company or designer can set up appointments to see many of the buyers under one roof.

When exhibiting at any trade fair or fashion event it is important to select the most suitable event which matches the particular market.

Below, far left to right: Basso and Brooke: *Present their signature style and aesthetics in a cohesive S/S collection.*
Press photographers at the end of the catwalk preparing for the show.
LFW - Designers Clements Ribeiro: *Present their S/S collection on models as a static presentation.*
LFW: *Celebrates 25 years of British Fashion.*

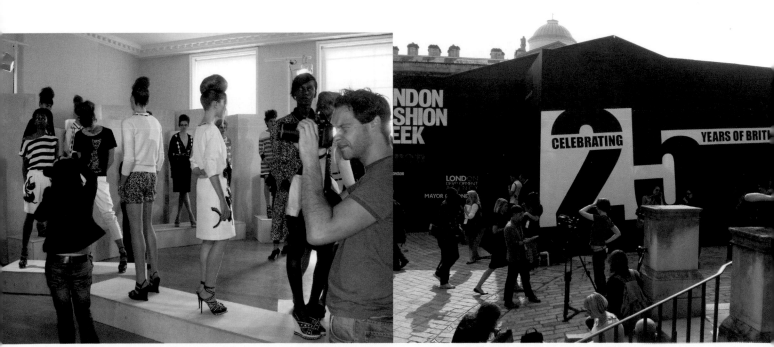

Presentation Options: Fashion shows and trade shows can be extremely expensive with the costs of the venue, models and choreographers let alone the enormous cost of producing the collection itself. Due to this, many companies promote and sell their collections in other ways by:

• Visiting the buyers directly in their own premises
• Showing in-house in their own or their agent's showroom
• Hiring a hotel room during fashion week, where they can comfortably display their merchandise and arrange for all their customers to come to them during the course of a few days and take their orders.

Sponsored, Off Schedule and Alternative Venues and Shows: Most upcoming fashion designers cannot afford the expense of the larger, more commercial fashion events. But, in collaboration with sponsors and supported by a range of creatives and professionals in the fashion business, including the fashion councils, they are able to show their collections at alternative venues during Fashion Week.

Shows might be held at galleries, museums, clubs, even railway stations, ballrooms and interesting old buildings. These events provide an excellent platform especially for the new generation of autonomous, progressive designers to stage cross-disciplinary presentations, where runway, dance, performance and installation can meet. They are marketed as unconventional shows and attract buyers who are looking for fresh products from emerging designers. The only negative can be that, unless you are a 'known

designer' mainstream fashion buyers and press might attend the key shows and not have the time to attend the alternative venues.

Graduate Shows: Graduates typically showcase their work at their end of year fashion shows or exhibitions, sometimes even at Fashion Week as part of a company sponsorship or competition. These events will naturally be attended by the designers' families and friends, but it is important for the student to promote themselves to the fashion sponsors, fashion industry, fashion designers, the press, media and fashion scouts who will be looking for the emerging talent. These events can lead to fruitful job opportunities for the designers to start a career in the fashion industry.

Graduate Fashion Week in London, for example, is an excellent venue where many universities and fashion schools throughout the UK exhibit and showcase their emerging designers.

Graduate Fashion Week (London), Leeds University School of Design stand.
David Backhouse, M. Des RCA, Head of Fashion. Photographer Mike Anderson.

5. Collections, Product Ranges and Sales

Brands will often produce more than two collections a year, perhaps four or more, depending on their market. This means that the fashion cycles are getting shorter as companies design closer to the market and react more quickly to create fast fashion. High street fast fashion retailers, such as Zara and H&M, introduce new styles and stories often weekly into their stores to keep customers interested.

And, as discussed in the *Color and Fabric* chapter, with more trans-seasonal fabrics, and changes in lifestyle (better temperature controlled buildings, cars, transport) there is less of a strict distinction between clothing for the different seasons.

Ready-to-Wear Pre-Collections (Pre-Coll): These are timed between the haute couture shows and the traditional prêt-à-porter collections. Buyers purchase their styles from a pre-collection viewing (pre-autumn/fall or a pre-spring collection) focused around a selection of key items and capsule collections. The styling is not strictly based on the runway collections which aim to present the '*red hot*' looks straight out of the design studio. The reason for the pre-collections is to generate greater impact in terms of sales by starting the season's buying cycle early when buyers' budgets are still open and to offer them an earlier delivery slot prior to the main collections.

- **Private label**: Is merchandise produced to the specifications of a particular retailer and includes the store's trademark or brand name.
- **Licensing**: Is a legal agreement that allows manufacturers the exclusive right to produce and promote particular fashion products that display the name of the designer.
- **Diffusion range**: Is designed by a top end fashion designer for a high street retailer. This could be a watered down version of the runway collection, would be less expensive and generally targeted to a younger customer.
- **Special lines**: Include ranges for specific holidays, periods and events - high summer, weddings, Christmas, graduation balls, etc.

Ranges, Products and Lifestyle:
Many companies and larger brands offer different types of ranges and products, even lifestyles to increase their market share, attracting different types of customers at different levels. Lifestyle marketing and branding especially has become a key marketing and branding strategy. Consumers can buy into anything from leisure styles, beauty products, fragrances, jewellery, eyewear, luggage, home accessories, to hotels and restaurants from their favourite brand.

For more information see:
Fashion Entrepreneur - *Marketing and Branding, Sales and Negotiation, Design and Production Cycle* chapter, and Appendices

Below left to right, Fashion Designer Georgia Hardinge: *Georgia's dress features on the promotional material of* 'All Walks Beyond the Catwalk' (LFW), *which celebrates models and all body sizes and shapes. The organisation aims to change the attitude of young designers towards age and size. Erin O'Connor, Caryn Franklin, Debra Bourne, Nick Knight, Rankin, and Twiggy, are just some of the names connected to and supporting this initiative.*

On the road to shoot the Samsung commercial; and the final shot.

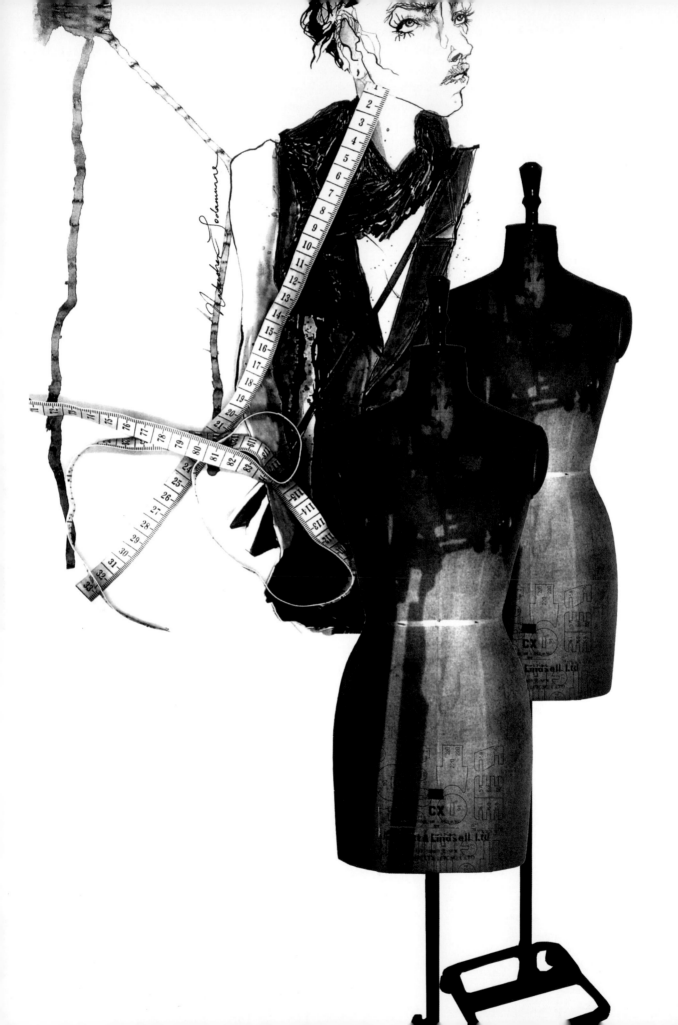

Appendices
Design and Production Process

The appendices presents a synopsis of the design and production process, under the following headings:

1. Design and Production - *William Hewett and Sandra Burke*
2. The Production Department - *William Hewett and Sandra Burke*
3. Style Control Sheet
4. Production Control Sheet
5. Taking Measurements
6. Design Style Sheet (Specification Sheet)
7. Costing Sheet
8. Tech Pack (Specification Documents).

1. Design and Production

The underlying commercial reality is that fashion designers need to design marketable products to remain in business. And, as they have a profound effect on the product, they need professional design skills and knowledge of production, together with an understanding of the quality level and cost budget of the product to allow them to be able to have designs produced more efficiently and cost effectively. In turn, this should result in products that are designed to the quality and price to suit the market.

Informed decisions about what fabrics, seam types and special embellishments to use, in accordance with how the products are going to be manufactured and produced and the final quality of the products, play a significant role in the design and production process.

If all these factors are taken into consideration it will help reduce any unnecessary hold ups in the production process, as any potential problems will have been resolved right from the conception of the products. Ultimately, it is important that designers work within the constraints imposed by the production department.

It is a broadly accepted statement that, *'If quality is not built into a product from the start (design, fabric, fit, construction methods), quality cannot be inspected into it in production.'* The balance between the quality of a garment/product and its cost is the secret of good commercial design.

The fashion designer and the production process: As a designer you will almost certainly be involved in the production process - the depth of involvement will vary depending on your role and who you are dealing with and where. For example, you might be involved with local and/or offshore production teams; if you have small production runs they might be produced locally, large production runs made in China or Vietnam and, for products that are highly embellished, you might have them made in India.

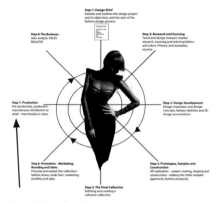

Step 7. Production

App1: *Fashion Design Process (see p.15)*

For more information see:

Fashion Artist - *Clothing Design* chapter.

Fashion Computing - *Flats and Specs* chapter.

Fashion Entrepreneur - *Opportunities in the Fashion and Creative Industries (Fashion and Textiles Supply Chain), Design and Production Cycle, Project Management Skills* chapters, and *Appendices - Range/Line Sheets (Brochures, Catalogues), Order Confirmation Form.*

Opposite page, Fashion Designer and Illustrator Nadeesha Godamunne (*illustration*) and Fashion Designer Frances Howie (*dress forms*)

Production Process, Courtesy of Foschini

2. The Production Department

As a fashion designer you will probably be working with:

- **Manufacturers/CMTs (cut, make and trim factories):** Who work on the production side of the fashion business and with all the processes required to make the products - samples, prototypes, grading and production runs.
- **Production managers:** Who are responsible for the smooth operation of the manufacturing of the products in order to meet the required design specifications, quality requirements and production deadlines.
- **Pattern graders:** Who are responsible for grading (sizing) the approved patterns for the garments that go into production.
- **Distribution managers:** Who are responsible for warehousing, shipping and transportation of products, and the administrative work that goes with it; importing and exporting. This involves all jobs associated with moving garments/products from the manufacturing plant to the warehouse. With orders fulfilled, goods are distributed to the retail stores or online services, etc.

Depending on the size and set up of the manufacturer, factory or CMT, the processes and functions of the production department will include:

- **Cutting room/floor:** Where the fabric for the production of the garments is laid up, marked, and cut using specialist machinery, then bundled (the cut pieces sorted and organized) ready for assembly.
- **Sewing room/floor:** This is where the products are sewn (known as garment assembly) and other operations such as fusing, under-pressing and in-process inspection are performed. During this process the sewing room might also take on outside contractors for operations which the factory is not equipped to perform, such as pleating, embroidery and quilting.
- **Pressing room:** This department gives the garment/product its final finish by a process called top-pressing.
- **Finishing:** After top-pressing, this section performs operations such as sewing buttons and buttonholes, attaching labels and hang tags, etc.
- **Final inspection:** Not strictly a production function, it is considered under production because the inspection department gives the final approval or non-approval and quality check for every garment produced.
- **Packing:** Before entering the finished goods warehouse, typically, shirts and underwear are boxed, while hanging goods such as skirts are bagged.

The organization structure *shows how the membership of the team for each design project varies to reflect the scope of the project. For example, fashion designer one is involved with all four teams; fashion designer two is involved with the design, production and buying teams; and fashion designer three is involved with the design, production and the marketing teams.*

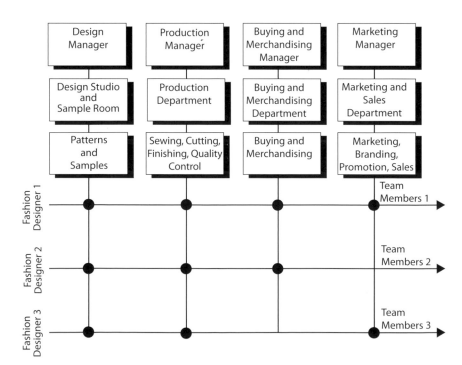

3. Style Control Sheet

The table below presents a *Style Control Sheet*, created in Excel, and shows the tasks involved in the design and pre-production phase of a collection. It shows how the design department works together to produce the samples and collection, and who is responsible for each stage of the development of the collection. For example, fashion designer Linda Logan is responsible for the designs; Ewa Liddington is responsible for the fabric sourcing and sampling; Sandy Stephenson is responsible for pattern drafting; Renee Duggan is responsible for the sewing of the samples; Jan Hamon is responsible for the costings for production; Linda Logan is responsible for the changes to the samples, the fitting and details; Sally Moinet is responsible for the final approval of the samples that go into the collection.

| Style ID: 01S/S12 | | | **Style Control Sheet** | | | |
|---|---|---|---|---|---|
| Style Desc: Dress | | | | | | |
| | | | | | | |
| Task | Description | Date Required | Responsibility | Date Complete | Date Approved |
| 1 | Styles Designed | | Fashion Designer, Linda Logan | | |
| 2 | Design Details Complete | | Fashion Designer, Linda Logan | | |
| 3 | Fabric Sourcing and Details Complete | | Fabric Buyer, Ewa Liddington | | |
| 4 | Sample Fabrics Available | | Fabric Buyer, Ewa Liddington | | |
| 5 | Trims Costing Complete | | Fabric Buyer, Ewa Liddington | | |
| 6 | Allocated to Pattern Maker | | Pattern Maker, Sandy Stephenson | | |
| 7 | Patterns Complete | | Pattern Maker, Sandy Stephenson | | |
| 8 | Fabric Ratings Complete | | Pattern Maker, Sandy Stephenson | | |
| 9 | Allocated to Machinist | | Sample Machinist, Renee Duggan | | |
| 10 | Sample Sewn | | Sample Machinist, Renee Duggan | | |
| 11 | CMT/Factory Costed | | Design Assistant, Jan Hamon | | |
| 12 | Cost Card Complete | | Design Assistant, Jan Hamon | | |
| 13 | Sample Change 1 | | Fashion Designer, Linda Logan | | |
| 14 | Sample Change 2 | | Fashion Designer, Linda Logan | | |
| 15 | Sample Approved | | Fashion Designer, Linda Logan | | |
| 16 | Sample Finalised for Collection | | Design Manager, Sally Moinet | | |

4. Production Control Sheet

The table below presents a *Production Control Sheet*, created in Excel, and shows the tasks involved in the production and shipping phase, and who is responsible for each stage.

| Style ID: 01S/S12 | | | Production Control Sheet | | | |
|---|---|---|---|---|---|
| Style Desc: Dress | | | | | | |
| | | | | | | |
| Task | Description | Date Required | Responsibility | Date Complete | Date Approved |
| 1 | Style Approved | | Fashion Designer, Linda Logan | | |
| 2 | Bulk Fabric Delivered | | Fabric Buyer, Ewa Liddington | | |
| 3 | Bulk Trims Delivered | | Fabric Buyer, Ewa Liddington | | |
| 4 | Production Patterns Finalized | | Pattern Maker, Sandy Stephenson | | |
| 5 | Production Samples Finalized | | Fashion Designer, Linda Logan | | |
| 6 | Labels, Packaging Delivered | | Fabric Buyer, Ewa Liddington | | |
| 7 | Graded Patterns (sizes) | | Pattern Maker, Sandy Stephenson | | |
| 8 | Markers Made | | Pattern Maker, Sandy Stephenson | | |
| 9 | Production Commences | | Production Manager, Maria Leeke | | |
| 10 | Quality Control Check 1 | | Quality Controller, Wendy Malone | | |
| 11 | Production Complete | | Production Manager, Maria Leeke | | |
| 12 | Quality Control Check 2 | | Quality Controller, Wendy Malone | | |
| 13 | Pack and Ship | | Warehouse Manager, Wendy Smith | | |

5. Taking Measurements

To achieve a good garment fit it is important to take accurate measurements and transfer those measurements on to your patterns. As a fashion designer you might be measuring the body or taking measurements off the dress form.

When taking measurements of the body:

• For accuracy measure over undergarments.

• Measure with the tape flat, firm but not tight.

• You might need to take some vertical measurements first, then the round, e.g. measure down from the waist to the hip lines.

• Bust: Measure around the fullest part and across shoulder blades.

• Waist: Measure around the natural waistline.

• Hip: Measure around fullest part of the hips (seat).

The chart below lists the key areas for measuring the body when drafting your patterns and garments, and for completing specs and tech packs (see following examples).

Most companies will have standard measurements for the different sizes (S,M,L, 8, 10, 12, and Misses, Junior, Plus, Petite and Tall ranges, etc.).

MEASUREMENT CHART	
	Area of measurement
1	Bust
2	Underbust
3	Waist
4	High Hip - 5 cms/2" below waist
5	High Hip - 10 cms/4" below waist
6	Hip - 20 cms/8" below waist
7	Low Hip - 25 cms/10" below waist
8	Thigh - girth
9	Knee - girth
10	Calf - at widest
11	Ankle - girth
12	Shoulder breadth
13	Neck around the base of neck
14	Across chest
15	Across back
16	Top arm - girth
17	Elbow - girth
18	Wrist- girth
19	Bustpoint to bustpoint
20	Shoulder to bust point
21	Bustpoint to waist
22	Neck (base) to waist
23	Nape (back neck) to waist
24	Neck shoulder point to elbow
25	Nape to wrist
26	Inside leg to floor
27	Outside leg waist to floor

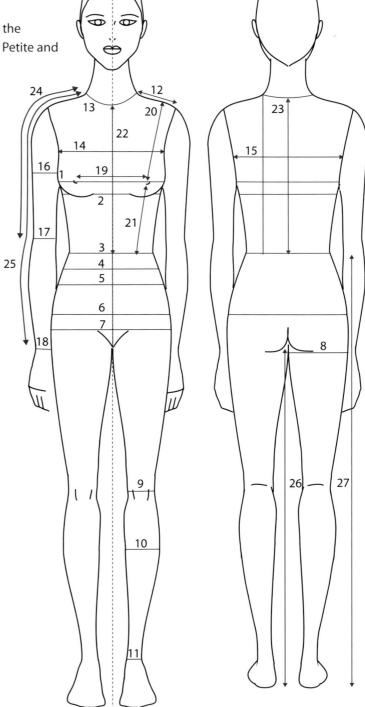

6. Design Style Sheet (Specification Sheet)

The following documents would be prepared by the fashion designer, fashion design assistant, pattern maker/team and are of particular importance in the fashion industry in the design and production process. They present all the key information about the garments/products to ensure they are made to the required specifications and include; the people who hold responsibility, the technical drawing, fabrics and trim details, any specific measurements, etc.

DESIGN STYLE SHEET/SPECIFICATION SHEET			
Style No	**Designer - Tina Fong**	**Customer/Buyer**	**CMT/Factory**
Season: S/S Yr	**Pattern Maker**	**Department**	**Sample Size**
Commitment No	**Machinist**	**Delivery**	**Created**
		Color	**Modified**
		Units	**Approved**
			To Grade

FABRIC DETAILS		GARMENT DESCRIPTION		
Fabric Swatch	**Description**			
	Design	**GENERAL NOTES/TRIMS**		**NOTES CONT'D**
	Type	**Fusing Info**		
	Order No	**Binding Details**		
	Composition	**Zip**		
	Quality	**Seams**		
	Weight	**Seams**		
	Width	**Hems**		
	Open/Tubular	**Wash**		
	Sub Sampling	**Label Position**		
	Check Repeat	**Buttons** (type, size, quantity)		
	Bulk Del. Due	**Thread**		
	Sample Fabric	**Swing Ticket**		
	Design	**Wash**		
		RATING		

FRONT DESIGN (or Front and Back)

PATTERN MAKER NOTES

(Specific measurements - lengths, widths etc.)

CUTTER NOTES

(Specific cutting instructions)

MACHINIST NOTES

(Specific sewing instructions)

BACK DESIGN (or specific details)

7. Costing Sheet

The costing sheets list all the required information to calculate the total costs to manufacture the garments or products, and to establish the required selling prices (wholesale and/or retail) and includes; the material/trims ratings and costs, processes, time costs, and all relevant information as shown in the example below.

COSTING SHEET

Style No	Buyer	Delivery Date	Units

Commit No	Dept	Style Description

FABRICS

Fabric Description	Color	Order No	Width	Rating	Rate + 7%	EST Cost	ACT Cost	Value
					0			0
					0			0
					0			0
					0			0
						FABRIC TOTAL		

TRIMS / **RATING**

Supplier	Description	Size/Type	Order No	Reference No	Mtrs/Yds	Quantity	Price		Value
	Hanger	Dress 10							
	Brand Label	Woven				1			
	Fabric Label					1			
	Wash Care	Dry Clean				1			
	Swing Ticket	Embossed				1			
	Polybag								
	Cut Bias	25 mm				0.88			
	H/ Tape	Branded							
							TRIMS TOTAL		

GARMENT SKETCH

Fabric + Trims	
Waste	
CMT	
Grand Total	
Mark Up	
Selling Price	
Gross Profit	
Retail Selling Price	
Sold to Buyer	
Actual RSP	
Actual Profit %	

8. Tech Pack (Specification Documents)

These documents form the 'pack' and include all the relevant technical drawings and specifications (design style sheet, artwork, labelling, stitching details, colorways) required to manufacture the garments/products in production. These documents need to show every detail leaving nothing to interpretation, especially as the samples or production might be made offshore in locations where English is not the first language or may not be spoken at all.

Tech pack by Fashion Designer, Soo Mok.

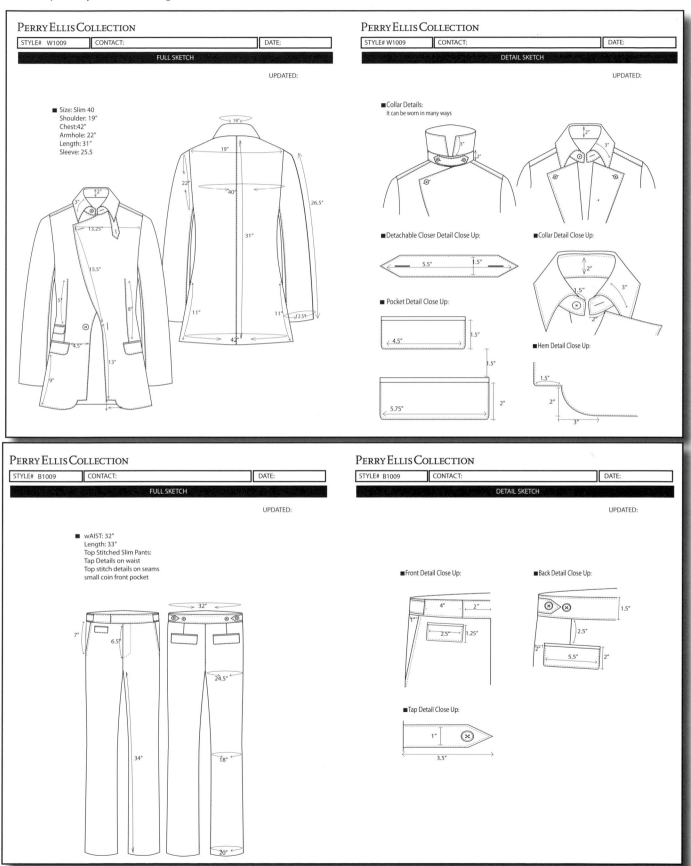

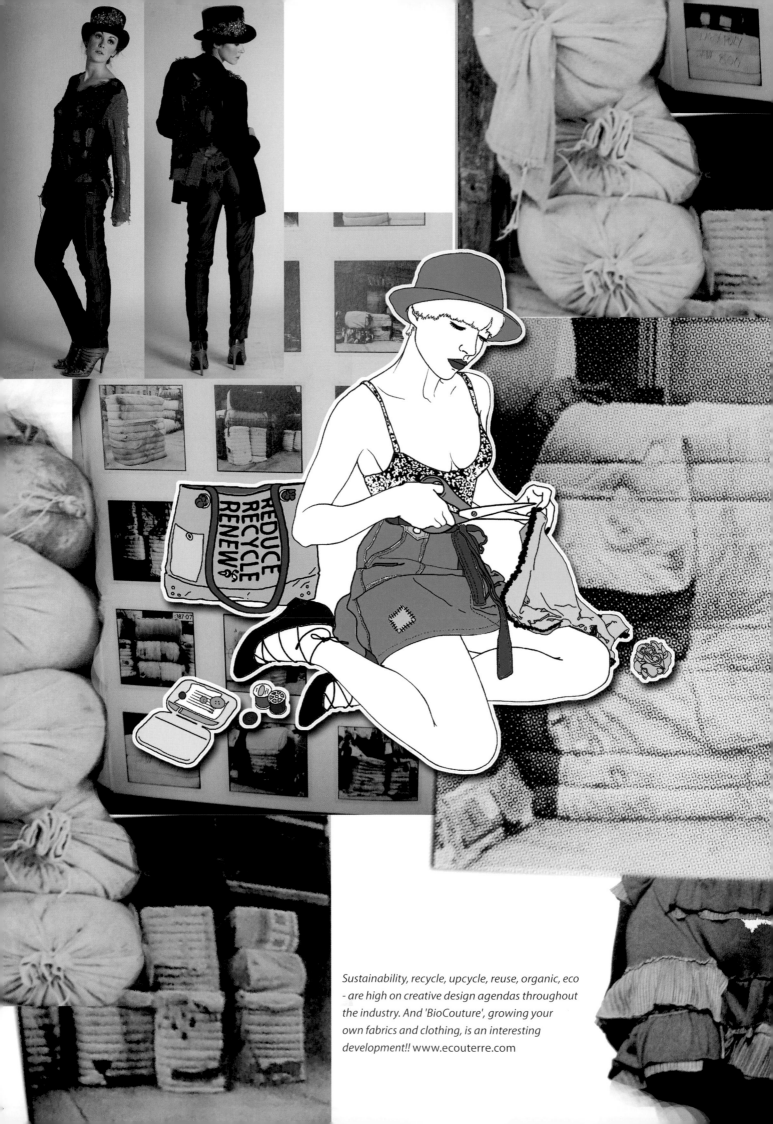

Sustainability, recycle, upcycle, reuse, organic, eco - are high on creative design agendas throughout the industry. And 'BioCouture', growing your own fabrics and clothing, is an interesting development!! www.ecouterre.com

Case Study
Sustainability

'𝓔clectic Shock' - *Irene Dee*

With *Zero Waste* the current 'buzzword' of the textile industry, and *Zero Waste Fashion* the latest eco-innovation circulating within the environmentally minded fashion industry, the challenge now facing designers is to think about fabric as a coveted commodity and use it sparingly - scraps and all. Designing around ethical and environmental sustainability is currently high on creative design agendas throughout the industry. This eco-fashion concept challenges designers, both eco and conventional, to reduce, reuse, waste less, save more and recycle.

Recycling however, is more than just '*recycling*'. To refer to the haute couture techniques used by **Maison Martin Margiela,** for example, as simply *recycling* would be an understatement. Margiela's process is '*upcycling*'. The materials are augmented into an object of higher status than the original object, fashioning craftsmanship garments that are highly exclusive, very fashionable and represent the top of the fashion industry.

Upcycling in this way is now being seen as the new way forward for future fashion. Every piece that is made according to this method, regardless of how many versions there may be, is a unique piece because the materials that are used in it are unique. The story behind the manufacture is a key element of the final value, and what gives the product cachet and style. If those origins and manufacturing processes can be shown to be eco-friendly and sustainable, they can add further to the value of the luxury garment.

A major part of the appeal of luxury clothes lies in the fact that they are often handmade in small quantities rather than mass-produced. The details of their production and the possibly exotic origins of the raw materials involved are all part of the 'story'. Tracing the supply source can bring out the individual creativity behind the product as well as the ecologically sustainable process involved, which makes them all the more valuable to ecologically conscious consumers.

Upcycling can also be viewed as a flexible manufacturing system; while mass manufactured merchandise more often than not guarantees a certain level of quality, it can also lead to products that are indistinguishable from one another. This is where *upcycling* can provide the means to bridge the gap between mass-produced and customised products, and thus add value and increase desirability.

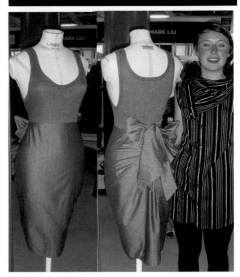

Above, Junky Styling at LFW: *An innovative design label - garments are made from the highest quality second hand clothing, deconstructed, recut and transformed into a new piece which belies the identity of the raw material.*

Opposite page,
Illustrator Montana Forbes: *Girl with hat*
Fashion Designer Priyanka Pereira: *Background*
Fashion Designer Hannah Cooper: *Upcycled Outfit - 'The Oxfam project promotes the process of 'upcycling', by which the clothing is given a new life and a higher status than it previously had.'*
Photographer Rae Hennessey

Upcycling Designer Waste

Claire Andrew

Brief: *'The Edge project led me to take waste from the S/S Giles collection to create the attached pieces. The brief was about taking waste fabrics that would be discarded and creating garments that dispelled preconceived notions of recycling, to create beautiful and unique high end garments. The project challenged me to balance my love for fashion with responsibility. The pieces were constructed piece by piece on the stand and the scraps that were discarded inspired the shape of the upcycled garments, as did time spent in Brick Lane during the run up to the S/S shows.'* Claire Andrew

This page and opposite: Fashion Designer Claire Andrew: *Upcycling designer Waste* and *Upcycling for Oxfam Boutique Opening*

Photographer Kirsty Messenger

Photographer Rae Hennessey

Giles Spring Summer - Paris, courtesy of Fashion Designer Giles Deacon, from www.style.com

Where It All Began

The Giles Studio Off Brick Lane

Clearing Up After Paris Fashion Week The Bags Contained Fabric That Was On Its Way To The Bin

The Tube Journey! Made It! Sorting Through!

From Catwalks of Paris

Giles Spring Summer - PARIS

 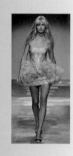 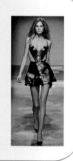

The Off Cuts

Initial Designs And Stand Work

The Final Outcome Designer Waste Given New Life.... Unique Pieces

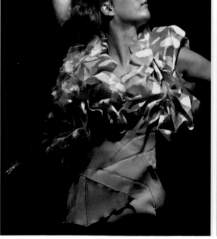 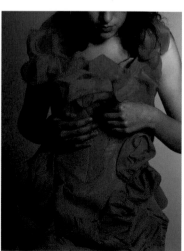

Off Casts Become On Trend

Claire Andrew

Brief: The Oxfam project promotes the process of 'upcycling', by which the clothing is given a new life and a higher status than it previously had. The aim is to use fabric as a coveted commodity, which effectively supports ethical and sustainable clothing.

The Organisation: Oxfam, a global charity organisation, has stores in many parts of the world. It has become a place where stylish people hunt for interesting items to create their individual look.

Always looking for the best ways to maximise their opportunities, Oxfam's market research indicated customers wanted a more contemporary shopping experience. So the traditional concept of the Oxfam shop is being turned around to provide a more luxurious and enjoyable fashion shopping environment.

The new stores are targeting the fashion market and the people who care about both what their clothes look like and the environmental and social impact of their clothes consumption. Oxfam are providing shoppers with unique style, beautiful one-off clothes, and the assurance that every item will raise money to fight poverty around the world.

Reworked pieces from an array of Oxfam donated second-hand clothing were upcycled to create original designed items.

An old skirt becomes a new jacket the hem detail is now shown to full advantage.

Old dress rejuvenated.

This Is Not Just Any Oxfam

It's Oxfam Boutique!

The aim was to breathe new life into discarded clothes. Their individuality and fresh style would make them desirable once again.

Within a couple of weeks the restyled garments had sold some for upwards of £100.

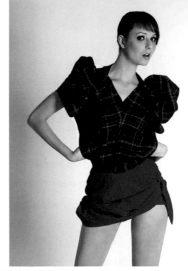

Tartan trousers becomes a top with voluminous shoulders.

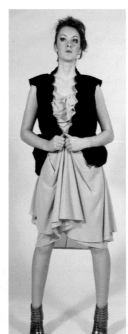

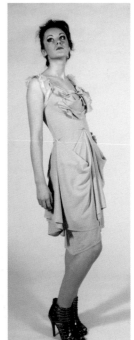

© Fashion Designer - Sandra Burke

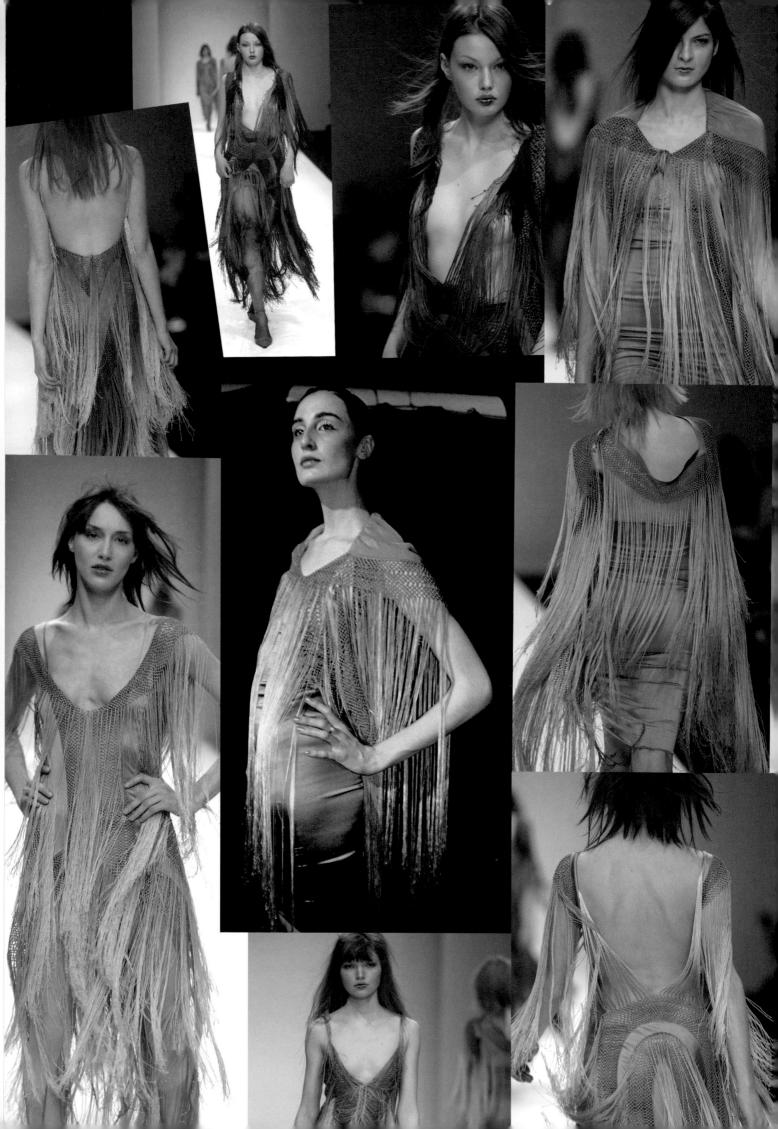

Frances Howie - Fashion Designer, Womenswear
High-End Luxury Label, Europe

Having been awarded her Masters in Fashion at Central Saint
Martins, Frances has established her career by designing for
several of the most influential high-end fashion houses in Europe.

1. As a fashion designer, how would you describe your design development process?

The job is broken up into stages. The first stage is the 'briefing'
with the Creative Director who gives us an overview of her
thoughts for the collection. Then the team will break up
to do research. Research could take a week to three weeks
depending on the situation. In my circumstances it is actually
very short, a few days of intensive research where I go to every
library, fashion bookshop, and vintage clothing market. I will
do Portobello Road's Vintage Market and Hammersmith's
Fashion Vintage Fair both of which are famous vintage markets
in London. We also buy from several contacts that auction
clothing for private sellers.

We then meet together as a team and pool our ideas. This is
a very inspirational discussion where we present ideas and
brainstorm as a group. The meeting would consist of knitwear
designers, accessories designers for handbags and shoes, the
ready-to-wear designers, embroidery designers, print, textiles
and fabric designers.

The creative director will select the most exciting ideas and
group them into a story. Then we develop the design work. I
will sketch and drape garments on the stand at this point.

After this we meet regularly to show the progression and the
development of the design work. Once the ideas are ready
we launch a package of designs with the factory in Italy that
produces the garments. This package includes sketches and
photographs, and stand work in the form of toiles and swatches
and notes explaining each design.

A series of fittings takes place every week; the Creative Director
is normally present for the fittings. We tweak the garments
to make sure they are looking the way we want them to look;
sometimes we completely cut them up and reconfigure
them - cut sleeves off and add new things. Fittings can be a very
creative time in the process, and a lot of the design happens
in the fittings until we achieve the look we want. We might fit
twenty garments in a day so we have to work very quickly.

We photograph the garments; we write 'fit' notes then send
the package back to Italy where they meticulously go over the
changes that we have made.

After about five or six weeks of fittings, we will have gone over
all the styles in the collection, and we will have a period which
is called 'Fabric to Sketch' when we take a small sketch of every
single garment that we have fitted and allocate the fabrics that
we have developed to each sketch.

This is the moment when we decide how each particular
garment will look to produce a cohesive message. Which colour
will it be and what handle of fabric? Will it be embroidered
all over? Where will it fit in in the final show or pre-collection
presentation?

Fabric to sketch is a really important, intensive period, when
many decisions are made as to how the collection will look - this
is when the collection really comes to life.

Then we launch the final designs and Italy produce the final
garments for us which get shipped to our showroom. Next we
have a styling period when we go through the collection, put
together looks, photograph the looks, upload these to style.com
or, if we are going to have a show it will be the preparation for
the show run.

If the collection is a seasonal show we will work with a casting
agent to decide which girl will wear which outfit. The models
will come in and we will fit the garments to their measurements.

Once that has happened there is an intensive sales period that I
am less involved in. This is when they sell the collection in New
York, Italy, Paris and London.

We produce four collections a year - two 'Show Collections' and
two 'Pre-Collections'. The pre-collection fits perfectly between
each show, so every three months there is a new collection.

Pre-collection is a collection we produce in-between shows for
Spring and Autumn. For pre-collection we do not have a show.
We might have a party or host a special event to unveil the new
season's collection.

2. How do you develop your designs?

I start with strong research; and through a process of
sketching and draping I toile a garment on the stand and then
photograph to document the development. I will make half a
garment if I am working to a tight deadline for speed.

Once I have a line up of photos I edit considering the strength
of each design. If there are ideas that are tricky or complicated
I consider the technical complexity of them - there is no
point in designing something no one can make. You need to
understand the limitations of the craftspeople you work with
and how far you can push them.

I was taught to focus on what you do well; never design using
a process you are not really skilled at. For example, if you are
brilliant at sketching, you should sketch and breathe life into
your ideas by working with beautiful drawings - if that is the

© Fashion Designer - Sandra Burke

Previous page and this, Fashion Designer Frances Howie: *'The Collection' and 'The Fashion Shoot'* - model Erin O'Connor, English supermodel.

way you think - it should all be put down on paper. The designs will come to life as beautiful considered sketches. If you cannot sketch or sketching does not come naturally rather present the designs in the most inspired way you can; drape a piece of fabric, make a quick toile, use photographs to show the feeling of the garment.

Every person I have worked with communicates their design development differently. It has to be visual, fashion is a visual medium, it is not just about words – and it should be inspirational.

3. Do you work to a design brief?

Yes - I think the vision and story are very important. I have found if you are not given a brief it's important to self impose one. The brief can develop over the course of the season. It can be shaped during creative meetings or fittings.

If given a brief it is important to respect it but also to contribute toward it - great designers will see an idea, and know it is relevant to the brief because they are in tune with the Creative Director and understand what that person is referencing. They help extend the vision, bringing ideas and providing lots of inspiration, lots of exploration, lots of wonderful things that they can incorporate into the designs - that's how it evolves. A large amount of the job is understanding what is relevant to the design conversation - it is intuitive, having the right idea at the right moment.

It is important to also be flexible - not all ideas will work and not all ideas you bring will be used. You cannot expect too much direction and to be given a clear brief for every project - you are trying to discover something that has not necessarily been made before and does not exist. The vision may be quite abstract at the beginning of the season.

4. Do you design with a target market, customer and price point in mind?

Definitely – our brand is very aware of what the customer is prepared to pay for the product - we think about that at every level. It does not really hinder what we do it just means our work is intelligent. We do not work with something that is very expensive when we can get a very similar thing at a better price. You have to make the product accessible to as many people as you can, not put barriers in the way. If you have a great idea but it ends up too expensive people will not buy it; it won't even end up on the shop floor in order for the customers to have the choice to buy it - your work is dead before you start. It has got to be the right price, not cheap but value for money. People need to perceive it as value, it needs to look as expensive as it is.

Each brand has a woman in mind that they dress; a vision of this woman, the type of look, the type of feeling, the type of personality and attitude that this woman has. She is almost like a three-dimensional character. This helps the brand to maintain a sense of design consistency.

5. Do you design with a theme, color palette, or particular fabrics each season?

The fabrics will depend on the vision. The vision is the story of the season. It might be very clear cut or it might be a very poetic idea; the inspiration might be about a certain girl from a movie, but it will not be as simple as re-working Faye Dunaway's look from a 1970s movie - its about injecting that reference with an original point of view.

You can have the most amazing fabrics in the world, and the best shapes and it might be successful, but it might not be directional; it might not have that energy. You've got to have a point of view - what are you saying with that fabric? You have to try to say something that has not already been said, is not a cliché.

Design is about proportion and silhouette, the oddness of over or under sizing things and putting them with an unusual shape; lengthening or elongating something when it should not be like that. There is a subtle play on shape, which is just as important as the story or inspiration. Many people have forgotten about the importance and power of silhouettes, and how this has to be defined in a collection.

I generally think inspiration should come from some kind of reference to the body, or to fashion or garments themselves. References to architecture, for example can be a much harder thing to translate onto the body without the design feeling awkward.

I usually find the idea and then the fabric to match it. For example when working around the concept of pleating - if the garment is fully pleated I look for fabrics that take that pleating; it becomes quite technical; it is about chasing the fabric that creates the correct emotion.

But it is also about using fabric to achieve shape. I have seen the way designers use a fabric to get the dress, to get it to move and drape and achieve a certain look. Obviously this is when you do need to start with the fabric to know what the form will be and how it is going to move.

6. What was your career path to your current job, and what advice do you have for someone wanting to get a job in your area of fashion?

Advice - coming from overseas, having worked in the industry for several years…if I had realized when I was young how hard it was going to be to work in Europe I might have thought twice about it.

I did the degree in NZ at *AUT*, worked in the industry as knitwear designer for 3 years, then entered the *Smirnoff International* design award for three years in a row, before I won. Winning that award gave me a scholarship to fund my Masters at *Central Saint Martins*, which was not something I had considered doing. My scholarship funded me for the entire time of overseas training, a year and a half; it was incredibly expensive - the MA…paying international fees, all of my materials, my accommodation.

When I arrived at *Saint Martins* to do the Masters everyone had a story to tell about how they had funded the course - finance was essential.

Completing the Masters at *Central Saint Martins* was essential to my career. The training was intense and helped shape me as a designer. It made me question who I was as a designer and what I wanted to do and what my style was. It gave me time to selfishly develop my sketching and draping. I wasn't working full time - I was purely devoted to the Master for a year and a half.

Once I graduated from the program I had job offers from international brands and I went around and interviewed at each of these houses. I decided I wanted to work in Paris. While I worked I would get calls from people I knew - you make connections in industry and people know if you can do the job, then they call you when there is a position. A lot of it is about personality not just pure ability; people in the fashion industry work very long hours, they want to work with people they like and have a great attitude.

So if I were to advise somebody of how to start or get a job in the industry, I would definitely say that competitions have played a big role in my journey. I would advise they enter lots of competitions, particularly those that offer great opportunity for exposure and financial reward. These things were invaluable to me, and really helped me start my career.

© Fashion Designer - Sandra Burke

Soo Mok - Fashion Designer High-End
Menswear Sportswear Designer, New York

As a young influential designer Soo specialises in high-end menswear. Her fashion industry design work experience, involvement and awards include; Calvin Klein (NY), Ralph Lauren, Perry Ellis, Saks Fifth Avenue (Vice President [VP] Fashion Director), DNR magazine, WGSN, Banana Republic, Gap, Parsons (NY) *Designer of the Year.*

1. How would you describe your job?

As associate designer for outerwear and sportswear, I am responsible for designing a whole line of outerwear, and knits.

I absolutely love my job and feel very fortunate it is something I enjoy and, meanwhile, can earn a living. People always think fashion is a glamorous job, but it is not all about designing and being creative, celebrities and models. As in all large organizations, my job also involves a certain amount of basic office type work - responding to lots of emails, updating sketches, and detailing and charting changes.

2. What was your career path to your current job?

I always wanted to do fashion, probably because my parents were fashion designers so it was just naturally a dream of mine. I applied to Parsons (NY) and was accepted with a number of scholarships. At Parsons I won several design awards, including *Designer of the Year* for menswear, and an internship at Banana Republic. After which I received job offers from several companies without even sending out my resume!

3. How do you approach designing a new collection - your design process?

We begin with the research; meeting with the color and trend companies who come to our office and present the forecasted trends for colors and concepts - we also purchase their trend books. We subscribe to WGSN and are particularly interested in trend ideas and runway shows.

Next, we select fabrics - we make appointments with fabric mills and visit the New York shows, Premier Vision and Texworld, and sometimes the Paris shows.

Then we check the runway shows, all the key magazines, and the stores - we might go to Europe for shopping/store visits and inspiration.

I also visit to Vietnam and India to see our factories and the protos (*prototypes*) that they develop for us.

With the research complete, we gather all the ideas and create mood boards, selecting the colors and concepts we feel most suit our customers.

TADAO ANDO & BRAQUE PATTERN

HANG TAG DESIGN

Sketches come next with new design ideas, which are also based on the previous season's best selling items.

We have an initial design meeting with the VP of design and the sales team when we do drop and add (*drop and add styles*).

Next, we prepare and send out tech packs (*technical specifications*) to the overseas factories making the samples - these could be in India and Vietnam.

Once we receive the prototypes, we follow up with fittings and specify, in detail, any design changes that need to be made for the SXS (sales rep samples).

4. Do you design with a target market, customer and price point in mind?

At Parsons I thought fashion design was all about innovative and creative design, which are important elements - if there isn't any newness no one will buy it. However, in reality, it is all about the customers and brand aesthetics. We design based on that.

5. Would you identify the creative elements and its presentation in your job?

Every part of my job contains a certain level of creativity. To make one garment, there is a lot of input from other areas such as the trim and sourcing department, the fabric mills, and trend forecasting agencies. I don't only design the garments, I am also involved in the design of trims, fabric/textiles, even labels - which are all important elements.

6. What advice do you have for someone wanting to get a job in fashion?

Firstly, getting a job in fashion is very competitive. However, if you do work hard and believe in yourself, it will work out.

Secondly, it is very important to network - two thirds of people who are higher than entry level get their jobs through networking.

Thirdly, finding the right company is important. Some people say, *'A good designer could design for any brand'*. I agree, but when you design for a company you admire and that company has a similar aesthetic to your own, you can sparkle and enjoy it so much more - the designing is easier and more natural.

I always admired modern architecture and minimalism which came over as my inspiration for my projects at Parsons. I think that is why I really enjoy designing at CK.

Lastly, I think finding the right environment, especially with your co-workers working together within a design team – you have to be a team member; there has to be harmony. You often spend more time with these people than your own family!

Design Skills: *As a fashion designer Soo's skills (manual and digital) include; Fashion design and illustration, flat sketching, sewing, draping, pattern making, trend researching, creating presentation boards, sourcing trims and fabrics, software skills (Adobe Photoshop, Adobe Illustrator Web PDM, U4ia, Microsoft Word & Excel, Power Point).*

Design Work: *Typically her work involves using her expertise to:*

- *Research trends, create mood and fabric boards and fabric selection for the collections, and design menswear (woven blazers, shirts, pants, outerwear, knits, and graphic t-shirts, design fabric/prints for shirts).*

- *Create presentation boards and cards for market week.*

- *Update information for the PDM (Product Development Management system).*

- *Sketch bodies using Illustrator, create Tech Packs (technical specification documents), and trim sheets.*

Fashion Designer Soo Mok: *Menswear Styling Presentations for F/W collections; fashion illustrations and mood board.*

© Fashion Designer - Sandra Burke

Eva Snopek - Textile Designer, New York

Having studied fashion design at college, Eva has worked her way up through the industry to specialise as a textile designer in New York, one of the four major fashion capitals, working for leading edge fashion companies.

1. As a designer, how would you describe your job?

My current position as a textile designer for menswear is designed to support silhouette designers with the development of knit and woven structures, graphics, print and pattern with the aid of CAD. Depending on the seasonal direction, I work with designers to help facilitate their vision through textiles from concept to finished garment. We collaborate on a season's palette and digitize it to later create interesting color combinations for fabrics. With the aid of computer graphic programs I design knits and wovens that are structured correctly for our mills to manufacture directly from our files. As for printed textiles, depending on the printing technique, I create color separations for each color to run as a separate screen, as opposed to digital printing where I don't have to worry about color separations. The majority of my work involves designing pattern in repeats and cleaning purchased pattern to fit the right rotary screens, then I work on recoloring them with our season's palette to achieve the desired look. This position also involves lots of trend and color research to be aware of where market trends are going and anticipate designing a 'trend right' garment.

2. What was your career path to your current job?

My career path started by painting and drawing flowers in my fashion design classes in college. With the up and coming computer design age, I wanted to combine my two interests of painting and fashion with technology by taking Photoshop and U4ia classes which led to an internship at Sears. After college I was hired by GAP as a Textile Designer, and later moved to work for Target as a Swat Textile Designer leading their women's brands in print and pattern. Thereafter, I was offered the opportunity to work for CK Men's in my current CAD position.

3. How do you approach designing a new collection - the design process?

Designing to me is like making soup, a little bit of this and a little bit of that with a dash of this and presto! There is no wrong way to design, just different preferences and outcomes. I get inspired by mood pictures and color and other times by fabric and texture depending on what is trending in the market. I usually work on color inspiration first. Than I need to know what type of fabric the design is going to be applied for. Because of the nature of the fabric some designs might not execute as

well - fine lines don't print well on coarse woven linen. Finally, I can conjure my design by combining different elements and looking at the layout - is it going to be spaced out, tight, allover or placed? Then I consider how many color limitations are designated for the print out within a price point - two screens, three screens, or twelve screens.

4. Do you design with a target market, customer and price point in mind?

Every season I design with a target customer in mind and manufacturing limitations for the textiles we design. While developing weave fabrics it's important to have construction and yarn size corresponding to reach a certain price point. Together, with sourcing, we figure out the best price for the construction and yarn and how we can afford to keep the desired aesthetics look, and hand feel.

5. Do you work in a design team?

Yes, most fashion design work is done within a team setting. The position of a textile designer takes on a supportive role. I work with design to enhance their vision into a workable textile. Fabric is one of the major components of the garment and it's very technical, especially when dealing with wovens. That's why the design team must have a knowledgeable person within those areas.

6. What advice do you have for someone wanting to get a job in your area of fashion and textiles?

Firstly, as a textile designer you need an eye for detail and complexity - be able to make sense out of chaos. Creativity follows, since you have to deal with a lot of critical thinking for solutions when given complicated weaves or detailed prints to work on. A good sense of color differentiation and combinations is a must when dealing with multiple color changes and blending colors.

Passion for wanting to draw all day is very motivating to reach your goal. In high school you should pick jobs that will help gain these skills; for example, work in a fabric store and learn all about the various types of fabrics and differences between them. In college, take courses that would help you with drawing, painting, fiber chemistry, computer design, etc.

Textile Designer Eva Snopek: *Placement print; Print and Styling Presentation for S/S.*

Glossary

Fashion Illustrator Stuart Whitton:
*Hand drawn illustration of clothing to
display the word 'Fashionable'*

If you want to enter the world of fashion design then you must speak the language of fashion. This glossary introduces many of the terms commonly used in the fashion industry globally. For further explanation and more terms refer to research on the Internet and in the glossaries in each book in this *Fashion Design Series* (Burke).

Apparel: Clothing, garment, esp. outerwear.

Bespoke (clothing/tailoring [a bespoke tailor]): Custom-made garments, individual made-to-measure tailoring for men's suits.

Block/sloper: A custom-fitted basic pattern from which patterns for different styles can be created.

Bottom weights: Heavier weight fabric typically used for pants, trousers and skirts.

Brainstorming: A group method of generating a flood of creative ideas and novel solutions.

Branding: The process a company uses to identify and communicate its product or services and provide customers with assurances of a level of quality and consistency of standard.

Bridge: (Used in apparel in the USA). 'Bridge' is between better/high street style and designer.

Budget: See mass market.

Cabbage: (UK) fabric/cloth scraps or oversupply that remain after the orders/garments have been cut from the production/bulk fabric.

CAD/CAM (Computer Aided Design/Computer Aided Manufacturing): An interactive computer design system for the apparel and textile industry.

Calico: See toile.

Capsule collection: A small range of key or basic items.

CMT (cut, make and trim): A factory that cuts, sews and finishes the fashion products - from cut fabric to finished garments.

Collection/line/range: A group of clothing designs put together to present the designer's/brand's inspiration and new trends for a particular season.

Colorway (color palette, color story): A range of colors for a collection of garments or fabric designs which offers the choice of available colors.

Competitive advantage: The strategies, skills, knowledge, resources and competencies that differentiate a business from its competitors - this might be by offering a product that customers find is more attractive than the competitors' products.

Concept/mood/styling/theme board: Creative ideas and designs presented together to show the overall concept or direction for a fashion or fabric collection.

Concession: Area of floor space in a department store leased to a particular brand or designer.

Consignment: A shipment of goods with the provision that payment is expected only when the goods are sold and that unsold items can be returned.

Consumer: The end user of a garment, product or service.

Croquis figure template: *Croquis* is a French word simply meaning a *sketch*. The croquis figure template can be used as a guide when drawing garments for technical specifications (specs), for production purposes. See the *Design Development* chapter.

Croquis sketchbook: A sketchbook where the designs are progressively developed on a croquis figure.

Cruise wear/resort wear: A specialized clothing style, originally marketed by upscale stores for affluent customers who spent the post-Christmas/New Year's weeks in warm-weather climates. Now a *year-round* clothing style and fashion season as many holiday destinations and resorts have become places of *year-round* living; labels include - J. Crew, Banana Republic, Michael Kors, John Galliano, Matthew Williamson, Vera Wang.

Demographics: A marketing term - data is based on the characteristics of the human population and includes gender, race, age, income, educational attainment, home ownership, employment status, and location.

Design brief (client/academic/competition brief): The starting point of a design project - written or verbal and is focused on the desired results of the design not the aesthetics.

Design concept: A creative idea that helps sell or publicize a new design, for example, a new concept in eveningwear.

Design development: The process of developing a design using research gathered, design elements and design principles, and based on a specific theme, fabric or style.

Designer label: Garments/products designed by a prestigious designer or brand, applied to luxury items, and targeted to a more affluent customer, e.g. Burberry, Gucci, Versace, Prada.

Design presentations (storyboards): A fashion designer's creative format to communicate clothing designs and concepts to the buyers, merchandisers, design and marketing teams.

Diffusion line/range: A secondary, less expensive collection by a high end designer/brand.

Draping/modelling: A technique that uses the dress stand to develop designs and help create the patterns - especially when creating couture, eveningwear, soft flowing designs (jersey, silk fabrics), complex shapes, and when working 'on the bias'.

Dress form/stand (mannequin): Is modelled on the human body, with style lines that correspond to the fit and construction lines from which clothing patterns and garments are made.

Entrepreneur: A person who identifies an opportunity or new idea and exploits and develops it into a new venture or project.

Fabric swatch: A sample of a fabric from the fabric roll; swatches are used to help inspire the designer when creating design concepts and can be presented as part of a design presentation.

Fashion week: Industry event where fashion designers, brands and design 'houses' display their latest collections as runway/catwalk shows. Particularly aimed at fashion buyers to view the latest trends, and the media for promotion. The four fashion capitals of the world hosting fashion week consecutively, twice a year, are New York, London, Milan and Paris.

Flagship store: A company's most directional store in regard to layout and merchandise.

Flats (technical/working drawings/diagrammatics): Explicit line drawings of garments, drawn to scale. See specification drawing.

Focus group: A form of qualitative research where a representative group of people is brought together to openly discuss their thoughts on a particular product, service, concept, the price, the packaging, advertising, etc.

Form: A shape, visible or tangible - the 'human form' is the shape of the body; the 'form of a fabric' is the effect from light as it falls on the fabric, and the way the fabric falls into folds and drapes.

Franchise: A regulated agreement enabling the franchisee to sell or provide a product or service owned by the manufacturer or supplier (franchisor). The franchise is regulated by a franchise agreement that specifies the terms and conditions of the franchise. The franchise fee usually includes management systems, equipment, training and support.

Grading: The process of mathematically adjusting a pattern to meet a range of specific sizes.

Greige goods (grey): Fabrics in their raw form - not dyed, bleached or finished; fabrics that have not been processed.

Haute couture: French for *'high sewing'*. Haute couture is the most prestigious level of fashion. To qualify as an official 'haute couture' house, the designer/company must be a member of the *Chambre Syndicale De La Haute Couture*, a Paris-based body of designers governed by the *French Department of Industry*.

Indie designers: Include independent designers, artists and crafts people who design and make a wide array of products without being part of large, industrialized businesses.

Innovation: Is more than a flash of inspiration, it is the systematic development and implementation of creative ideas.

Inspiration: A creative, brilliant or timely idea that stimulates the concept, development and production of a design for a fashion garment, costume, print, embellishment, etc.

Inventory: All stocked goods/merchandise - fabric, trims, garments, finished goods which a company has available to sell.

Jobbers: A trader who acts as a middleman and buys inventory (surplus stock/fabric) from manufacturers or wholesalers, then resells the goods to fashion designers and fashion businesses that do not require large quantities of cloth or cannot warrant purchasing the normal minimum wholesale lengths.

Just-in-Time (JIT): JIT manufacturing or JIT inventory - manufacturing and stock-control system where goods are produced and delivered just before they are required. This eliminates the need for large inventories.

Licensing: A legal agreement that gives manufacturers the exclusive right to produce and promote fashion products that display the name and/or logo of a designer in exchange for royalty payments.

Line: Use of line in artwork, boldness of line, a contour or outline of a design, the clean lines of an illustration; in a garment it relates to its cut and style lines, its construction.

Line sheets/range sheets: A catalogue of all the styles available in a product range used to market the collection to the retail buyers - includes flats/working drawings of the range, the fabrics and colors available, prices, and often photographs of the products.

Look book: Hard copy or digital, showcasing a fashion designer's or fashion brand's collection in photographic form.

Mannequin: See dress form/stand. Also, an artist's miniature wooden figure with movable joints, useful for displaying body positions, proportions and perspective.

Market research: The study and questioning of groups of people to help determine the target market, what the market wants, what products it wants, determine the competition, and ensure a product has competitive advantage and the best chance of success.

Marketing: The co-ordinated process to promote and inform potential customers and existing customers of the company's products or services and create an interest.

Marketing strategy/plan: A document outlining marketing objectives, strategies and activities - part of the business plan.

Marking: The process used to determine the best layout when cutting each pattern piece for a garment/style.

Mass market/budget: Low end of the apparel spectrum - sometimes a knockoff of higher priced designer items sold at popular prices to the masses, hence the name 'mass market.'

Moderate: Moderately priced clothing made in volume - dresses, sportswear, career wear and nationally advertised apparel brands.

Mood: The theme and feeling brought about by tangible and intangible objects, images and circumstances. For example, a piece of antique cream lace, or soft, downy white feathers can bring about a feeling (mood) of calm and/or romance.

Muse: The source of an artist's/designer's inspiration - this could be a style icon, celebrity, poet, etc.

Muslin: See sample and toile.

Networking: The ability to connect and interact with a broad range of contacts for the purpose of sharing useful information and resources. The relationship is usually mutually advantageous and collaborative (win-win).

Niche market: A non-mainstream market, usually small and requiring specialised skills.

Offshoring: Outsourcing work to an overseas company.

Opportunities (business/fashion): Design or financial ideas and changes that could give the company or designer competitive advantage over competitors.

Outsourcing: The term used when a product or service task which has previously been carried out within the company (an inside source), is now being purchased from another company (an outside source). It usually refers to non-core activities which can be performed cheaper by an outside company that specialises in that line of work.

Pattern cutting/drafting/making: The technique of creating a flat pattern from measurements and the use of blocks/slopers.

Piece goods/yard goods (textiles): Fabrics made and sold in standard lengths.

Pinking shears: Scissors that cut with a zigzag pattern to prevent the edge of a fabric from fraying.

Point of difference (POD): See Unique Selling Point.

Portfolio of skills (fashion design): The fashion designer's portfolio of skills is an inclusive term used to describe the sum of the knowledge of the industry; the skills, creativity, tools and techniques within the fashion profession.

PowerPoint: Software used to create a digital presentation (for slide show/video/web/email attachments).

Pre-production: The processes necessary to produce the products/garments before production.

Presentation: (Boards, digital, portfolio, fashion presentation, design presentation), the professional method used to visually display a design concept in a creative, dynamic format, enhancing individual pieces of artwork or products. The concept could be for a fashion range, a fashion mood or theme, fashion colors, fashion fabrics or fashion promotion.

Primary data: Data obtained directly (firsthand) through questionnaires, interviews and focus groups.

Private label: Merchandise manufactured by a company to the specifications of a particular retailer and includes the store's own trademark or brand name, e.g. Barneys, Saks, Harvey Nichols.

Problem solving: Generating a number of technical solutions to solve a problem, which is then handed over to the decision-making function to select the solution that enjoys the widest support and commitment from the team members.

Production: The construction process by which products or garments are made – in the fashion industry this is the manufacture of garments or products which results from the orders collated after the sales of a collection.

Production sample (sealing/sealed sample): The approved sample that serves as the approved standard to which the product must be made.

Products: Goods or services the brand/designer intends to manufacture and sell.

Project management: Management techniques used to plan and control the change process, e.g. implementing a new venture, business, service, fashion collection, fashion project.

Prototype: See sample.

Qualitative research: Data based on a customer's attitudes, views and feelings.

Quantitative research: Data based on numerical information (sales figures, people's sizes).

Range: See collection.

Range sheet: See line sheet.

Ready-to-wear (prêt à porter/off-the-peg [shelf, rack]): Clothing carrying a designer's label, made in standard sizes and readily available to purchase from merchandise in stock.

Resource folders and files (design, cutting, magazine clipping, reference, swipe): Used to store research information for collating magazine clippings/tear sheets, images, photographs and fabric swatches.

Retail: Goods or services sold by a business directly to consumers.

Roughs: Quick drawings capturing ideas and concepts in a sketch book, and usually drawn using a pencil, fine liner or marker pen.

Sample garment (calico, muslin, prototype, toile): A trial/test garment which has been interpreted from a designer's concept or sketch, initially made from an inferior/less expensive fabric such as calico.

Secondary data: Data obtained from published information, government statistics, libraries, etc.

Sector (fashion): An area of the fashion industry where businesses share the same or related product.

Signature style (designer): A distinctive mark or characteristic, that identifies the designer, for example, a design, fabric, print.

Silhouette: Overall outline of a garment, or 'look', and includes its shape, volume and form.

Sloper: See block.

Specification drawing (technical): Explicit line drawing of a garment/product, for production, drawn to scale identifying all construction lines (seams, darts), and styling details (pockets, buttons, trims).

Specs (specification sheet): Production document containing all the specifications (spec drawing, instructions, measurements) needed to produce the garment or product to the required standard and design. It forms the basis of a binding contract between the design house or client, and the factory that produces the garment.

Storyboards: See design presentations.

Street fashion: The fashion and clothing that the public are wearing and the innovative way they put it together.

Style icon: See muse.

Style lines: The fit, shape and construction details that make up a garment.

Sub-brand (endorsed brand): A product/service that has its own brand identity (persona and brand values) that separate it from the parent brand e.g. Polo by Ralph Lauren, Emporio Armani by Giorgio Armani.

Supply chain (value chain): The vertical integration of the key links in the supply chain from textiles to retail (sales to the customer). At each point on the supply chain there are potential business opportunities for a brand or fashion designer.

Swatch: See fabric swatch. (Also used in computing software - one of a series of solid-colored patches used as a sample when selecting color. Swatch also refers to the colors contained in the color palette.)

Swipe files (US): See resource folders.

Target market: A specific group of consumers or market segment at which a company aims its products and services.

Technical drawings: See flats, and specs.

Template: See croquis.

Toile (also known as a calico or a muslin): *Toile* – French word for a sample garment made up in a less expensive cloth (calico) used in the design and construction process.

Torso: (Upper and lower torso), the trunk of the human body.

Unique Selling Point (USP) or Point of Difference (POD): (Used in marketing.) A particular element that makes a product/service different from anything else on the market and gives competitive advantage.

Viral marketing: Promoting a product/service/brand - a message is passed from person to person using social networks (Facebook, YouTube, MySpace), and through viral promotions such as, video clips, interactive Flash games, e-books, and text messaging.

Virtual runway/catwalk show: Digital fashion show using computer software to create digitally-generated models, clothing, the runway and special effects.

Warehousing: The facility used to store merchandise or other materials or equipment. Warehousing usually involves storing, stock control, inventory control and retrieval.

Wholesale: The selling of goods/merchandise from business to business (retail) - usually in bulk quantity and includes terms and conditions that might cover discounts and credits.

Working drawings: See flats.

Zeitgeist: The 'spirit' of the times.

Internet Resources

'The Cyber Information Runway to Success'. As a designer, you can travel on the Internet global information highway to search for information and advice to help develop your designs and create your collections. This includes researching and sourcing the latest fashion trends; historical references; fashion and textile shows; trend forecasting agencies and publications; fabrics; fashion and textile suppliers; manufacturers; PR agencies; stylists; and wholesalers, etc. The Internet is your international fashion **Yellow Pages**, an A to Z. Bloggers also cannot be forgotten - they have become an important part of the industry and a voice for a new generation of style aficionados, providing commentary at the click of a mouse. Listed here are examples of sites and the type of information available. Do a **key word** search using apps or a search engine such as Google to find the information you need pertaining to your specific location and country. And, by using social networks, you can also further develop your network of contacts who might be able to advise and guide you through the fashion design process.

Industry/Trade Shows and Sourcing

www.apparelnews.net: California/LA fashion specific - apparel news, trade info, industry trends.

www.apparelsearch.com: Fashion industry news; search for services, events, shopping globally; one of best sites for sourcing information.

www.biztradeshows.com/apparel-fashion: Search for global clothing industry trade fairs, fashion & textile exhibitions, apparel trade shows, garment technology.

www.britishfashioncouncil.com: The British Fashion Council organises LFW and is an excellent interface between the fashion industry and fashion education.

www.cottoninc.com: Agricultural, fiber and textile research, market information and technical services, fashion forecasts and retail promotions, and global sourcing of fabrics.

www.ehow.com/fashion-and-style: General and industry useful facts, tips, articles, videos.

www.fashion.about.com/od/stylebasics: Useful for information on sizing, measuring and general queries.

www.fashioncenter.com: Based in New York's Garment District - provides lists of factories, fabrics and services.

www.photographiclibraries.com/fashion_photographers: List of photographers and agencies who contribute to projects including advertising campaigns, editorial shoots and fashion shows - links to fashion, art and related sites.

www.polyvore.com: Links to fashion websites - start or create new trends, create mood and style boards/concepts, discover the hottest brands, products, trends and looks.

www.premierevision.fr: Première Vision, the key fabric trade fair held in Paris, together with Expofil and Indigo.

www.weconnectfashion.com: Global fashion industry search engine - fashion calendar, trade events, manufacturers, apparel, textile and accessories products.

Trends, Collections, Forecasting

www.elle.com: Elle magazine - runway shows, collections, fashion and trend topics, pop culture, etc.

www.fashion.net: Links short cuts to other sites, fashion magazines and general industry news.

www.fashionangel.com: Fashion designers, magazines online, services, shopping.

www.fashioncapital.co.uk: News of the latest trends in fashion, and forecasting trends for the coming season.

www.fashionguide.com: Info, sourcing, brands, shopping, and links to other fashion/clothing, music and related sites worldwide, plus global news.

www.fashionmall.com: An international fashion industry Yellow Pages list from A to Z, dedicated to fashion; update on collections, seasonal highlights and what to wear.

www.fashiontrendsetter.com: Online fashion forecasting, trend reporting and news e-zine.

www.fashionwindows.com: Fashion trends, runway shows and a calendar of events and fashion topics for research.

www.hintmag.com: Hint magazine - great articles, trends, fashion, people, collections.

www.londonfashionweek.co.uk: Great catwalk shows.

www. modainfo.com: Global suppliers of trend information - publications, tools and consulting services.

www.modaitalia.com: Fashion from Italy plus a lot more such as; textiles, beauty, fashion calendar.

www.nytimes.com/pages/fashion: New York Times fashion.

www.promostyl.com: International trend/design agency researching trends, trend books and products online.

www.showstudio.com: Fashion broadcasting initiative that invites leading creatives from the fields of art, fashion and design to collaborate on new work and transmit live events.

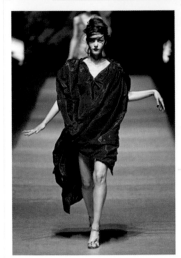

see the slideshow › | view full screen ›

STYLE COM/

FASHION SHOWS | PEOPLE + PARTIES | NEWS | TRENDS + SHOPPING | ACCESSORIES | BEAUTY | VIDEO | COMMUNITY | Search

new today: garance's beauty secrets, new year's eve jumpsuits, and pre-fall

PARIS, October 1
By *Meenal Mistry*

The show notes at Vivienne Westwood felt like an e-mail from an old, dear friend who happens to think and feel very deeply. They began with the words: "Bullet points are a good way of setting out your ideas." And the designer did just that, enumerating a slightly

Vivienne Westwood

REVIEW COMPLETE COLLECTION

Save the planet.

Westwood titled the collection The Only One, presumably in reference to Earth, but she could have been talking about her own singular role—equal parts grande dame, provocateur, and industry Cassandra. Certainly these clothes, which had a recycled

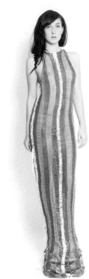

LONDON FASHION WEEK

Canon

Collette Dinnigan
Elie Saab
Hermès
Kenzo
Louis Vuitton
Miu Miu
Neil Barrett
Paul & Joe
Talbot Runhof
Valentino
Wunderkind

Craig Lawrence

◄ • • ►

www.style.com: Excellent site linked with Vogue and 'W'; video and slide coverage of the latest designer shows; celebrity style, trend reports and breaking fashion news.

www.thetrendreport.com: Cool site - fashion runways, editorial and consumer buying.

www.trendland.net: Online magazine - art, culture, design, fashion, photography and consulting.

www.vogue.co.uk: Online version of UK monthly - daily news, interviews, job opportunities, plus limited access to the archive from 1946-92.

www.wgsn.com/public/wgsndaily: Worth Global Style Network - online news and information service for the fashion and style industries. Separate from the main WGSN service.

www.wwd.com: Womens Wear Daily free online version of American fashion retailers' daily newspaper - headlines, links to other sites, and subscription details plus preview of full online version.

Costume History, Museums, Educational Research

www.fashion-era.com: Research period fashion.

www.nga.gov/collection/gallery: National Gallery of Art and Index of American Design - thousands of watercolor renderings of American decorative arts objects from the colonial period through the nineteenth century. Excellent visual archive.

www.vam.ac.uk: V&A museum, London - events and exhibitions, education, historical research and more.

www.vintagefashionguild.org: Excellent information/research on vintage - Vintage Fashion Guild (VFG), international collective with members in the USA, UK, Can and Aus.

Blogs

www.ashadedviewonfashion.com: Diane Pernet, American-born journalist and editor, based in Paris, front row at fashion shows, blogs all about young talent.

www.facehunter.blogspot.com: Travelling the globe on the lookout for new subjects on the streets from Reykjavík to Vienna, Yvan Rodic focuses on personal style.

www.thesartorialist.com: New Yorker, Scott Schuman's blog has become a phenomenon, travelling the globe shooting simple portraits of well-dressed individuals including fashion insiders.

Others include www.: bryanboy.com, catwalkqueen.tv, feelslikewhitelightning.com, jakandjil.com, nymag.com/daily/fashion, redcarpet-fashionawards.com, stylebubble.typepad.com, themoment.blogs.nytimes.com.

For more information (see this *Fashion Design Series*):

Fashion Forecasting chapter, *Fashion Forecasting Services* section and website links.

Fashion Computing - *Fashion Internet*.

Fashion Entrepreneur - *Internet Resources*.

New Sites: The Internet is constantly developing as more companies make the transition to using and establishing their presence on the Internet. Key word searches are the only sure way of accessing the latest sites and information.

Further Reading

 This selection of books and periodicals will keep you informed about fashion design, illustration, business, entrepreneurship, and future trends. With growing public interest in fashion, most countries now have their own fashion based publications, of which many periodicals are also available online. For more information do a keyword search on the Internet and visit the fashion bookshops and websites such as Fashion Design Books (NY), Fashion Bookshop (LA), www.thefashionbookstore.com. and www.rdfranks.co.uk.

Fashion Design and Illustration

Abling, Bina, *Fashion Sketchbook*, Fairchild Books

Armstrong, Jeni, *From Pencil to Pen Tool*, Fairchild Books

Borrelli, Laird, *Fashion Illustration by Fashion Designers*, Chronicle Books

Burke, Sandra, *Fashion Artist - Drawing Techniques to Portfolio Presentation*, Second Edition, Burke Publishing

Burke, Sandra, *Fashion Computing - Design Techniques and CAD*, Burke Publishing

Callan, Georgina O'Hara, *The Thames and Hudson Dictionary of Fashion and Fashion Designers*, Thames and Hudson

Dawber, Martin, *Big Book of Fashion Illustration*, Batsford

Jenkyn Jones, Sue, *Fashion Design*, second edition, Laurence King

Lazear, Susan, *Adobe Illustrator for Fashion Design*, Prentice Hall

McKelvey, Kathryn, *Fashion Source Book*, Blackwell Science

Morris, Bethan, *Fashion Illustrator*, Laurence King

Seivewright, Simon, *Research and Design*, AVA Publishing

Stipelman, Steven, *Illustrating Fashion: Concept to Creation*, Fairchild Books

Tain, Linda, *Portfolio Presentation For Fashion Designers*, Fairchild

Zaman, Zarida, *The Fashion Designer's Directory of Shape and Style*, Barrons

Fashion Business and Entrepreneurship

Bruce, Margaret, and **Hines**, Tony, *Fashion Marketing: Contemporary Issues*, Butterworth Heinemann

Burke, Rory, *Entrepreneurs Toolkit*, Burke Publishing

Burke, Rory, *Fundamentals of Project Management*, Burke Publishing

Burke, Rory, *Project Management Leadership*, Burke Publishing

Burke, Rory, *Small Business Entrepreneur*, Burke Publishing

Burke, Sandra, *Fashion Entrepreneur - Starting Your Own Fashion Business*, Burke Publishing

Easey, Mike, *Fashion Marketing*, Blackwell Publishing

Gehlar, Mary, *The Fashion Designer Survival Guide*, Dearborn

Goworek, Helen, *Careers in Fashion & Textiles*, Blackwell Publishing

Granger, Michele, and **Sterling**, Tina, *Fashion Entrepreneurship Retail Business Planning*, Fairchild Books

Harder, Frances, *Fashion for Profit*, Harder Publications

Jackson, Tim, and **Shaw**, David, *The Fashion Handbook*, Routledge

Raymond, Martin, *Tomorrow People*, Pearson

Roddick, Anita, *Business As Unusual*, Thorsons

Trade Publications / Journals

3rd Floor (British)

California Apparel News (US)

Color Association of U.S. Women

Color Essence Women/Men (American)

Close-Up Tokyo/Runway New York, etc.

Drapers Record (British)

Fashion Theory: The Journal of Body, Dress and Culture

Gap Press

Journal of Fashion Marketing and Management

Retail Week

Selvedge (British)

Textile Report (Trend info for Fashion and Textiles)

View on Colour

Textile View Magazine

Viewpoint

WeAr (Collections, Stores, Market News - Global)

Woman's Wear Daily (WWD) (American)

Zoom on Fashion Trends

Trend / Fashion Forecast Services

Doneger Design Direction (American)

Faces Fashion Reports (British)

Jill Lawrence Design (British, Fashion and Colour)

Milou Ket (Trends, Colors - Netherlands)

Pantone View Colour Planner

Promostyl (French, American and International Agencies)

The Wool Bureau (American)

Trend Union

Trends West (American, Trends and Textiles)

Trendzine (On-Line Forecast and Trends)

Publications and Magazines

Another Magazine (British)

Arena Homme (Men)

Bloom

Collezioni (Italian): Trends, Sport and Street, Ready to Wear, Accessori, Bambini (children), Donna, Uomo (men)

Dazed and Confused (British)

Elle (American, Australian, British, French, German, Italian, SA, Spanish Publications)

GAP Collections (Paris, Milan - Japan)

Fashion Show (American)

Fruits (Japan)

GQ (Men)

Harpers and Queen (British)

Harper's Bazaar (American, Italian)

ID (British)

Joyce (Hong Kong)

L'Officiel da la Couture (French)

Marie Claire (American, Australian, British, French, German, Italian, SA, Spanish publications)

Numero Magazine

Oyster (Australia)

Pop (Australia)

Tank (British)

Vogue (American, Australian, British, French, German, Italian, SA, Spanish publications): also **L'Uomo**, Bambini, Vogue Sposa Italia

Visionaire (American)

W (American)

Wallpaper (British)

Online Publications

There are an ever increasing number of fashion publications online. Examples include Elle, Harpers Bazaar, Vogue, etc., and:

www. drapersonline.com

www.view-publications.com

www.papermag.com

www.vogue.com

Index

Burke Publishing Book Series

Bluewater Cruising Series by Rory and Sandra Burke
Managing Your Bluewater Cruise, ISBN: 978-0-473-03822-9
Greenwich to the Dateline, ISBN: 978-0-620-16557-0
Bluewater Checklist, ISBN: 978-0-9582391-0-3

This *Bluewater Trilogy* includes a preparation guide, a travelogue and a checklist.

Project Management Series by Rory Burke
Fundamentals of Project Management, ISBN: 978-0-9582733-6 -7
Project Management Techniques, ISBN: 978-0-9582733-4-3
Project Management Leadership, ISBN: 978-0-9582733-5-0
Advanced Project Management, ISBN: 978-0-9582733-7-4

These books include: An introduction to the field of Project Management, the planning and control techniques needed to manage projects successfully, and the essential leadership skills to manage the human side of managing projects.

Entrepreneur Series by Rory Burke
Entrepreneurs Toolkit, ISBN: 978-0-9582391-4-1
Small Business Entrepreneur ISBN: 978-0-9582391-6-5

These books outline the essential entrepreneurial skills to; spot a marketable opportunity, develop a business plan, start a new venture and make-it-happen, and manage a small business on a day-to-day basis.

Fashion Design Series by Sandra Burke

Fashion Artist - *Drawing Techniques to Portfolio Presentation, 2ed*
ISBN: 978-0-9582391-7-2

Fashion Computing – *Design Techniques and CAD*
ISBN: 978-0-9582391-3-4

Fashion Entrepreneur - *Starting Your Own Fashion Business*
ISBN: 978-0-9582733-0-5

Fashion Designer – *Concept to Collection*
ISBN: 978-0-9582391-2-7

This *Fashion Design Series* will guide you through the *Fashion Design Process* introducing you to the essential design techniques and skills required to achieve a successful career in the fashion industry. Presented in easy steps, the books are packed with fashion illustrations, designs and photographs, from international designers and illustrators, to visually explain the accepted fashion industry theory and practice. These books are structured in line with fashion courses globally and designed as self-learning programs proving invaluable textbooks for fashion students and aspiring designers.

Sandra Burke, M.Des RCA (Master of Design, Royal College of Art), is a fashion designer, author, publisher, and visiting lecturer to universities in Britain, America, Canada, South Africa, Australia, New Zealand, Hong Kong and Singapore.

www.burkepublishing.com www.fashionbooks.info